THE VICTORIAN TREASURE-HOUSE

T The Victorian
Treasure-House

PETER CONRAD

COLLINS
ST JAMES'S PLACE, LONDON
1973

William Collins Sons & Co Ltd
London · Glasgow · Sydney · Auckland
Toronto · Johannesburg

First published 1973
© Peter Conrad 1973

ISBN 0 00 211883 1

Set in Monotype Scotch Roman
Made and printed in Great Britain by
William Collins Sons & Co Ltd Glasgow

CONTENTS

ACKNOWLEDGEMENTS

I hope John Buxton will not mind finding himself thanked in a book on the Victorians, for I owe a great deal to the kindness and encouragement of him and his wife, and to their hospitality at Cole Park. From John Bayley and Iris Murdoch have come both inspiration and helpful practical advice, for which I am deeply grateful. Much of the writing was done in Lisbon, in the home of Jorge Calado and his family, and I hope they will accept this small tribute to their generosity. Finally, I must thank the Warden and Fellows of All Souls for the award of a fellowship, which set me free to begin this work.

PETER CONRAD

ILLUSTRATIONS

PREFACE

'A TREASURE-HOUSE OF DETAIL,' said Henry James of *Middlemarch* – 'but it is an indifferent whole.' The same might be said of the entire Victorian period. Its works of art often seem, like its interiors, containers to be stuffed as full as possible. Its paintings are cluttered with objects, each precisely and conscientiously depicted; its novels expand to take in a miscellany of characters and incidents, delighting in loose ends. Paintings and novels and even poems have a chaotic fullness, a superabundance, which James thought to be their weakness, but which is perhaps their glory. He was offended by the obesity of the Victorian novel: it bulged into those loose baggy shapes which he found so unsightly, but which accord perfectly with the self-satisfied curves, the prosperous embonpoint, of Victorian ornament. It was a fluid pudding to tempt the voracious Victorian appetite, and James put it on a diet; his was the desire and pursuit of the whole, rather than the detail.

Careless of refinement and selection and of classical notions of beauty and harmonious form, Victorian artists are always perilously close to badness, and their triumphs are almost always flawed – reckless, extravagant, slightly monstrous, their masterpieces, *Modern Painters, The Old Curiosity Shop, The Ring and the Book*, the pictures of Holman Hunt and the buildings of Butterfield, seem in a rather exhilarating way to have only just saved themselves from calamity. They succeed by daring, by energetic idiosyncrasy, by force of will, rather than by artistic scruple. They seem to have had a pact with their genius never to be perfect.

The first chapter considers their 'indifferent wholes', and argues that the Victorians profit from the state of literary freedom proclaimed by the romantics – the conviction that nature knows no genres or rules, and the example of Shakespeare who (he and nature being the same) mingled high and low, tragic and comic, to create works which desert the formality of art for the plenitude

9

of life. Shakespearean drama is re-created in the Victorian novel; and the novel seems to benefit as well from romantic attempts to write drama which is spiritual and internal, retiring from action into the hidden world of thought and sentiment. The romantics were anxious to prove that Shakespeare's plays could not be staged; the Victorians go further, and turn them into novels. The second part of the chapter deals with the adaptation to the novel of the Shakespearean double plot and its layering of comedy and tragedy like streaky bacon, and with the grotesque art of the Victorians, the cheerfully anarchic way in which they permit the details to rebel against the whole, the subsidiary figures against the heroes and heroines.

The novel emerges in this chapter as the central literary form, and it re-makes painting – traditionally allied with epic, history and mythology – in its own image. Hence the second chapter is about Victorian methods of pictorial narrative; it points to what the genre painters learnt from Hogarth, whose satiric art becomes in them sentimental, solicitous, novelistic. But the novel seems to demoralise painting: badness is always dangerously near in this period, and this chapter goes on to suggest how the painters were led astray by their determination to narrate.

The narrative pictures are notoriously evasive, spreading a varnish of contentment over the problems they depict, eliciting sympathy but transforming it into harmless sentiment; and the next chapter concerns another means of evasion, the idea of the picturesque and the use of a sort of genre painting in the novel. The notion of the picturesque crosses from painting into literature, and comes to be used not in the connoisseurship of landscape but – as will be seen from Blanchard Jerrold's very Dickensian book on London – in the control of the chaos of the city. For the city is also a treasure-house of detail and an indifferent whole, and it is intimately connected with the novel – like nature and Shakespeare, the city is an anti-classical phenomenon; tragedy and comedy bump into each other in its congested streets as they do in the scenes of Shakespeare's plays, and its very formlessness is an important imaginative stimulus to Dickens.

The realism of the Victorians has an anxious, preoccupied quality; they feel an obligation to tell the truth but back nervously away from its implications, retreating, for instance, into the

picturesque, the soothing resolution of antagonisms and conflicts into a picture. Detail, the subject of the fourth chapter, is another symptom of anxiety. There always is, with the Victorians, a disparity between indifferent wholes and abounding details; and the meticulous rendering of the minute can become an excuse for blurring over the implications of the whole. John Brett, for instance, in his picture of a stone-breaker in the Walker Art Gallery in Liverpool, lingers over the chalk flint and the minutiae of shrub and leaf in the Box Hill landscape as if to avoid having to think about the gratuitousness and iniquity of this kind of labour. A picture of the same subject, exhibited in the same year, 1858, by Henry Wallis, brutally tells the truth: this old stone-breaker has collapsed, dead, among his rubble, and a rousing quotation from Carlyle's *Sartor Resartus* is appended to enforce the moral. Brett, however, diverts attention from the abuse to the calm exactitude of the surrounding detail, and he makes the scene picturesque – the boy swings his hammer merrily, his puppy romps, a bird sings. It is an image of contentment and happy industry; and Brett's own patience over the detail is equally a labour of love, that possessive love which dotes on, even ingests its object, which this chapter reveals in the novel as well. And this prominence of detail leads to another aesthetic miscalculation of the Victorians, another explanation of the badness which is always threatening – a tendency to identify creativity with work, to equate understanding with mastery of the details.

The fifth chapter follows another idea from art and architecture – that of Gothic – into literature. This too implies pursuit of the detail rather than the whole: a Gothic cathedral is a treasure-house of detail, and the Victorians developed a sort of literary equivalent to this architectural style. *The Ring and the Book* is a novel-poem which is like a city (the theme of the third chapter) but also like a cathedral, growing, sprawling, shooting into excrescences or rambling into detours. Literature takes over some of the properties of architecture, and architecture in its turn becomes literary: the Victorians were taught by Ruskin to read buildings as they were taught by the narrative painters to read pictures – buildings for him possess character, a moral life which can be read in the detail of their structures. Architects, like painters, become narrators, novelists; and in the process, perhaps, they become bad architects.

The second chapter argues that it is safer for literature to become pictorial than for painting to become literary, and the conclusion here must be similar – Ruskin in his evocations of San Marco can triumphantly transform architecture into literature, but the only designs of his ever realised were a window and half a dozen brackets on the Oxford Museum; and those Victorian buildings which exploit Gothic for its literary or its sanctimonious associations are interesting literature but bad architecture.

Several themes are drawn together in the final chapter around the central idea of Arnold's grand style. The book begins with the romantic rejection of classical values and ends with an attempt to recover them – the stern and superior manner of the grand style was a defence of poetry against the incursions of the novel, a return to the idea of high art which had been confounded first by romantic poets and then by Victorian novelists. This chapter describes the competition between poetry and the novel, between the past and the present, between classical reverence for the whole and the messy, burgeoning, indisciplined pursuit of details. The grand style is connected as well with the picturesque theme of the third chapter, for Arnold's grandeur is a way of keeping at a distance the troublesome aspects of contemporary life, and it is timorous and uncertain rather than self-assured. In struggling to free himself from his time, Arnold only reveals himself as more completely its prisoner.

1. INDIFFERENT WHOLES

SHAKESPEARE haunts the nineteenth century. Like other national heroes, who though dead were said to be lying in wait, ready to return in an hour of need or to issue in a golden age, he waited two centuries for his resurrection at the beginning of the romantic period. The romantics summoned him up, as if striking Drake's drum, in their greatest need – for though their criticism seems to have rescued him from the scorn of neo-classicism, in a more important sense he rescued them: he was the conclusive and liberating example of indifference to classical rule, and he allowed the romantics to hail as the supreme literary virtues those very qualities earlier generations could only see as unlearned and grotesque faults. Shakespeare presides over the poetry of the romantics, and it is through him that the transition from romantic to Victorian – from poetry and drama to the age of the novel – can be understood.

The freakish starts of inspiration, the lack of artistic good breeding, the rude genius uncontrolled by judgement, to which the neo-classic critics point in Shakespeare become, for the romantics, the marks of sublimity; wild and vibrantly alive, Shakespeare comes to seem less an artist than a force of nature. He leaves behind the order and harmony of classical art, as Schlegel said in his lectures on the drama, for the restless, striving, chaotic excitements of romanticism: 'Greek art is simpler, cleaner, more like nature in the independent perfection of its separate works; Romantic art in spite of its fragmentary appearance is nearer to the mystery of the universe.' The romantics approach Shakespeare's plays as works of nature, illimitable, unconfined, deep and wide, powered by an exhilarating energy like Shelley's west wind. Coleridge responds to this quality of uninhibited, peremptory force in the plays: *Macbeth* is the most rapid of them, *Hamlet* the slowest, but '*Lear* combines length with rapidity – like the hurricane and the whirlpool, absorbing while it advances. It begins as a stormy day in summer,

with brightness; but that brightness is lurid, and anticipates the tempest.' The play becomes a landscape, a Turnerian atmospheric drama of warring elements.[1] 'Oh! mighty poet!' gasps de Quincey. 'Thy works are not as those of other men, simply and merely great works of art; but are also like the phenomenon of nature, like the sun and the sea, the stars[2] and the flowers, – like frost and snow, rain and dew, hail-storm and thunder, which are to be studied with entire submission of our faculties, and in the perfect faith that there cannot be too much or too little in them.' Johnson defended Shakespeare in his common-sense way for permitting nature to prevail over accident: his Romans are not necessarily Roman, his kings not always regal; de Quincey extends this argument to say, on the analogy of things in nature, that though a careless glance will discover nothing but accident, the further we penetrate into the works 'the more we shall see proofs of design and self-supporting arrangement'. But the design is hidden, and it is biological rather than formal: it derives not from rule but from the life of the organism. Plan is replaced for the romantics by proliferation: their long poems grow in an exploratory, self-modifying, tentative, essentially incoherent fashion, uncertainly edging forward from one mode of being to another; and Shakespeare is made the great exemplar of this, for he follows, as Pushkin said, no rule but that of inspiration.

The Victorians find a different kind of limitlessness in Shakespeare: for them the analogy to Shakespeare is not nature but the novel (and the novel takes over the romantic idea of a poem's growth – though if romantic lyrics grow as flowers do, Victorian novels, with their leisurely expansiveness, spreading and branching,

[1] This style of thought persists into the Victorian period, so that Charlotte Brontë can incongruously compare the placid Thackeray, in the dedication of *Jane Eyre*, to a romantic tempest: his wit and humour 'bear the same relation to his serious genius, that the mere lambent sheet-lightning playing under the edge of the summer-cloud, does to the electric death-spark hid in its womb'. And Ruskin, in *Praeterita*, with equal incongruity writes of the judicial balance of Johnson's rhyming prose as possessing the 'symmetry ... of thunder answering from two horizons'.

[2] Again there is a surprising Victorian reminiscence, in a review of some religious novels by George Eliot in the *Westminster* in 1852: she attacks them for teaching by means of inflated reflection and melodrama, 'instead of faithfully depicting life and leaving it to teach its own lesson, as the stars do theirs'.

grow as oak trees do; or, sending out excrescences, restlessly sprouting into outcrops and details, as Gothic cathedrals do). Novels are limitless by inclusion; Shakespeare's plays by implication. The characters of drama normally have no past or future, but exist only in the theatrical present of the action, whereas we accompany the characters of novels from birth to death; we can follow them out of the novel – Dickens, for instance, confides in us about Mr Micawber's career in New South Wales. The characters are larger than the plots, or the novels, which contain them; they swell beyond their roles. Mrs Gamp or Pecksniff, though introduced as static social portraiture, soon cease to be the satirist's easily-defined and clearly-demarcated targets, and envelop themselves in macabre and absurd worlds of their own making, in which they insist on living: as Sairey defiantly says, 'Gamp's my name, and Gamp's my nater.' In the nineteenth century, Shakespeare's characters were felt to have this novelistic existence, rather than the limited life-span of the dramatic character – Falstaff and Hamlet, for instance, swamp the plays they are in with their individuality, holding up the course of the action while they explore, the one with humorous indulgence, the other with morbid disquiet, the mysteries of themselves. Between Morgann's attempt to supply Falstaff with the detailed novelistic past which Shakespeare, he feels, implies but does not include, and Bradley's attempt to determine the 'events before the opening of the action in *Hamlet*', the prince's age and where he was at the time of his father's death, critics habitually re-write the plays as novels and release the characters from the dramatic structures in which Shakespeare places them. The Victorian sense of friendship with novel characters, which brought Dickens so many letters begging him to spare Paul Dombey or Nell, or inquiring what other characters were up to now, after having been released from the novel into the freedom of private life, begins in the criticism of Shakespeare, in Lamb's gregarious intimacy with his favourite characters, or Ellen Terry's reconstruction of the history of Falstaff's page Robin, or Swinburne's anxious affection: 'Other friends we have of Shakespeare's giving whom we love deeply and well ... but there is none we love like Othello.' So far do the characters emerge from Shakespeare's and the play's ownership of them that Hartley Coleridge can suggest, 'Let us, for the moment,

put Shakespeare out of the question and consider Hamlet as a real person, a recently deceased acquaintance.'

This is a reversal of the classical attitude to character, which, following Aristotle, defines a character according to his moral quality and fastens him into the sort of action appropriate to him – tragedy for those who are above the average, comedy for those who deserve nothing better than buffoonery and indignity. Thus neo-classic critics found the contradictoriness of Shakespeare's characters an offence not only against decorum but against moral law: Rymer thinks it villainous and sacrilegious to put the noblest Romans in fools' coats, and is disgusted by the way in which Othello bestrides the genres, at once an epic hero and a gull and cuckold – 'We see nothing done by him nor related concerning him that consorts with the condition of a general. . . . His love and his jealousy are no part of a soldier's character, unless for comedy.' But Shakespeare refuses to make character characteristic; nature does not recognise the Aristotelian unities, and neither does he.

Shakespeare, posthumously made the first and greatest of the romantics, provides a justification for the anti-classical art of the nineteenth century in his indifference to unity, genre and rule – a justification for both the endlessly growing accumulations which are the long poems of the romantics, and the loose baggy shapes or fluid puddings which are the novels of the Victorians. Romanticism begins in poetry but finds a more permanent home in the novel, and the example of Shakespeare's anti-classic formlessness has its most profound influence neither on poetry nor the drama, but on the novel. For as the romantics release Shakespeare's characters from his plays, so they detach the action of the plays from theatrical possibility, making them explorations of the inner life – Coleridge, denying that Shakespeare's plays are either tragedies or comedies, calls them romantic dramas or dramatic romances, and specifies that romantic poetry and Shakespearian drama appeal 'to the imagination rather than to the senses, and to the reason as contemplating our inward nature, the workings of the passions in their most retired recesses. But the reason, as reason, is independent of time and space.' These inner hidden recesses are the province not of drama but, increasingly, after Coleridge wrote this note in 1810, of the novel. The romantics, indeed, are careful to insist that the drama is accidental, a form adopted for commercial reasons, rather

than the natural vehicle of Shakespeare's imagination. Lamb was pleased to find that 'Lear is essentially impossible to be represented on a stage'; and, feeling that the appearance on stage of a man coated with black make-up interfered with his poetic sympathy for Othello, he ingenuously recommended that, like Desdemona, we should see Othello's colour in our minds. Carlyle laments that all we have of Shakespeare is *disjecta membra,* windows through which we can only glimpse an inner world which a novelist would have explored but which a dramatist had to desert in the interests of objective theatrical action: 'All his works seem, comparatively speaking, cursory, imperfect, written under cramping circumstances; giving only here and there a note of the full utterance of the man. . . . Alas, Shakespeare had to write for the Globe Playhouse: his great soul had to crush itself, as it could, into that and no other mould. It was with him, then, as it is with us all.'

The Tempest was eagerly enlisted in evidence, as a feat of levitation on Shakespeare's part: in his last play he leaves the earth altogether, his imagination moving aloft into an airy atmosphere quite unable to be represented in the theatre. Lamb objected to attempts to stage it, which crudely anchored its romantic stratosphere of spirit in a grossly literal world of matter: 'the elaborate and anxious provision of scenery . . . works a quite contrary effect to what is intended. That which in comedy, or plays of familiar life, adds so much to the life of the imitation, in plays which appeal to the higher faculties positively destroys the illusion which it is introduced to aid.'

Prometheus Unbound derives from the romantic interpretation of *The Tempest* – Shelley called it a lyrical drama, and the hybrid term is an interesting one: it begins as drama, but lyricism comes to prevail, until in the fourth act character and circumstance and action give way to lyrical atmosphere, utterly disembodied, all fire and air, purged of the baser elements. Drama delights in the substantiality of character, its physical presence; but Shelley's characters are the inorganic voices of unseen spirits, and his action shadowy because it passes in 'dim caves of human thought'. Even love is a passion inside the mind: the poet

feeds on the aëreal kisses
Of shapes that haunt thought's wildernesses.
Conversation is wordless, the 'liquid responses' of 'aëreal tongues';

it becomes music, and even music is disembodied – heard melodies are sweet, but those unheard are sweeter, so music passes into 'echoes, music-tongued', and thus into silence. Shelley's lyrical empathy, his urge to get inside, to feed on thoughts and sensations, to apprehend the spirit of character, means that Prometheus has no life and no power to move – smothered by lyricism, even his cry of agony is not painful but exquisitely beautiful and musical:

> The crawling glaciers pierce me with the spears
> Of their moon-freezing crystals, the bright chains
> Eat with their burning cold into my bones.

The romantics subvert drama by making it lyrical – it explores mental states and worlds of the spirit, inward and insubstantial, rather than creating a human action in which characters can participate. The Victorians make a further change, transferring the delight in innerness, in leisurely self-exploration, in one's unique individuality, from drama to the solitude of the dramatic monologue, in which the character is not bothered by involvement in an action. Plot, as J. S. Mill said, is a necessary evil. Browning in *The Ring and the Book* briskly narrates the events of marriage, murder and litigation at the outset, so as to be free thereafter to devote the poem not to the interplay but to the isolated, self-obsessed self-justifications of the protagonists, who are quite unrelated to one another, each treasuring his own version of the truth of what occurred but not sufficiently interested to want to impose it on anyone else. Dickens places such self-absorbed, demonic dramatic monologuists in the novel, and here they never seem quite at home – they are always, like Miss Flite or Mrs Gamp or John Jasper, larger and more interesting than the actions in which they are incongruously involved; and on the occasions when they are conscripted into the service of this action, as when Micawber is jerked out of his splendid, futile isolation and inconsequence and made to do the detective work which foils Uriah Heep, we feel the novelist is employing force.

What is of interest is character on its own, self-communing and marking out the limits of its private world – bounded, like Hamlet, in a nutshell, these people count themselves kings of infinite space – not character in action. Hamlet, indeed, is the first such character, for he positively refuses to engage in the action he is meant to serve. I have argued that the romantic interpretation of Shake-

speare, and particularly the abstraction of characters from the plays they appear in, leads from drama to lyricism and thence to the dramatic monologues and the novel; and it is interesting to find Goethe, in *Wilhelm Meister's Lehrjahre*, transferring Hamlet from drama to novel. During the rehearsals for their performance of *Hamlet*, Serlo and Wilhelm attempt to define the limits of the drama and the novel, and they agree that the drama deals with characters and deeds, the novel with sentiments and events. The drama has a certain velocity because character is a positive force, striving towards the dénouement, whereas the novel is retarded by the sentiments of its hero, who demands leisure for self-scrutiny. The efficiency of dramatic action becomes the mystery of novelistic event, because in a novel the incidents derive from sentiments. Wordsworth, in justifying the paucity of action in *The White Doe of Rylstone*, speaks of the narrative poem in Goethe's novelistic terms: 'If he [the man of genius] is to be a Dramatist, let him crowd his scene with gross and visible action,' he says with distaste, his view of the grossness of action echoing Lamb's revulsion from a visible representation of *The Tempest*; 'but if a narrative Poet, if the Poet is to be predominant over the Dramatist, – then let him see if there are no victories in the world of spirit, no changes, no commotions, no revolutions there, no fluxes and refluxes of the thoughts. . . .' Mood creates and gives significance to situation, not vice versa.

Sentiment means passivity, and Wilhelm and Serlo name as suffering novel-heroes Grandison, Clarissa, Pamela, the Vicar of Wakefield and Tom Jones; an even more apt case which they do not mention is that of Tristram Shandy, who is blocked and restrained in every direction, unable to complete a single action, including that of writing the novel: he is sentimental to the point of impotence. The novel is a means of introspection, and *Hamlet* is singled out because in it monologues stall the action – all occasions inform against Hamlet, the dramatic fate and the role of revenger assigned to him in the action press him forward, but he delays, preferring to talk about himself. He would rather be in a novel than in a drama. Sentiment overpowers action, as lyricism does in *Prometheus Unbound*, and the play becomes a romantic novel: 'the hero in this case . . . is endowed more properly with sentiments than with character; it is events alone that push him on; and

accordingly the piece has in some measure the expansion of a novel.' The same distinctions occur to Werther, who, like Hamlet, returns into himself and finds a world, 'but again a world of groping and vague desires rather than one of clear delineation and active force' – a world, that is, suited to the novel rather than to the drama.

Mrs Browning also discusses this disembodiment of drama – one aspect of the century's subversion of classical forms – in her novel-poem, *Aurora Leigh*. Aurora in the fifth book urges us to think less of the proper forms for poetry and other merely external criteria, and to

> Trust the spirit,
> As sovran nature does, to make the form;

to allow the work to grow from within. Strictness of external form imprisons rather than embodies the spirit. Therefore, she says rather pettishly, 'I will write no plays', because the drama is shackled to literal truth, to action, to the basely material rather than free and loose in the realm of spirit; it is, as Lamb and Carlyle lament in Shakespeare's case, corrupted by its linkage to the stage:

> 'Tis that, honouring to its worth
> The drama, I would fear to keep it down
> To the level of the footlights.

Aurora looks forward to the increasing spiritualisation of drama: abandoning care for form and convention, it is to spread into limitlessness, and to move inside the mind, or soul:

> The growing drama has outgrown such toys
> Of simulated stature, face, and speech,
> It also, peradventure, may outgrow
> The simulation of the painted scene,
> Boards, actors, prompters, gaslight, and costume;
> And take for worthier stage the soul itself,
> Its shifting fancies and celestial lights,
> With all its grand orchestral silences
> To keep the pauses of the rhythmic sounds.

Hamlet would be the ideal protagonist for this new kind of drama, for he shares Aurora's contempt for painted, simulated fripperies, for the solid or sullied world, for the trappings and the suits of emotion, claiming to have that within which passes show and retiring into the soul with its silences and shifting fancies. Drama is

to become spiritual by eliminating action and other people and becoming monodrama, as in the work of Robert Browning; Hamlet turns his play into a novel by flooding it with his own sentiment and self-questioning. This retreat into the soul entails a subversion of classical form, for the inner life is infinite and formless, and 'grows from within', as Aurora says of life in her arguments with the systematising Romney: Aurora, therefore, adopts a Coleridgean attitude to 'the literal unities of time and place', and would rather 'leave the generous flames to shape themselves', let spirit shape form as happens in nature or Shakespeare (and the two were, for the romantics, the same):

> Five acts to make a play?
> And why not fifteen? why not ten? or seven?
> What matter for the number of the leaves,
> Supposing the tree lives and grows?

This is more than an excuse for the garrulous, gushing formlessness of Mrs Browning's poem, its welter of emotion and nervous intensity: it implies that drama must grow into the novel – for the novel gives up the clear classical graph of dramatic action, to revel in the loose ends and complications of experience; it swells beyond five or even fifteen acts, with the solid, leisurely, comfortably expanding growth of Aurora's tree. Coleridge pointed out that nature gives no recognition to the unities; neither does passion, as Aurora says – its essence is to ignore time and place; and neither does the novel.

Drama is disembodied into lyricism, or internalised and expanded into a novel, but in either case is released from its classical form. Oddly, there seems to be a continuity leading from Shelley's lyrical drama to Wagner's music-drama, in which the dramatic identity of the characters is dissolved by the music which rolls like an ocean over them, and what they are and do is submerged in what they feel, or rather what the orchestra feels on their behalf. Yet Wagner has another connection with the novel. George Eliot, reporting in *Fraser's Magazine* in July 1855 on performances of his works in Weimar, writes of his reforms so as to suggest a parallel with developments in the novel: 'Wagner would make the opera a perfect musical drama, in which feelings and situations spring out of *character,* as in the highest order of tragedy, and in which no dramatic probability or poetic beauty is sacrificed to musical effect.'

The music imposes no demands for action on the characters, but devotes itself to following the movements of their spirits; as Goethe says of the novel, the characters do not serve a plot, rather the situations are spun from their sentiments. 'In Meyerbeer's operas,' George Eliot goes on, 'the grand object is to produce a climax of spectacle, situation, and orchestral effect; there is no attempt at the evolution of these from the true workings of human character and human passions.'

Because this drama is sentimental and internal, Wagner's critics were as anxious as Shakespeare's had been earlier in the century to separate it from the literalism of stage representation. Wagner himself at the Bayreuth Festival of 1876 put his hands over the eyes of Malwida von Meysenberg, who was scrutinising one of the *Ring* scenes through opera glasses, and hissed, 'Don't look so much at what is going on. Listen!' The music, like Shakespearean verse, suggests limitless possibilities to the imagination which the visible spectacle can only diminish; if we should read Shakespeare rather than seeing him, the romantic logic runs, so we should listen to a Wagner performance with our eyes shut. Romain Rolland, sounding exactly like Lamb, says in an essay of 1915, 'I have never shared the opinion that Wagner's works may be best appreciated in the theatre. His works are epic symphonies. As a frame for them I should like temples; as a scenery, the illimitable land of our thoughts; as actors, our dreams.' The last phrase suggests Prospero; and the illimitable land of thought is the realm of *The Tempest*, and of Shelley's fourth act – but it is most thoroughly explored by the novel. 'Scenic reality,' says Rolland, again echoing Lamb, 'takes away rather than adds to the effect of these great philosophical fairylands,' and, like Lamb, he finds the disparity between imaginative suggestion and theatrical actuality quite painful, as when, in the second act of *Tristan und Isolde*, the passionate storm of the music is contradicted by the timidity and conventionality of the behaviour of the lovers on the stage. More than this, so complete is Wagner's disembodiment of drama that words seem a limiting convention as well: the music enacts what Shelley's sylphs call a 'wordless converse', directly confessing feeling without the mediation of language, so that words often seem laughably inadequate – while the breakers of sound crash and foam in the orchestra, Tristan and Isolde, as if in a philosophy seminar, are discussing

whether '*dies süsse Wörtlein: und*' which binds them together would endure if one of them were to die; or the gasping ecstasies and all-obliterating climaxes of Isolde's '*Liebestod*' are sung to turgid and jaw-breaking, highly cerebral verses – but sense is in any case overborne by the torrents of mere passionate sound.

In *Tristan*, perhaps the only great drama of its century, the disembodiment of drama becomes, one might say, the annihilation of drama. Shelley's drama begins with sketches of character and situation but floats off quite soon into an atmospheric revel; in Wagner the change is more absolute, the break more violent. Passion tears the characters from their duty and inclinations and relationships and thrusts them together; they become one another – in the second act they even change names – fused into one soul, transforming the play into a romantic monodrama. No one else exists, hence the gratuitous disposal of the bodies at the end of the third act; passion has annihilated reason, music action, spirit matter, night day, and finally love annihilates death. The characters become spirits, their voices floating through the night unseen. As much as Hamlet, Tristan and Isolde turn out to be characters belonging to the novel rather than to drama: absorbed by a sentimental compulsion, refusing to act even to protect themselves, they are the decadent last word in suffering passivity.

This submergence of external, classical form in the interests of expression, growth, nature and sentiment, which tends to lead from drama in the direction of the novel, has an interesting parallel in the visual arts, in the victory of painting over sculpture and, within the field of romantic painting, of colour over line. At a party in Lytton's *The Last Days of Pompeii* some of the Pompeiian young bloods are discussing the superiority of the moderns over the ancients, Homer and Virgil, and Lepidus says, 'Those old poets all fell into the mistake of copying sculpture instead of painting. Simplicity and repose – that was their notion; but we moderns have fire, and passion, and energy – we never sleep, we imitate the colours of painting, its life, and its action.' It is a comment with much more relevance to the year 1834 than to 79. For romantic criticism prefers painting to sculpture for the same reasons it prefers the novel to drama: because the one can depict the soul, whereas the other is bound to mere physical appearance; the one is more spiritual, more interior than the other, which depends more

on severity of external form. Lepidus's opinion is widely shared – Gautier claimed that sculpture was a classical and not a romantic art, possible only in antiquity; Madame de Staël thought sculpture pagan, but painting Christian, by which she means spiritual. Stendhal commented of Canova that 'the Greeks esteemed physical strength most highly, while we esteem spirit and feeling'; and attacking the dreary classicality of the 1824 Salon he joins in disapproval sculpture and Aurora Leigh's pet hate, the five-act structure, symbol of the senseless tyranny of formal rules – he sneers at the rude groups inspired by antique statues and heavy tragedies in verse in five acts.

Classical art, it is felt, deals with the external structure and appearance, and this can be sculpted; romantic art with the inner life, the soul, and this can only be painted, for painting, as Constable said, is 'but another word for feeling'. Sculpture is solid, creating permanent forms; painting, however, can express the romantic sense of evanescence, the spots of time in which the poets glimpse some illumination for a moment and then lose it, like a patch of light passing over a landscape. This fleeting, time-bound aspect of painting, most fully developed in the tremulous forms of Turner, links it with music, the other central romantic art; and indeed painting is thought to possess a musical quality – Pater says that Giorgione paints 'the musical intervals in our existence' when 'life itself is conceived of as a sort of listening', as in romantic poetry we are privileged to *overhear* the poet's self-communing.

Painting must feel – this is what Hazlitt means by gusto, 'the power or passion defining any object', the inner feel of it. Titian's colouring has it, for 'not only do his heads seem to think – his bodies seem to feel', where the bland, null flesh colouring of Vandyke lacks this 'internal character, the living principle'. Painting is synaesthetic, like poetry: Hazlitt complains that the landscapes of Claude are mere mirrors which 'do not interpret one sense by another. . . . His eye wanted imagination: it did not strongly sympathise with his other faculties. He saw the atmosphere, but he did not feel it.' This repeats Coleridge's point in the 'Dejection' ode, which is as true of the romantic painter as of the poet: he sees how excellently fair the night sky is, but it is not enough to see – he must feel its beauty. Only then can a poem or painting be created from it.

Stendhal argues that anyone could learn to paint like David, because his anatomical drawing is an exact science, like arithmetic; but the passions cannot be painted as an exact science. The school of David can paint only bodies (like the theatre, in Aurora Leigh's view); it is incapable of painting souls. Stendhal's examples of the expressive manner the painter should aim for are very interesting, for they are, like Victorian narrative pictures, anecdotal: 'the despair of a lover who has just lost his sweetheart,[1] or the joy of a father who sees the son appear whom he believed to be dead.' The romantic desire to paint the passions leads towards the narrative picture as practised by the Victorians, just as the stress on the inner life leads towards the novel. Victorian painting is a tribute to the sentimental life within. The paintings have a narrative structure because they strive to provide a background to the sentimental moment of suffering or happiness framed on the canvas, just as the critics of Shakespeare hastened to invent a history for his characters extending outside the frame of the plays. Lessing laid it down that poetry could portray thought and motive but painting only movement, the one confined to temporal sequences, the other to spatial areas. Victorian painting, charged with its literary task of painting the passions, forgets this restriction; it must narrate because the sentiment must be provided with a cause, a novelistic history in time – hence the presence of so many letters, Millais's order of release in the Tate Gallery picture or the black-rimmed letter from home the disconsolate governess is holding at her abstemious meal in Richard Redgrave's 'The Poor Governess' in the Victoria and Albert. A letter turns the painting into an epistolary novel; it implies a past and invites us to construct a future. But, working against the tendency of the form, the painters can only supply this sentimental history in part: hence the situations in so many of the Victorian pictures are enigmatic, puzzles we must work out from the clues provided, guided by our sympathy and a novelistic habit of mind. But this is a subject which will recur in the next chapter.

As in romantic literature external form is weakened so that the generous flames may shape themselves, so in romantic painting line is weakened to release colour. The classical attitude insists on the rectitude of the line: Ingres, who told Degas he could become a

[1] Compare William Windus's 'Too Late', Tate Gallery.

25

painter only by drawing lines, demanded that even smoke should be expressed by a line. Line, severe and ideal and moral, is the enemy of colour, as the romantic poets feel form to be the enemy of spirit; colour is spiritual but also sensual, or rather it makes the two one, hallowing sense. It communicates mood, the flux of feeling, as apart from the eternal ideas of structure and identity enforced by line; and as the poets sought to colour language to make it more emotionally expressive, so Turner experimented with colour harmonies, a pictorial equivalent of musical modes. He wrote of Guercino's 'Resurrection of Lazarus': 'the sombre tint which reigns throughout acts forcibly and impresses the value of this mode of treatment, that may surely be deemed Historical Colouring.'

In 1856 Mrs Browning celebrates the freeing of passion and 'the soul itself' from the constraints of form and rule; in 1855, in a review of the Exposition Universelle, Baudelaire celebrates the similar emancipation of colour from the tyranny of time in the painting of Delacroix. He calls the 'Lion Hunt' an explosion of colour: 'M. Delacroix's colour *thinks for itself*' – as Aurora says passion and the excitement of the inner life must do – 'independently of the objects which it clothes'; and he employs the musical analogy; colour like modes in music or language in poetry is in the service of mood, and 'these wonderful *chords* of colour often give one ideas of melody and harmony, and the impression that one takes away from his pictures is often, as it were, a musical one.' Baudelaire goes on to defend the draughtsmanship of Delacroix in terms which invite comparison with the romantic theory that poems must grow, expanding naturally in protest against convention as Delacroix's drawing unfolds in protest against the systematic law of the straight line: 'What am I to say, except that a good drawing is not a hard, cruel, despotic and rigid line, imprisoning a form like a strait-jacket? that drawing should be like nature, alive and in motion? that simplification in drawing is a monstrosity, like tragedy in the world of the theatre, and that nature presents us with an infinite series of curved, receding and crooked lines, in which parallelism is always vague and sinuous, and concavities and convexities correspond with and pursue one another?' The defence has the trenchancy but also the partiality of a contribution to a political debate; it is a challenge thrown out in the heat of battle,

and this warns us that it is based, like the romantic criticism of Shakespeare, on a misunderstanding. For Delacroix does draw carelessly; colour soaks into and dissolves line as music dissolves words in *Tristan* and as the spasmodic gush of Aurora Leigh's sentiment dissolves the form of the poem and deprives it of self-control and balance. Shakespeare's example begins as a liberating force, but becomes an excuse for anarchy. Delacroix draws carelessly, so does Blake, and in Turner's paintings all solid objects deliquesce into haze and misty glow; the painters seem prepared to sacrifice artistic to psychological qualities, for so long as an image is emotionally potent it can make its effect felt – prove itself upon the pulses – no matter whether well painted or not. Aurora Leigh represents a comparable extreme of emotional freedom in poetry; the hectic fervour of her reactions makes it impossible, she says, for her to shape and control a work of art. She wrings her life-blood on to every leaf of her poem, and hopes that it is fertilising. The book is written with blood, she says, just as Baudelaire described Delacroix's colour as 'lac de sang'.

> I lived, those days,
> And wrote because I lived – unlicensed else:
> My heart beat in my brain. Life's violent flood
> Abolished bounds. –

Or the rush of blood becomes a torrent of tears – Marian's letter is blotted like that of a Richardsonian heroine, the wet smudge bearing witness like the pulsing excitement to the breathless immediacy of the style, emotion not recollected in tranquillity:

> 'There's a blot!
> This ink runs thick . . . we light girls lightly weep. . . .'

Incoherence and shapelessness become virtues: when Romney reveals his love, the writing fairly expires in shudders and tremors and dots and dashes:

> Did I think
> That such a passionate rain would intercept
> And dash this last page? What he said, indeed,
> I fain would write it down here like the rest,

but she cannot control the pen: his breath against her face confuses all, rather as Fanny Squires in *Nicholas Nickleby* protests at a time of crisis, 'I am screaming out loud all the time I write which takes off my attention rather and I hope will excuse mistakes.' The same

collapse into shapeless emotion occurs earlier, when Aurora defends herself against her aunt:

> Then, at last, I spoke, –
> Spoke veritable words, but passionate,
> Too passionate perhaps . . . ground up with sobs
> To shapeless endings.

The romantic interpretation of Shakespeare, then, leads either to disembodiment or to the abolition of bounds: drama loses contact with an ordinary reality which can be represented, and floats off into the rarefied air of the spirit; or external form gives way under the onrush of sentiment, in spasmodic verse, or a torrent of colour, in painting. Only the novel was able to contain romanticism, and to absorb Shakespeare's example, for it had no rules, it was not a genre, and it did not matter if it became an indifferent whole.

'L'exemple de Shakespeare,' noted Delacroix in his journal in 1837, 'nous fait croire à tort que le comique et le tragique peuvent se mêler dans un ouvrage.' The novel, however, was able to accommodate the two in its leisurely expansiveness. Tragedy and comedy must collide if they are to share the confines of a drama; the area is so small that they cannot avoid meeting one another, but in a novel they can live amicably at a distance, intertwining without competing. For there often is such a competition in the double plots of Elizabethan drama: Falstaff, the king crowned in the Eastcheap tavern, performs a successful coup and unseats the play's titular hero, attracting all the attention to himself; Rosencrantz and Guildenstern or the players or the grave-digger or Osric interrupt the revenge action of the drama, and their intrusions are welcomed by Hamlet who is reluctant to do his tragic duty in any case; we can take Othello at his word, and see him as a tragic figure whose generous susceptibilities have been abused, or rather take sides with Iago, who sees him as a cuckold in a farce, or Emilia, for whom he is a gull, a dolt, as ignorant as dirt, a sort of Malvolio. But a novel can keep comedy and tragedy at peace with one another, allowing room for both, without incurring the risk of these ambiguities, which Shakespeare glories in but which lesser men cannot control.

This mingling of comedy and tragedy, from which the novel benefited, is one of those qualities in Shakespeare which the romantic critics felt to be Gothic. Berlioz describes his discovery of

Shakespeare as an apparition, a thunderstorm, a staggering revelation of the might and sublimity of nature; Shakespeare is a vision from a Gothic novel: 'Shakespeare, en tombant ainsi sur moi à l'improviste, me foudroya. Son éclair, en m'ouvrant le ciel de l'art avec un fracas sublime, m'en illumina les plus lointaines profondeurs. Je reconnus la vraie grandeur, la vraie beauté, la vraie vérité dramatiques.' His head is crowned with lightning, abysses gape at his feet. Fuseli said Sophoclean poetry is daylight, whereas Shakespearean poetry is like the 'incessant flashes of a tempestuous night' – just as Hazlitt said that to see Kean's performance as Lear was like watching the play by flashes of lightning. This shock and the sense it brings of the awesome immensity of nature, its ecstasies and terrors, is something that other romantics experienced on their passage of the St Gothard or the Vale of Chamonix, or their first sight of Mont Blanc. So close have art and nature become that Shakespeare and the Alps excite the same reaction. Indeed, Shakespeare is felt to be like the Alps – as Gray, ascending to the Grande Chartreuse, was stunned by the 'magnificent rudeness' of the scene, so Wagner praised the 'sublime irregularity' (*'erhabenen Unregelmässigkeit'*) of Shakespearean drama. The rescue of mountains from condemnation as ugly and dangerous eruptions from the ordered regularity of nature took place, in the romantic period, at the same time as the rescue of Shakespeare from condemnation as a wild and unregulated outcrop of raw imaginative force disfiguring the classical literary landscape. The majesty shared by the Alps and Shakespeare was felt to be Gothic: Gray writes to West of the Grande Chartreuse in terms of the Gothic novel – 'You here meet with all the beauties so savage and horrid a place can present you with; Rocks of various and uncouth figures . . .' – and Shakespeare is often compared with the dizzy heights and awe-inspiring precipices of a Gothic cathedral. Hugo in *Notre-Dame de Paris* calls Shakespeare the last of the Gothic cathedrals; Schlegel in his lectures on the drama says that 'the Pantheon is not more different from Westminster Abbey or the church of St Stephen at Vienna, than the structure of a tragedy of Sophocles from a drama of Shakespeare.'

This comparison perhaps begins with Pope's comment in 1725: 'One way to look upon [Shakespeare's] works, in comparison with those that are more finished and regular, is as upon an ancient

majestic piece of Gothic architecture, compared with a neat modern building; the latter is more elegant and more glaring, but the former is more strong and more solemn. . . .' The sprawling disorderliness of Gothic – in which, as in the novel, the parts grow out of proportion to the whole – evokes the unconfined expanses of nature; the Grecian, on the other hand, imposes a fixity and order which are merely human fictions. Thus Walpole felt that no Grecian temple, however noble, could 'convey half as many impressions to the mind as a cathedral does of the best Gothic taste.' The one is a product of education, the other of romantic impulse and excitement: 'one must have taste to be sensible of the beauties of Grecian architecture; one only wants passions to feel Gothic.' Grecian is a matter of sense, Gothic of passion and feeling. Its wandering, branching, growing movement expresses the energies of life, in Shakespeare and in the rowdy, enthusiastic, undiscriminating chaos of the Victorian novel. 'Grecian,' wrote Blake of Virgil in 1820, 'is Mathematical Form: Gothic is living form, Mathematical Form is eternal in the Reasoning Memory: Living Form is Eternal Existence.' Where Schlegel sets the Pantheon against Westminster Abbey, Blake in an illustration to *Jerusalem* makes the cerebral Vala preside over St Paul's, the static, monumental, classical tribute to a scientific and mechanical view of the universe, whereas Westminster symbolises spiritual religion, and over it hovers Jerusalem, the soul and the bride of Christ. In a letter to Moore in 1821, Byron employs the same comparisons, though he claims, despite the follies of Newstead Abbey, to revere the Grecian rather than the Gothic: 'As to Pope, I have always regarded him as the greatest name in our poetry. Depend upon it, the rest are barbarians. He is a Greek Temple, with a Gothic cathedral on one hand, and a Turkish mosque and all sorts of fantastic pagodas and conventicles about him. You may call Shakespeare and Milton pyramids, if you please, but I prefer the Temple of Theseus or the Parthenon, to a mountain of burnt brick-work.'

I have argued that the romantic approach to Shakespeare, the desire to disembody drama – as Wagner wished to reach 'perfection of musical form through its final emancipation from every remaining fetter' – and to see it acted out in the land of thought, a land as broad and general as the casing air, benefited neither poetry nor

drama, but the novel, in which the exploration of the self could be conducted at leisure under the guise of exploration of a specially designed, seemingly objective world. Similarly, the Gothic qualities the romantics discovered in Shakespeare found adequate expression not in their own poetry or drama, but in the novel. 'Disproportion of parts, is the element of hugeness, – proportion, of grandeur,' wrote Fuseli; 'all Oriental, all Gothic styles of architecture, are huge; the Grecian alone is grand.' And this hugeness, this sense of multitudinousness, gets into the novel or, as we shall see when discussing *The Ring and the Book*, into the novel-poem.

The Grecian delight in proportion creates images of ideal beauty; the Gothic attraction to the disproportionate leads it to the grotesque – and it is here that Shakespeare's mingling of tragedy and comedy, and its influence on the novel, with which this section began, become relevant. The most important statement about the grotesque is in Hugo's 1827 preface to his unwieldy anti-classical drama *Cromwell*, in which with epic confidence he distinguishes three ages of humanity, primitive, antique and modern, and identifies the literary form which best suited the spirit of each. Primitive man, existing in the pristine youth of the world, is conscious of his closeness to God, and his religious sense finds its literary expression in the ode: the commanding poem of primitive times is therefore the Book of Genesis. Antique man has acquired a past, a history; poetry must now reflect his grand achievements, must become epic. Thus Homer dominates antique society; its very history is epic: Herodotus is Homer by other means. Even ancient tragedy is epic, it walks on tiptoe: 'les acteurs grossissent leur voix, masquent leur traits, haussent leur stature; ils se font géants, comme leurs rôles.' All is solemnly monumental. This era is supplanted by the third, the Christian age, with its spiritual religion which sees man as a puzzling compound of soul and body, high and low, and which consequently leads poetry towards realism: the modern muse is duty-bound to recognise the ugly as well as the beautiful, the grotesque as well as the sublime; and this grotesque vision creates a new form – comedy. It specialises in contrast: beauty and the beast, the sylph and the gnome, the contradictory characters forced into proximity by the Shakespearean double plot; it gives demonic vigour and comic verve to the decoration of the Gothic cathedrals, and has free rein in the

three modern *Homères bouffons,* Ariosto, Cervantes and Rabelais. But the central literary work of the third epoch, the modern and romantic, is the drama of Shakespeare, which holds together the grotesque and the sublime, the awesome and the absurd, tragedy and comedy.

Primitive times, Hugo sums up, were lyric; classical times epic; and modern times are dramatic. The ode lives in eternity, the epic in history, the drama in the felt life of its time. The characters of odes are colossi – Adam, Cain and Noah; those of epic giants – Achilles, the Atreids, Orestes; those of drama mere men – Hamlet, Macbeth, Othello. Literature has descended from the heavens to the earth in these three stages, from the ideal in the Bible, through the grandiose in Homer, to the real in Shakespeare. And the evolutionary process goes on, beyond the point at which Hugo was writing, to connect the Shakespearean drama with the novel. For the realist novel continues to study man himself, to explore the mixed nobility and baseness of his nature, bringing up to date the Shakespearean characters and subjecting them to the trials of a world of prose – as Dorothea Brooke is a modern St Theresa, so Wilhelm Meister is a modern Hamlet, Père Goriot a modern Lear.

Flaubert, writing to Louise Colet in 1852, in describing his ambition to write a book without a subject, a book held together by style alone and not dependent on the external world, sets out an interesting variation on Hugo's evolution. He takes it beyond Shakespeare into his own century, and connects it with that disembodiment, that desire to emancipate literature from rule and from material form, which, as we have noted, leads from romantic drama to the novel. 'The finest works,' for Flaubert, 'are those which contain the least matter.' Art becomes progressively less massy, less bulky, refining itself, 'from the Egyptian pylons to Gothic lancets, from the 20,000 line Hindu poems to the effusions of Byron. Form, as it becomes mastered, becomes attenuated; it becomes dissociated from liturgy, rule, yardstick; the epic is discarded in favour of the novel, verse in favour of prose; there is no longer any orthodoxy, and form is as free as the will of its creator.' At first sight, this idea seems to contradict Hugo's scheme – Hugo sees literature moving gradually down the chain of being to acquaint itself with the lowliest and most earth-bound aspects of the lives of men; Flaubert sees it etherealising itself,

purging itself of the gross weight of earth and flesh, to hang, beautiful and self-contained, in the void, as the earth is suspended, needing no external support. But there is no contradiction: as the romantic criticism of Shakespeare shows, the two processes are the same. For in coming down to earth, art disburdens itself of formal rule and restriction, and frees itself to live in the unconfined land of thought. Shakespeare is a realist; but he is also the greatest of the romantics. He is grounded in the low, the comic, the earthy; but his characters have not only a time-bound physical existence which makes them comic, but also a limitless world of thought and feeling within — and therefore they are too large to be represented on the stage. The drama, earthy and substantial, dealing with character in action, transforms itself into the novel, which has the freedom of thought as well as of action; which indeed need not vex its characters with the need to act, and which has no loyalty to the orthodoxy of a classical genre. Form, in the novel, can become as free as the will of its creator. Only in it is the romantic promise of Shakespearean drama fulfilled.

Shakespeare's blend of tragedy and comedy leads, then, to the novel, which also takes up his blend of high and low, the sublime and the grotesque. Ruskin has some interesting comments on this anticipation of the Dickensian double plot. In *Mornings in Florence*, discussing a Giotto fresco of the meeting of Joachim and Anna in Santa Maria Novella, he notices, between the saints and the angel, two rough shepherds, Joachim's employees, going about their business, 'one bare-headed, the other wearing the wide Florentine cap . . . both carrying game, and talking to each other about — Greasy Joan and her pot, or the like.' According to the laws of Racine and Voltaire, this pair is out of harmony with the exalted scene, 'but according to Shakespeare, or Giotto, these are just the kind of persons likely to be there. . . . And now that you have had Shakespeare, and sundry other men of head and heart, following the track of this shepherd lad, *you* can forgive him his grotesques in the corner,' admonishes Ruskin. Life, with apparent casualness, strolls in and upsets the classic form. Similarly in the third volume of *Modern Painters* he complains that 'the modern German and Raphaelesque schools lose all honour and nobleness in barber-like admiration of handsome faces, and have, in fact, no real faith except in straight noses and curled hair.' They prefer beauty to

truth. However, 'Paul Veronese opposes the dwarf to the soldier, and the negress to the queen; Shakespeare places Caliban beside Miranda, and Autolycus beside Perdita; but the vulgar idealist withdraws his beauty to the safety of the saloon, and his innocence to the seclusion of the cloister; he pretends that he does this in delicacy of choice and purity of sentiment, while in truth he has neither courage to front the monster, nor wit enough to furnish the knaves.' Dickens sets the ethereal and saintly purity of Nell against the grotesque animation of Quilp – her weakness is spiritual, his energy is demonic, and the Gothic atmosphere of this contrast between beauty and the beast is well suggested in the illustrations made by Cattermole for the later parts of the novel: Nell sits wearily amid Gothic tombs and fretwork, or expires in a bed whose posts soar upwards like pinnacles, with a vision of the Virgin and child above her head and a pointed window next to her.

But the grotesque Hugo finds in Shakespeare and Ruskin in Giotto or Veronese is quite different in spirit from that of Dickens or Browning. In Shakespeare and his medieval forbears, the grotesque has a religious warrant: it derives from a sense of man's sinfulness – the self-dramatisation of the Wife of Bath or the Pardoner or Falstaff grows, in part at least, from their gleeful, naively confessional obsession with their own particular favourite among the deadly sins: they boast of their failings without remorse, with the self-betraying garrulity of the sins in Langland. The Shakespearean grotesque creates a charitable, forgiving comedy – 'this thing of darkness I acknowledge mine' – which is Christian in that it pityingly releases characters from the consequences of their actions, instead of legalistically exacting penalties as Jonson, true to classical example, does. But the grotesque as Hugo describes it is not so much Christian as sentimental and political. It is sentimental because it evinces a sense of man's fellowship with all the creatures of nature – Coleridge's sympathy for the ass, for instance. This has political implications as well: Carlyle urges in *The French Revolution* that the working people ought not to be dismissively thought of as an undifferentiated mass, for 'every unit of these masses is a miraculous Man, even as thou thyself art', and if you prick him he will bleed.[1]

[1] Dickens forces a similar recognition on Louisa Gradgrind in *Hard Times*,

And the romantic mode is sentimental because it wants to pry into the feelings of its grotesques. Caliban, though he is allowed to respond to the music in the air, is ultimately merely a thing of darkness we must acknowledge to be ours – he is there, we must not conceal him, but admit our ownership, and hope he will reform, as he promises to do. But his romantic offspring, Quasimodo or Quilp, have no such moral meaning: they exist so that Hugo and Dickens can indulge a strange eager curiosity about how such people act and feel, and their demonic energy is weirdly sympathetic. Their deformity is a challenge to classical notions of beauty, as their secret inner lives are a challenge to the classical demand that character should be related to moral quality. This empathy was excited in Dickens by his grotesques, and never by his normal characters. His double plots reverse the classical law of character, and even reverse Shakespeare. For the classical rule is that we admire the hero because his nature is exalted above our own, and despise the comic figure because he is beneath our normality, and in Shakespeare the tragic characters have our sympathy and concern while the comic ones cannot grow or change, but simply reappear, intruding on the tragedy and startling us into a sense of the chequered nature of our life. But in Dickens the heroes and heroines are dull and lifeless; our imaginative excitement is transferred to the lower level of the double plot, to the grotesques. We read *Martin Chuzzlewit* for Mr Pecksniff, *Oliver Twist* for Fagin and Bill Sikes, *David Copperfield* for the Murdstones and Miss Trotwood; but we do not read *Hamlet* for Polonius, or *Macbeth* for the porter, or *Lear* for the fool. Dickens transfers our interest from those who are most like ourselves – the heroes, through whom, in Shakespeare, we explore the extreme possibilities of our own natures – to those, the deformed, the mad, the grotesque, we should

when she goes to Stephen Blackpool's room: 'For the first time in her life, Louisa had come into one of the dwellings of the Coketown hands; for the first time in her life she was face to face with anything like individuality in connexion with them. She knew of their existence by hundreds and by thousands. She knew what results in a week a given number of them would produce, in a given space of time. She knew them in crowds passing to and from their nests, like ants or beetles. But she knew from her reading infinitely more of the ways of toiling insects than of these toiling men and women. . . . She had scarcely thought more of separating them into units, than of separating the sea itself into its component drops.'

have thought most unlike ourselves. (Keats makes yet another downward transference, involving us in the bright-eyed instincts or anxieties of a stoat, a fieldmouse, or a deer.)

The sentimental interest in the grotesque connects with the political: nature is a democracy, so that every being in it, no matter how humble, merits attention. From Keats's stoats and fieldmice we pass to dogs, whose presence in nineteenth century painting was taken as a sign of both sentimental affection for the non-human and a political concern to unseat man from his dominance of nature. Kingsley in *Alton Locke* (1850) greets Tennyson as a democratic poet, revealing, as Dickens wished to do in *Household Words*, the poetry which lies in common things, irradiating with beauty the flowery dykes of Battersea Fields; the art of the age is a great leveller, and Landseer's dogs are his first example of this tendency. In them art moves onward 'towards that which is common to the many, not that which is exclusive to the few – towards the likeness of Him who causes His rain to fall on the just and the unjust, and His sun to shine on the evil and the good; who knoweth the cattle upon a thousand hills, and all the beasts of the field are in His sight.' Alton goes on to call Shakespeare the great exemplar of this spiritual democracy of universal sympathy. Ruskin in a lecture delivered at Oxford in 1883, by which time his aesthetic judgements were rather unsettled, establishes a Gothic tradition for Victorian dogs. He points out that classical art specialises in figures, whereas Gothic draws beasts, hobgoblins, admitting all of God's creatures, so that tenth century Benedictine manuscript illustrations of dogs are 'distinctly progressive Gothic art, leading infallibly forward – though the good monks had no notion how far – to the Benedictine collie, in Landseer's "Shepherd's Chief Mourner" and the Benedictine bulldog, in Mr Britton Rivière's "Sympathy".' Toddlers are as Gothic as dogs, for later Ruskin, praising the dolls' tea parties of Mrs Allingham and the fairyland of Kate Greenaway, takes it as a 'singular defect in Greek art, that it never gives you any conception of Greek children. Neither – up to the thirteenth century – does Gothic art give you any conception of Gothic children; for, until the thirteenth century, the Goth was not perfectly Christianised, and still thought only of the strength of humanity as admirable in battle or venerable in judgement, but not as dutiful in peace, nor happy in simplicity.' Sentimentality,

like the grotesque, is a result of that introversion characteristic of romantic literature – emotion has become more significant than action, and the idiosyncratic life within more interesting than external conformity to an idea of beauty.

Wordsworth adheres to the democracy of nature by his blunt insistence on humble objects – the thorn tree, the spinning-wheels, or the stones of Michael's sheep-fold – and on characters like the leech-gatherer who exist at such an elemental level of necessity that they seem to become part of the inanimate landscape and its slow, dumb movements, as the old man is metamorphosed into a stone or a bank of clouds. And a similar nature is apparent in Constable, who in a letter to Fisher in 1821 interestingly imposes the same intention on Shakespeare: '. . . the sound of water escaping from mill-dams, etc., willows, old rotten planks, slimy posts, and brickwork, I love such things. Shakespeare could make everything poetical; he tells us of poor Tom's haunts among "sheep cotes and mills".' But Shakespeare, of course, is never peremptory about such things; he accepts everything in his wonderfully absorbent impartiality, and never presses the superiority of sheep-cotes to palaces or shepherds to aristocrats. One of the functions of the grotesque in the nineteenth century, however, was to upset a literary class-system which segregated high from low. In this sense, Dickens continues what Wordsworth began. John Forster's biography contains some interesting remarks on this subject – he believes the rapturous welcome Dickens received in America was an expression of an aggressive democratic contempt for the old world: the Americans singled him out because he had busied himself 'to discover what is beautiful and comely, under what commonly passes for the ungainly and deformed; . . . to have made known to his countrymen the wants and sufferings of the poor, the ignorant, and the neglected.' Dickens's grotesque vision dwindles, in this view, into a part of his social conscience. Elsewhere, Forster says that *The Battle of Life* exhibits 'the power peculiar to him of presenting the commonest objects with freshness and beauty, of detecting in the homeliest forms of life much of its rarest loveliness, and of springing easily upwards from everyday reality into regions of imaginative thought.' Dickens inverts the double plot, making the first last and the last first, the titular heroes dull and the subsidiary characters fascinating; and Forster finds a social moral

in this, recognising in Clemency in this Christmas book 'one of those true souls who fill so large a space in his writings, for whom the lowest seats at life's feasts are commonly kept, but whom he moves and welcomes to a more fitting place among the prized and honoured at the upper tables.' Something like this is implicit in Falstaff's take-over bid – he leads a rebellion of comedy against tragedy, of social history against the long jars and wearying failures of the political history, of the resurgent life of the people, which continues, against the life of the king, which must end; as much as Hamlet he retards the forward movement of the action to gain time to talk about himself, and to play games, and in doing so turns the play into a novel. But he is chastened in the end, and sent to die off-stage, while Hal graduates from the comic irresponsibility of the sub-plot, outside history, to assume the new role of king. No such chastening, however, occurs to Dickens: he suffers the grotesques to take over the novels and to stall his plots. The details rebel against the whole (as, we shall see, Ruskin said they did in Gothic), the grotesques against the heroes; the novelist wishes to develop relationships and follow actions, but these supposedly minor characters insist on staying as they are, on being themselves, and must either be press-ganged into the plot's service, as Micawber is, or eliminated, as Mrs Proudie, rather like Falstaff, is.

This reversal may, then, be explained in political terms – the low rises up against the high because Dickens wishes, as Dr Channing put it, 'to awaken sympathy with our race, and to change the unfeeling indifference which has prevailed towards the depressed multitude, into a sorrowful and indignant sensibility to their wrongs and woes.' But this is a comfortable misunderstanding: there is nothing progressive about Dickens's grotesques; they represent a deep inertia, a refusal to be changed or reformed, and their stubbornness invites not sympathy but horrified and spell-bound eavesdropping on their conversation with themselves. Other Victorians rather resented this. Forster is suspicious of what he calls Dickens's 'grotesque extravagances', feeling that whimsy has run away with him: 'in this, however, humour was not his servant but his master: because it reproduced too readily, and carried too far, the grotesque imaginings to which great humourists are prone; which lie indeed deep in their nature; and from which they derive their genial sympathy with eccentric characters that enables them

38

to find motives for what to other men is hopelessly obscure, to exalt into types of humanity what the world turns impatiently aside at, and to enshrine in a form for eternal homage and love such whimsical absurdity as Captain Toby Shandy's.' This is to render Dickens harmless by trivialising him, though the mention of the Shandys does recall the similarity between the fixity, the self-obsessed inertia of his gargoyles and that of the Shandy males, over all of whom hangs the suspicion of impotence. George Eliot, however, in a *Westminster Review* article of 1856 on the social history of Riehl, brings out the intellectual issue at stake. For her, Dickens's grotesques retard not only the plots, as the Shandys riding their hobby-horses do, but also the march of mind. Dickens can depict the external traits of the urban poor, and can ventriloquistically re-create their speech, but conveys no sense of how or what they feel and think, and thus disqualifies himself from making a contribution 'to the awakening of social sympathies'. Art should help us to understand one another, and the characters in a novel should learn, as Dorothea or Gwendolen Harleth do, a respect for the rights of others; but Dickens seals his characters off from one another and from us in their own egotism – his novels are not a community whose members give and take and learn from one another, like George Eliot's, but a city where physical crowding goes with anonymity and loneliness and people pursue their mad fancies linked only by collisions in streets or by an external fate, like the epidemic in *Bleak House*, which they all must share.

George Eliot complains that Dickens does not give us the 'psychological character', the 'conceptions of life' of his people – and the answer is that he does not do so because they have none. She objects to the picturesque pathetic fallacy of the artist's condescending projection of his own emotion on to ploughmen and woodcutters, but her own rural novels do reveal something similar; she encases her carpenters and farmers not in flattering sentiment but in intellectual generalisations, sacrificing the individual not to a sentimental stereotype but to genus, idea. Her attempt to make the novel a branch of natural history, its characters obedient to inexorable laws, raises the picturesque to the dignity of an intellectual system: the cosy distance of the picturesque becomes in her the intellectual disengagement of the view from the box-seat at the beginning of *Felix Holt*. This is very remote from Dickens's

39

apprehension of the uniqueness of his characters, whose grotesque-ness is the mark of their individuality, a way, one might almost say, of defeating any sense of a human norm and of keeping others at bay. They remain private and secret, whereas George Eliot, mesmerising her characters with her studious gaze, wishes to draw them into the higher pains of consciousness, which means making them aware of themselves and us aware of them.

Dickens inclines to the detail at the expense of the whole, the eccentric at the expense of the normal; the gargoyles are good, as Orwell said, but the architecture is rotten. The Victorian idea of the picturesque, and the Victorian attraction to detail, will both be discussed in later chapters; but it is relevant to consider here the relation between the grotesque art of Dickens and the picturesque. George Eliot ridicules the dishonesty of the picturesque which arranges rural life into an idyll, but her own early novels employ an intellectual variant of it in her ruminative, analytical attitude to her characters as specimens of a certain mentality rooted in habit and custom: 'No one knew where these wandering men had their homes or their origin,' she writes of the nomadic weavers in *Silas Marner*; 'and how was a man to be explained unless you at least knew his father and mother? To the peasants of old times, the world outside their own direct experience was a region of vagueness and mystery. . . .' In the scenes at the Rainbow Inn she patronises her characters not sentimentally, but intellectually: when the landlord makes a point about seeing ghosts by reference to his wife's inability to smell the rankest cheese, she refers to his 'analogical argument'; and village humour is neatly characterised, as if by an anthropologist taking notes in the field – 'this kind of unflinching frankness was the most piquant form of joke to the company at the Rainbow. . . .' It is an idyll of an intellectual kind: the figures become not sentimental fictions – jocund peasants quaffing nut-brown ale, or simpering Dresden shepherdesses – but social types, fused with the beliefs and ways of the community they live in. Pictorial fixity is joined to humorous condescension. This is the Flemish variety of the picturesque, as it is called in *Adam Bede*, which seeks out the lovably typical, the amiably characteristic. Dickens, however, relishes not the type but the freak, who is in a class and indeed a world of his own; and de Quincey has some interesting remarks in an essay of 1840 on Westmorland which

perhaps help to explain the nature of the Dickensian grotesque. For de Quincey sees the grotesque as an extension of the picturesque. As apart from the beautiful and the sublime, the picturesque is 'the characteristic pushed into a sensible excess' – it might be called the characteresque. The prevailing character of an object, however unbeautiful, is exaggerated to produce a strong sense of its oddity and uniqueness. This effect depends on the '*secondary* interest of a purpose or of a character expressing that purpose', on the quiddity of a thing; the sublime and the beautiful, on the contrary, invite 'the *primary* interest in that (form, colour, texture, attitude, motion) which forces admiration, which fascinates the eye, for itself, and without a question of any distinct purpose: and, instead of character – that is, discriminating and separating expression, tending to the special and the individual – they both agree in pursuing the Catholic, the Normal, the Ideal.'

Character is identified, for de Quincey, with the individual, the peculiar, and not with the normal or general, as it had been in the classical conception and as it remained in the satires and novels of the eighteenth century, in which character is classified, fitted into its genus, for purposes of moral appraisal. The grotesques of Fielding and Smollett are representative; those of Dickens utterly, monstrously unique. In this sense, Dickens is picturesque, for to him character is the principle of separateness, of self-absorption; grotesqueness is a Dickens character's way of sealing himself off, of remaining secure from the incursions of the normal or ideal. Characters of this kind could not, because of their incapacity for action or relationships with others, exist in a drama; perhaps they could not even really exist in the novel, and they eventually find asylum in the dramatic monologues of Browning, who gives them their own cells to occupy, locked in and safe from intrusion. The romantics turn drama into novel; but in *The Ring and the Book* the novel is turned into a series of dramatic monologues. It is perhaps this pursuit of character which leads nineteenth century literature away from the whole to the detail, and from the normative standard of beauty to the infinite variety of ugliness: for ugliness becomes the principle of character – we are individual in our departures from the ideal of beauty. Pater considers this abandonment of beauty in his essay on Winckelmann, whose serene, lucid, harmonious Greek notion of art is contrasted with the oddity and

ugliness of the moderns: 'Living in a world of exquisite but abstract and colourless form, he could hardly have conceived of the subtle and penetrative, yet somewhat grotesque art, of the modern world. What would he have thought of Gilliatt, in Victor Hugo's *Travailleurs de la Mer*, or the bleeding mouth of Fautine in the first part of *Les Misérables* . . . ?' Art has descended from the Olympus of general truth and beauty and clean, precise forms, into the world; its spirit is now relative rather than absolute, and the grotesque is a part of this relativism.

Shakespeare mingles the genres; and so, for Carlyle, does history. In an essay on Baillie the Covenanter he writes, 'Such is the drama of Life, seen in Baillie of Kilwinning; a thing of multifarious tragic and epic meanings, then as now. A many-voiced tragedy and epos, yet with broad-based comic and grotesque accompaniment; done by actors *not* in buskins. . . .' Or in *Sartor Resartus* he calls Monmouth Street 'Murja's Hill, where, in motley vision, the whole Pageant of Existence passes awfully before us; with its wail and jubilee, mad loves and mad hatreds, church-bells and gallows-ropes, farce-tragedy, beast-godhood, – the Bedlam of Creation!' The rich confusion he describes is that of Shakespearean drama and, even more, Dickensian fiction, with its collisions of farce and tragedy, angel and demon, domestic idyll and melodramatic coup; Dickens's novels are indeed bedlam creations. This tragi-comic idea gives shape to *The French Revolution*, in which the romantic understanding of the forces of nature is applied to politics, and in which Shakespearean history becomes a novel, for the work was the model and source for *A Tale of Two Cities*. Carlyle gives a political meaning to the grotesque anti-classical form: for just as in Shakespeare life invades and confounds the classical segregation of forms, bringing a messenger of death to the garden of love and play, or sending a fool to accompany Lear through his agony, or in Dickens the eccentrics rebel against their confinement in the sub-plot and take over the novels, so Carlyle turns the rebellion of the sub-plot, the comic and grotesque underside of history, into the uprising of the mob. Hugo had called the grotesque democratic; Carlyle makes it revolutionary. History is changed by a convulsion from below. The people refuse to accept the subordinate role, the imprisonment in the underplot, forced on them by the aristocrats, and their rebellion shatters the confident classical separation

between high and low. 'The highest, as in down-rushing of a world, is come in contact with the lowest: the Rascality of France beleaguering the Royalty of France; "iron-shod batons" lifted round the diadem, not to guard it!' History becomes a tragi-comedy or farce-tragedy, because the noble and the grotesque are hopelessly confused: 'Poor Louis has Two other Paris Processions to make: one ludicrous – ignominious like this; the other not ludicrous nor ignominious, but serious, nay sublime.' As Dickens was to point to the odd contradictoriness of city life, with joy bumping into sorrows in the streets, and sentimental spirituality and grotesquerie as next-door neighbours, as the justification of his creative method, so Carlyle points in justification of his tragi-comic history to the incoherent alternations of seriousness and absurdity in the febrile revolutionary city: 'On Monday gone five weeks, which was the twenty-first of January, we saw Paris, beheading its King, stand silent, like a petrified City of Enchantment: and now on this Monday it is so noisy, selling sugar! Cities, especially Cities in Revolution, are subject to these alternations; and the secret courses of civic business and existence effervescing and efflorescing, in this manner, as a concrete Phenomenon to the eye.' The heroic image is replaced by the grotesque: Mirabeau, carbuncled, rough-hewn, is a compound of opposites, natural ugliness and the fire of genius, 'like comet-fire glaring fuliginous through murkiest confusions'; Marat, too, small and squalid, is 'a living fraction of Chaos and Old Night, visibly incarnate', a freak – 'Did Nature, O poor Marat, as in cruel sport, knead thee out of her *leavings* and miscellaneous waste clay; and fling thee forth, step-dame-like, a Distraction into this distracted Eighteenth Century?' He is a piece of Gothic architecture, brother to Quasimodo and Quilp.

The subplot is subversive in its grotesquerie, but also in its naturalness – it is a Dickensian bedlam, but also a romantic force of nature, like Shelley's millennial west wind or the *fracas sublime* Berlioz felt Shakespeare to be. 'Your mob,' says Carlyle, 'is a genuine outburst of Nature; issuing from, or communicating with, the deepest deep of Nature,' a dumb dread silently growing force. Romantic landscape is transferred to politics: Philosophism is a wind like Shelley's, or a storm; the revolution is an electrical thundercloud, as Charlotte Brontë felt Thackeray to be; bankruptcy becomes a great bottomless gulf, recalling the Miltonic chasms of

John Martin, and the attack on Versailles a mountain avalanche, like those of de Loutherbourg or Turner; the insurrection is also a volcanic lava-flood, as Byron called poetry; and at the Bastille the minor whirlpools which simmer at street-barricades all 'play distractedly into that grand Fire-Mahlstrom', which suggests that late incendiary picture of Turner's of a fire at sea. Or the fluent population inundates the courts like a deluge – another Turnerian subject. Carlyle dramatises politics in terms of landscape. For the mob is an organism, a 'Life-Sea', and its movements follow a life-cycle like that of a plant. Hence Carlyle's history, like Shakespeare or the novel, must abandon classical form and submit to the flow of life: he calls it a 'natural Greek drama, with its natural unities' – its unities, that is, are not a matter of exclusive rule, but of nature; it has the limitlessness of romantic drama, as Coleridge called it. Like nature or the novel, it has no shape and therefore nothing can be concluded: 'Homer's Epos, it is remarked, is like a Bas-Relief sculpture: it does not conclude, but merely ceases. Such, indeed, is the Epos of Universal History itself.'

Romanticism tends towards either disembodiment or dissolution – the emancipation from the material and substantial world which romantic drama longs for, or the hectic gushing formlessness of Mrs Browning, with her insistence that poems should spread and grow at will. In the drama the inner life comes to prevail over action and situation, and the plays retire inside the mind; in poetry life overflows the bounds and regulations of form. In both cases forms are eroded; only the novel can withstand this. It too is the only form which could accommodate the example of Shakespeare, and Dickens and Carlyle, as has been seen, create a new version of his double plots.

Life overflows – and something similar is felt in the narrative pictures of the period, which try to paint the passions and which borrow their techniques from the novel; for they tend to overflow their frames, to imply a sequence of events in which the picture itself is only a single incident, as Shakespeare's or Dickens's characters were felt to be larger than the works which contained them, possessing an existence which stretched before and after. This extension of the novel into painting will be the subject of the next chapter.

2. READING PICTURES

'I WAS PLEASED,' writes Lamb, 'with the reply of a gentleman, who, being asked which book he esteemed most in his library, answered, "Shakespeare"; being asked which he esteemed next, replied, "Hogarth". His graphic representations are indeed books; they have the teeming, fruitful, suggestive meaning of *words*. Other pictures we look at – his prints we read.' There is some similarity between the development from Shakespeare to the Victorian novel and that from Hogarth to Victorian narrative painting: for as in the dramas and novels the characters swell beyond their roles, so the situations and sentiments in the paintings spill beyond their frames. The characters emerge from the works which enclose them to draw us into friendship, the situations in the pictures to invite our solicitude and provoke our speculation. As the novels hint at a limitless field of life which sprawls outside their frame – 'To tell of half the queer old taverns that had a drowsy and secret existence near Todger's, would fill a goodly book; while a second volume no less capacious might be devoted to an account of the quaint old guests who frequented their dimly-lighted parlours'[1] – so the pictures imply an emotional life which we all share, and the canvas itself exists merely to stimulate our sentimental musings on this. Both novels and paintings press against their frames: the novels are crowded with more people and incidents than they can hold, the paintings stuffed with clues, tiny details, nuances and warnings, all pointing to a moral or meaning. They abolish the boundary between art and life, either inviting us in, drawing on our complicity or sympathy, or coming out to meet us, calling attention to the likeness between their characters and situations and those we have encountered in life.

Sculpture had been abandoned for painting because the one could represent only the external attributes of strength, composure, heroic will, whereas the other could depict the inner life: sentiments

[1] *Martin Chuzzlewit*, ch. 9.

45

could be painted but not sculpted. Yet painting also strains towards the condition of literature, away from its confinement to a moment in space to novelistic sequences in time, which can narrate the development of sentiments instead of simply presenting their crisis. Hogarth is literary because he is satiric: the moral intention cannot be trusted to the brush but needs to be enforced with some of the explicitness of the pen. The Victorians, however, are literary because sentimental: sentiments are best unravelled in a story. The Victorian novel both expands the Shakespearean play, stretching itself to give room to all the unframed complications of experience which the drama with its rigorous frame must omit, and disembodies it, removing the action from the public realm of theatrical situation and self-dramatisation to lodge it inside the mind. The painters adapt the example of Hogarth in a rather similar way: his moral exemplifications become their sentimental explorations – his figures serve the cautionary lesson of the paintings or prints, but theirs free themselves from moral captions and acquire a novelistic life of emotion. What they feel and what we feel about them becomes more important than what they represent morally.

Hogarth has close connections with Shakespeare as interpreted by the nineteenth century, the poet of the democratic grotesque and of incongruous collisions of tragedy and comedy. In *The Analysis of Beauty*, the treatise in which classical regularity is abandoned for a flowing, wayward, growing, serpentine line of beauty, he points to Shakespeare as a fellow-opponent of the ideal and the norm: 'Shakespeare, who had the deepest penetration into nature, had summed up all the charms of Beauty in the words "infinite variety" ' – though this variety is perhaps closer to the grotesque, the manifold idiosyncratic variations of ugliness, than to the classical notion of beauty; and Hogarth's emphasis in this work on avoiding the straight, the symmetrical, the ordered, aligns him with the romantic Shakespeare. Ruskin interestingly picks out the element of grotesqueness in Hogarth, and compares it with Gothic: in *The Seven Lamps of Architecture* he finds in some sculptures of the inferno on the portal of St Maclou at Rouen 'a degree of power whose fearful grotesqueness I can only describe as a mingling of the minds of Orcagna and Hogarth. The demons are perhaps even more awful than Orcagna's; and, in some of the expressions of debased humanity in its utmost despair, the English

painter is at least equalled.' But his gargoyles are not only tragic; the grotesque is for him, as muddle is for Sterne or hysteria for Smart or Pindaric obscurity for Gray and Collins, a way of evading the claims of clarity and reason, of liberating the imagination, either for self-delighting play or for portent and vision. The clutter of his pictures, their enjoyment of chaos and distortion and deformity, are part of that movement to abolish bounds which links the romantic Shakespeare and the Victorian novel.

Lamb, indeed, interprets Hogarth in terms of the Shakespearean double plot, arguing that the bedlam scene in *The Rake's Progress* is superior to *Timon of Athens* and only comparable with the mad and harrowing medley of king, fool and bedlam beggar in *Lear*: both on the heath and in the madhouse the ludicrous and the terrible are forced into intimacy, 'strange bed-fellows' like Dr Johnson's mourner and reveller or Dickens's angel and gnome. Lamb is as anxious as Ruskin with the Giotto frescoes to clear these collisions of agony and absurdity of the charge of vulgarity: he argues that Hogarth's demented rake is as tragic a conception as the boys under demoniacal possession of Raphael and Domenichino, and that 'we might as well deny to Shakespeare the honours of a great tragedian, because he has interwoven scenes of mirth with the serious business of his plays, as refuse to Hogarth the same praise for the two concluding scenes of *The Rake's Progress*, because of the comic lunatics which he has thrown into the one, or the Alchymist that he has introduced in the other. . . .' Both Shakespeare and Hogarth turn from the false purity of genre to 'the drama of real life, where no such thing as pure tragedy is to be found', and, like Dickens with his streaky bacon, they employ a novelistic admixture of 'merriment and infelicity, ponderous crime and feather-light vanity, like twiformed births, disagreeing complexions of one intertexture.' Hogarth possesses, in Lamb's view, a 'universality of subject, which has stamped him perhaps, next to Shakespeare, the most inventive genius which this island has produced', and in both of them comedy does not impertinently interrupt the serious action, but extends and enriches it.

Dickens, as it has been argued, allows his grotesques to escape from the lower level of the double plot and, rather as the madmen do in Middleton's *The Changeling*, to subvert or invade the upper level; and here too Hogarth is relevant. In his biography Forster

prints a piece on him by Dickens, confessing himself 'glad to be able to preserve a masterly criticism of that great Englishman, by a writer who closely resembled him in genius'; elsewhere, discussing the grotesquerie, hideous in Quilp's case, quaint in that of the show-people, in *The Old Curiosity Shop*, Forster says that not even Hogarth could have done better in the scenes in the cottage, furnace and the burial-place of the old church, while in discussing *Barnaby Rudge* he remarks that 'Mr Dennis the hangman is a portrait that Hogarth would have painted with the same wholesome severity of satire.' Hogarth's censoriousness is less appealing to Dickens than the obscene fascination of the grotesque, the preference for the monstrous individuality of ugliness over the dull norm of beauty, which he revealed in his attitude to Italy: 'he did not think the peasant girls in general good-looking,' Forster reports, 'though they carried themselves daintily and walked remarkably well: but the ugliness of old women, begotten of hard work and a burning sun, with porters' knots of coarse grey hair grubbed up over wrinkled and cadaverous faces, he thought quite stupendous. He was never in a street a hundred yards long without getting up perfectly the witch part in *Macbeth*.' These witches were of course a favourite subject of Fuseli, for whom they possessed the sublimity of horror; and it is very characteristic of Dickens to join Gothic nightmare with a sort of grisly comedy, as he does again in Mr Venus's shop in *Our Mutual Friend*, fusing tragedy and comedy in a unique way to produce a fearful laughter, a hilarious terror. (A similar imaginative feat of Dickens's – the acclimatisation of Gothic fantasy to the conditions of Victorian London – is discussed in the following chapter.)

As well as possessing these literary qualities, Hogarth anticipates the Victorian genre painters. In his pictures and theirs, traditional iconography with its public meanings gives way to a method of scattering symbolic clues to the narrative situation and its moral; this system of detail is, unlike the iconographic method, a matter of whispered suggestion, proleptic hint: a stray object, a piece of furniture, a picture on the wall, the presence of a pet, alerts us to the meaning of the scene – the spectator is a detective assembling fugitive scraps of information, probing and guessing, whereas in a classical picture he is merely required to recognise motifs whose meaning has been established by convention. The Victorian spirit

does differ from that of Hogarth – his details are scandalous betrayals, inadvertent confessions, emblems of guilt: they are satiric; those of the Victorians are fondly treasured keepsakes, mementos of affection and tokens of emotion: they are sentimental. For instance, in the fifth scene of *The Rake's Progress,* the nature of Rakewell's marriage is betrayed by the cobweb over the poor box in the church, the mildew and the crack covering the tenth commandment; whereas Rossetti in 'Found' employs comparable details not for satiric subversion but for sentimental intensification of the painful reunion between the young countryman and his deflowered love, now living in sinful despair in London – the rose in the gutter, the inscription over the gravestone, the two birds building a nest with straws fallen from the drover's cart, the calf tramelled in the net and carried helpless to death symbolising, as F. G. Stephens pointed out, the plight of the fallen girl. Yet there are many similarities. In Hogarth's 'Children's Party', for instance, the precarious house of cards and the upturned table suggest the vanity and fragility of youthful happiness; and the same detail is employed by Augustus Leopold Egg in the first canvas of 'Past and Present', in which, while the adulterous wife sobs on the floor – her crime discreetly imparted to us by the halved apple she was peeling before the discovery – her daughters construct a teetering house of cards on a chair. Hogarth's animals tell tales as much as do those of the Victorians: he underlines antagonisms by setting dogs to squabble in a corner in 'A Christening', or makes a limp exhausted dog sympathise with the flushed embarrassment and disarray of the couple in 'After II', or has another dog in 'Marriage à la Mode II' pull a lace cap from the pocket of the philandering Viscount. Similarly, Holman Hunt uses a cat tormenting a bird to explain the entrapment of the ruined girl in 'The Awakening Conscience': this girl, incidentally, is caught in the same compromising grasp as her Hogarthian sister in 'Before II'. Dogs abound in Victorian painting, offspring of Hogarth's stubborn, defiant, satiric pug – yet their function is not so much satiric, to sniff into or to ape the vices of their masters, as sentimental: they help to suffuse the paintings they appear in with emotion. They are not sardonic, like the bewigged pug in Hogarth's 'Lord George Graham in his Cabin', or the pug with the twig between his teeth mocking the military pretensions of the boy at

the children's party; they are suppliant, like the begging dog in Millais's 'The Black Brunswicker', whose eager attention lends poignancy to the farewell. The sniffing and romping of the dogs in Landseer's 'The First Game-Bag' seems to bind the family together and friskily celebrate its happiness, as putti would have done in a Renaissance painting. Or, in his 'The Queen and Prince with the Princess Royal', Albert lounges on a sofa still wearing his hunting boots, dead birds scattered before his feet like tribute, with Victoria in submissive admiration at his side, and instead of sycophantic courtiers a throng of domestic pets – four or five dogs straining worshipfully upwards, craving for favours with extended paws and soulful eyes. Cruelty to animals is a subject Hogarth shares with the Victorians, but again there is a difference. Hogarth's series of 'The Four Stages of Cruelty', has a violent satiric tit-for-tat: the biter is bit, with violent literalness – a dog chews on the heart of the villain who has beaten and tormented innocent animals. Ford Madox Brown, in his 'Stages of Cruelty', is interested, however, in sentimental subtleties – his child is whipping the long-suffering dog with a spray of love-lies-bleeding, and her cruelty is drawn into comparison with that of the young woman behind her, teasing her lover. Hogarth's humanitarian outrage has become a novelistic fascination with the perverse ways of the human heart. The public issue has become private, emotional.

Interiors are important in both Hogarth and the Victorians. Decoration lets us into the secrets of the characters in 'Marriage à la Mode': the ostentation of Lord Squanderfield's residence in the first plate, his coronet stamped on everything, his portrait as *Jupiter furens*; the modish Kent decorations and the half-uncovered prurient pictures in the second plate; the erotic drawings of Giulio Romano, the statue of the horned Actæon and the salacious pictures of Olympian promiscuity in the boudoir of the countess; and, in contrast, the depressing Dutch low-life scene of the final picture. Bric-à-brac becomes symbolic in the Victorians as well, and a number of cases of their strange attitude to inanimate objects will be discussed in the next chapter; and they also use pictures or posters within the painting to evoke sentimental nuances, as with the reproduction of David's figure of Napoleon crossing the Alps which presides over the Black Brunswicker's farewell to his sweetheart, or to grimly enforce the moral, as in 'Past and Present',

which develops a kind of pictorial equivalent to the play within a play. On the wall in the first picture hang paintings of 'The Fall' and 'The Abandoned', and in the third the destitute adulteress is huddled beneath the Adelphi arches against a background of advertisements for pleasure excursions to the treacherous capital Paris, and for plays entitled 'Victims' and 'A Cure for Love'.

Egg's triptych transforms the Hogarthian moral progress into something like the three-volume novel. Hogarth's progress is simply regress, following the rake or harlot or married couple with terrible neatness from one stage of decline into the next, with no attempt to knit the stages together into a narrative, to fill in the gaps with sentimental suggestion as Egg does. Egg indicates, for instance, by the waxing moon that the second painting depicts the same moment as the third. In one, the daughters, whose father is recently dead, sit, comfortless, at an open window and gaze at the moon, thinking of their lost mother; in the other, she, nursing a new child, stares at the same moon above the Thames, thinking of them. This notion of connecting people in different places derives from the novel, and particularly from Dickens in a work like *Bleak House*, which coincidentally yokes together characters from utterly different backgrounds.

It is perhaps Frith who goes furthest in adapting Hogarth to the Victorian novel. William Bell Scott in his autobiography links Frith and Hogarth, but merely as journalists: 'Frith will be much thought of in some future day because he has illustrated the age in which we live. . . . As Hogarth's scenes are for ever authoritative, so in a lesser degree will be Frith's; but in a lesser degree only, as our pictorial newspapers now narrow the field for the painter in this respect.' However, there is more to connect them than this. Frith's five-part series, 'The Road to Ruin', about a well-born young man who destroys himself and his family by a weakness for gambling, is a Victorian version of 'The Rake's Progress', but with the difference that Hogarth's progress is satiric, whereas Frith shows some of the narrative inquiry and sentimental sympathy of the novel. Hogarth's rake, satirically singled out and isolated from us as a cautionary instance, is comically passive – his weakness makes an ignominious victim of him and the plates show him being variously used by others, measured by a tailor, flattered by poetasters, fondled by whores, arrested in the street for debt, put

upon by an old maid, until he subsides into defeated inanity in the madhouse. Frith's hero, though, is not a satiric victim reeling from one misdemeanour to another, but a character from a novel who creates his own ruin as we watch – we are concerned with what he feels, and with his effect on others, so that in his crude way he might have come from one of George Eliot's studies of the painful, inexorable law of consequences, by which our own misdeeds imprison us. Various narrative clues enable us to fill in the gaps between the pictures – in the fourth scene, set in France, while his wife deals with the dunning landlady, he sits, like Hogarth's distressed poet, trying to write a play. (His wife has been working to help support them by painting watercolours.) In the final scene, in which he locks the attic door before shooting himself, a letter on the floor reveals that the Theatre Royal, Drury Lane, has turned down his comedy. Narrative creates sentimentality, in revealing the distress the hero's fall causes to others – in the French episode the two children are more haggard than in the preceding scene, and in the meagre attic room at the end are scattered an empty cradle and some forsaken toys: in the scene in the Royal Enclosure at Ascot an older and wiser man attempts to draw the hero away from the touts, and in the following scene, in which the bailiff comes to the ruined man's house, the bailiff's assistant casts a wondering and sympathetic glance at the startled wife and her children. Satiric glee gives way to sentimental solicitude – in Hogarth we merely watch a decline, in Frith we see the hero growing from foolish innocence in the university scene to hopeless distraction in the attic.

A similar comparison may be made between Hogarth's 'Four Times of Day' and Frith's three pictures of London street scenes at morning, noon and night. Hogarth's scenes are satiric and anarchic, Frith's sentimental and orderly. Hogarth's oppose tavern to church, Carnival to Lent; they are full of fighting, burning, spilling, tumult and collision – the drunken freemason on whose head the chamber pot is being emptied; an overthrown coach and sedan chair; the extremes of cold and snow in the first two scenes and of heat in the other two; the bonfire in the first plate becomes the conflagration in the last. But the 'full tide of active life', as he called it, which Frith depicts in Regent Street in his noon picture is a bustling orderly prosperous tide, not a Hogarthian torrent, and

justice is done – in 'Morning', burglars are stopped red-handed by the police – not maimed, as it is in Hogarth, whose puritanical but venal magistrate has the chamber pot poured on his head. Hogarth's city is that of Gay's *Trivia*, Frith's that of the Victorian novel – his emphasis is not on ironic incongruity but on narrative, which means sentiment. He singles out affecting incidents which the spectator can expand into a story, for instance the blind beggar conducted across the street by his daughter and his dog; or, in the night scene, the gentleman in Haymarket tenderly arranging a lady's cloak around her shoulders, observed, as Frith describes it, 'by an over-dressed, and be-rouged woman, whose general aspect plainly proclaims her unhappy position; and by the expression on her faded though still handsome face, she feels a bitter pang at having lost for ever all claim to manly care or pure affection.' This sentimental and Dickensian situation is inverted in Hogarth's first picture, with the wintry piety of the old maid, against the bleakly classical and austere façade of St Paul's, Covent Garden, opposed to the rollicking lechery of the couples outside Tom King's tavern and brothel. Sentiment becomes satire: instead of the prostitute envying the pure lovers, we have the old maid envying the impure. Satiric art exploits gaps, compromises us by revealing the discrepancies in our behaviour; but sentimental art explores these gaps as interesting relationships. And although the Victorians learn from Hogarth, they transform his satiric techniques to sentimental purpose. Hogarth's incidents have the wild contradictory absurdity of Pope's

> Mad at a fox-chase, wise at a debate;
> Drunk at a borough, civil at a ball;
> Friendly at Hackney, faithless at Whitehall,

where Frith's possess rather the fond, doting narrative sympathy of the Victorian novel. He wants to know, as Wordsworth does with the leech-gatherer, 'how is it that you live, and what is it you do?' – hence 'the homeless wanderers, asleep and sleepless' in the morning scene, or the blind beggar and the foreigners bewildered by the maps of London in the noon painting. Hogarth's pictures are read by being decoded: he specialises in a sort of visual pun, superimposing church and brothel, or the horns of the cow behind the head of the exhausted husband being marched past Sadler's Wells by a domineering wife in 'Evening', or having a girl whose breast is

being squeezed spill some milk. But Frith's are read by unravelling the stories of the people involved.

Hazlitt writes interestingly on the difference between the satiric realism of Hogarth and its sentimental development by the nineteenth century in his 1818 lectures on the comic writers. He contrasts Hogarth with Wilkie, the precursor of Victorian genre painting. 'Mr Wilkie's pictures . . . derive almost their whole value from their *reality*. . . . Nothing human is indifferent to him. His mind takes an interest in, and it gives an interest to, the most familiar scenes and transactions of life. He professedly gives character, thought, and passion, in their lowest degrees, and in their every-day forms. . . . Mr Wilkie is a serious, prosaic, literal narrator of facts; and his pictures may be considered as diaries, or minutes of what is passing constantly about us.' This is rather Wordsworthian: the hierarchy of literary subjects, with arms and the man or man's first disobedience at its summit, is toppled, and the humblest things are felt to be pregnant with significance, though this is *not* to be demonstrated by the writer so much as discovered by the reader:

> O reader! had you in your mind
> Such stores as silent thought can bring,
> O gentle reader! you would find
> A tale in everything.

Wordsworth's encounter with Simon Lee is deliberately accidental and pointless:

> It is no tale; but should you think,
> Perhaps a tale you'll make it.

The onus of defining the meaning has been transferred from poet to reader, as it is from painter to spectator in many Victorian paintings; the work of art becomes a test of his sentiments, of his understanding, perspicacity and sympathy. Wordsworth's strategy here is the same as Alfred Elmore's in a problem picture like 'On the Brink'. A distressed girl, some torn paper at her feet, sits outside the hellish glare of one of the gaming rooms at Homburg; a young man leans through the window importuning her. This is the *donnée*; the rest is up to us. Henry James's method of starting a novel from an enigmatic clue like this is similar, and he applied to himself the suppression of evidence which makes the paintings problematic: he refused to listen to more than ten words from the

lady who provided him with the germ of *The Spoils of Poynton*. But he shuts his ears to the evidence because of fear of contagion from vulgar actuality, 'clumsy life again at her stupid work'; he wishes to steal the idea from life and make it safe for art, whereas the painters project their crucial and puzzling moments from art into the life of the spectators, forcing them to inquire, to narrate, to sympathise, to predict.

Wilkie finds a tale in everything; but Hogarth, for Hazlitt, still sees life through the selective medium of genre: he is 'essentially a comic painter; his pictures are not indifferent, unimpassioned descriptions of human nature, but rich, exuberant satires upon it. . . . Hogarth paints nothing but comedy, or tragi-comedy. Wilkie paints neither one nor the other. Hogarth never looks at any object but to find out a moral or a ludicrous effect. Wilkie never looks at any object but to see that it is there.' He has moved beyond genre, into a settled, contented mean between tragedy and comedy, and it is this comfortable area between the extremes which is inhabited by the novel. Its sentimental realism is midway between comedy and tragedy, treating the humble situations of the one with the serious attention of the other. It makes tragedy, as James said of George Eliot, out of unpaid butcher's bills. Hazlitt chooses an example from the novel to characterise that ideal art which can arise from familiar subject-matter, and which Hogarth cannot manage: 'When Meg Merrilies says in her dying moments – "Nay, nay, lay my head to the East," what was the East to her? Not a reality but an idea of distant time and the land of her forefathers; the last, the strongest, and the best that occurred to her in this world. Her gipsy slang and dress were quaint and grotesque; her attachment to the Kaim of Derncleugh and the wood of Warrock was romantic; her worship of the East was *ideal*.'

Sentiment ennobles the commonplace; but whereas literature is able to analyse the workings of sentiment, the paintings, confined to a different medium, can only hope to stimulate sentiment in the spectator. They rely on the emotional concern of their spectators; and because of this they are themselves diminished. They merely provide the clues; the spectator goes on to solve the mystery. And in becoming stories, they cease to be pictures. The Victorians insist that paintings should be read rather than looked at. In 1855, in an essay on Thackeray's *The Newcomes* in the Pre-Raphaelite

Brotherhood magazine, Burne-Jones demanded, 'When shall we learn to read a picture as we do a poem, to find some story from it, some little atom of human interest that may feed our heart within, lest the outer influences of the day crush them from good thoughts? When will men look for these things and the artist satisfy them?' Charles Reade, begging Millais for 'Sir Isumbras at the Ford', which he was later to acquire, said, 'I could write a whole three-volume novel on it, and then have sentiment enough to spare.' Val Prinsep recalls the Royal Academy exhibition at which Lord Leighton's 'Flaming June' and Millais's 'Speak! Speak!' hung in the same room: 'The one seemed to me like music – the harmonies all thought out, the lines artfully and carefully composed, self-contained, melodious, and monumental in qualities, like a great sonata. The other like the drama – full of humanity and feeling, stirring a different set of nerves, striking a more human chord, enchanting us by its surprise and its wisdom.' Professor Sir William Richmond, R.A., wrote in a memorial tribute to Millais, 'While he was a poet he was also a novelist; people interested him more than things. . . . He was a great story-teller; his Art is extremely dramatic; he arrived at the roots of the sentiment that was prompting the actors of his drama with whom he became, as a great novelist does, intimately acquainted. Millais's literary sympathies were with Scott, Thackeray and Dickens, and lastly Louis Stevenson. He loved anecdote and story as well as the literary embodiment of character.' This is not merely a case of fatuous exaggeration: the judgement is deranged because of a confusion about the nature of the two arts.

The twisting of an anecdote into pictorial shape can be seen in Sir Luke Fildes's 'Return of the Penitent', which monopolised attention at the Academy in 1879. Fildes had seen a girl just released from Reading gaol in one of the villages on the Thames, and this clue, together with that of an empty house in the village, provoked him to invent a history for the scene which is ingeniously implied by the painting, but which the spectator must decipher. In it the miserable girl has thrown herself down outside a cottage and lies there under the gaze of a number of villagers – has she been turned out? has she fallen? We invent the story. Tom Taylor wrote of it in *The Times*, 'I have heard it called stagey. I fear that any painter who aims at telling a story dramatically must be prepared

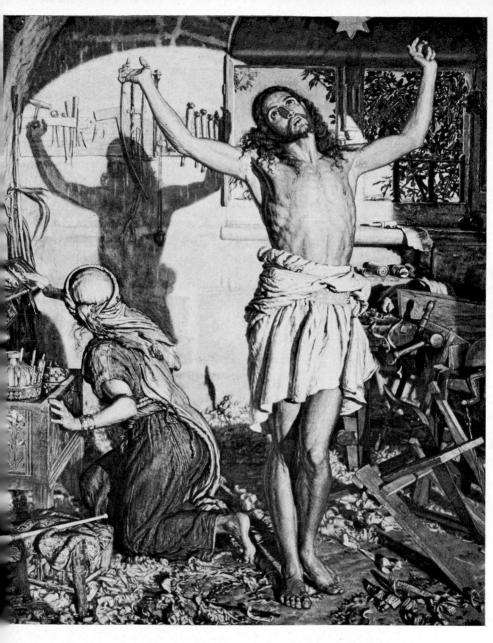

W. Holman Hunt 'The Shadow of Death'

The background is a historical museum of carpenters' tools, comparable to
the contemporary detail in Bell Scott's scene overleaf

Ford Madox Brown 'Work'

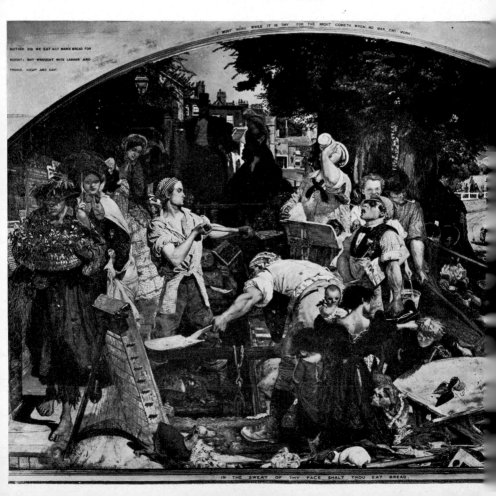

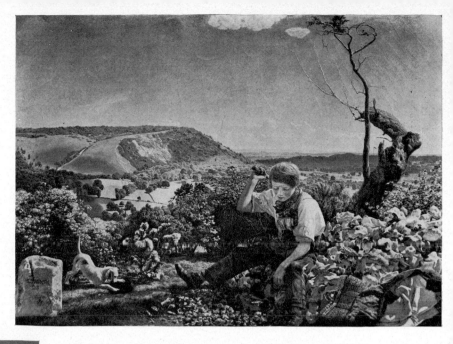

John Brett 'The Stonebreaker'

Two interpretations of work, the sentimental and the strenuous

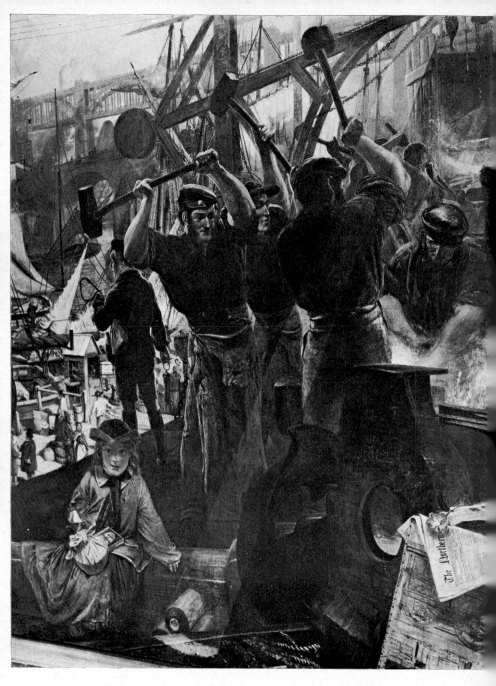

William Bell Scott 'Iron and Coal (Newcastle Quay in 1861)'

for this charge.' But this is not the point: the picture's badness derives from its combination of blatant emotionalism with literary ingenuity – it is not only bad art, but pseudo-literature, pretending to narrate but actually merely exploiting sentiment.

The attempt to narrate in painting creates distortion: the problem pictures merely cleverly turn the impossibility of depicting a sequence of events in a painting to advantage by making of this very incoherence a quiz to interest the spectators. Hence also the reliance on letters in Victorian painting. Letters give an immediate clue to the sentimental situation, and they are a way of stimulating and accounting for the display of emotion by the characters – for instance Frith's picture of bad news being received at the breakfast table, in the Courtauld; or Mulready's 'The Sonnet', in the Victoria and Albert; or Frederick Walker's 'Woman's Mission – Bad News' in the Tate, in which the letter brings news of bereavement; or Webster's 'A Letter from Abroad', also in the Tate. Here too the necessity of providing a motive for the sentiments is turned to glib advantage, for letters are themselves sentimental. In a picture by Frederick Walker in the Walker Art Gallery a woman sits pensively looking through old letters; Mrs Gaskell has a chapter on the same subject in *Cranford*, in which yellow bundles of love-letters sixty or seventy years old are undone by Miss Matty amid sighs regretting the flight of life and time. These family letters are read through before being burnt, because Miss Matty cannot allow them to fall into the hands of strangers, and the narrator comments, 'I never knew what sad work the reading of old letters was before that evening.' The vivid happiness of the letters makes them all the more melancholy, because these warm, living hearts are long since dead; and as Miss Matty reads, the tears steal down her furrowed cheeks, and her spectacles have to be wiped. The use of correspondence in paintings creates a link with Richardsonian fiction, and with the novel's burrowing into private experience. The epistolary form turns the novel into a sort of licensed eavesdropping, tempting us with the revelation of the secrets of others, allowing us, as it were, to open their letters; and if the novelist is an eavesdropper, the Victorian genre painter is something of a peeping tom, spying through the keyhole on private moments of distress, remorse or happiness – for instance in 'The Awakening Conscience', or Francis Bernard Dicksee's 'Reverie' in the Walker Gallery, in which an

apparition of a lost love appears to the bereaved man listening to another woman playing and singing. Such penetration of privacy is new in painting – classical art deals with the public face of things, not with things hidden.

This sort of art places us in the position of spy – as Beerbohm's brilliant cartoon has Henry James furtively kneeling at the door of the hotel room with the double pairs of shoes outside it – and also in that of detective. The problem picture refines the technique whereby a written solution to the mystery is provided in the form of a letter or an order of release or a printed explanation in the catalogue, and leaves the spectator to complete the work; an appeal is made, as in a detective story, to his analytic capacity. Poe describes this in the 1841 preface to *The Murders in the Rue Morgue*: the analyst glories 'in that moral activity which *disentangles*. He derives pleasure from even the most trivial occupations bringing his talent into play. He is fond of enigmas, of conundrums, hieroglyphics. . . .' Detective stories in urging us to disentangle involve us in the mysteries of truth and guilt and responsibility – we are forced into the problematic role of judge, yet at the same time compromised by being implicated in the guilt, made to probe ourselves as well. This is the subject of *The Ring and the Book*, and the justification of its repetitiveness; whilst *The Mystery of Edwin Drood*, being unfinished, is the most disquieting of detective stories because the mystery remains larger than any possible explanation. The problem pictures seek to implicate us not in guilt, however, but in affection, in sentimental familiarity – in assembling the clues we befriend the characters, extend our sympathy to them, and follow them outside the frame, as romantic critics did with those of Shakespeare or Victorian readers with those of Dickens. This sentimental solicitude appears, in rather embarrassing form, in several of Ruskin's Academy notes. In 1856, he writes of Frith's 'Many Happy Returns of the Day', 'One is only sorry to see any fair little child having too many and too kind friends, and in so great danger of being toasted, toyed, and wreathed into selfishness and misery.' Or in 1857, he warns those who look at F. B. Barnwell's 'Adopting a Child' not to miss 'the indication of the reason for the adoption, in the portrait of their own lost child which hangs behind the parents; and to which the girl shrinking from them to her mother's side, evidently bears a close resemblance.' And the

following year, on G. P. Boyce's 'At a Farmhouse in Surrey': 'How pleasant it is, after looking long at Mr Frith's picture, to see how happy a little girl may be who hasn't gone to the Derby!' Ruskin shares with Morgann and Bradley the conviction that the characters exist when we're not looking at them; but whereas the characters of Shakespeare and Dickens genuinely are rich, various and mysterious, and so can justify endless, if inconclusive, speculation, the Victorian paintings can only produce a much more limited response – instead of fascinatingly involving us in the mystery and uncertainty of personality, they invite us to indulge a comfortable disapproval or moralising sympathy. We are not made to ponder a strange, unknowable identity different from our own – Hamlet, Falstaff, or Mrs Gamp – but simply to draw the characters out of the painting and to make them obliging objects of our sentimental patronage. The romantic characters are mysteries, as other people are, infinitely suggestive but remote, closely guarding their secrets; the Victorian paintings present no more than crossword puzzles, which perplex us briefly in order to reward us with a pleasant self-satisfaction when we find the solution.

Taine observed that English artists possessed 'a turn for psychology', a fondness for studying and depicting motives and states of mind; they painted the passions, in Stendhal's phrase. And yet rather than offering real acuity of insight, these paintings beguile us into smugly feeling that we have perceived something, that we have felt nobly – our hearts are made to stand up and answer, 'I have felt!' The Victorians, bemused by literary example, fail to paint emotion – as Rembrandt *paints* the feeling of old age, or the bliss of fulfilled love, not by facial expression or sentimental situation, but by the loving richness of the pictorial texture; they can only illustrate it. Portraiture becomes a literary art, and just as the painters insist on our reading their pictures, so the novelists develop a means of reading faces. This detective work, the decoding of expression and interpretation of facial structure, was given a scientific authority by phrenology; and the best genre painting in this period, the most subtle reading of the external evidence of character, occurs in literature. For de Quincey, Wordsworth's nose is the clue to his character: 'The nose, a little arched, and large, which . . . has always been accounted an unequivocal expression of animal appetite organically strong. And that was in fact the basis

of Wordsworth's intellectual power: his intellectual passions were fervent and strong, because they rested upon a basis of animal sensibility superior to that of most men, diffused through all the animal passions.' For Mrs Gaskell, Branwell Brontë's moral nature is imprinted on his face with the graphic violence of caricature: 'there are coarse lines about the mouth, and the lips, though of handsome shape, are loose and thick, indicating self-indulgence, while the slightly retreating chin conveys an idea of weakness of will.' Charlotte Brontë read Lawrence's portrait of Thackeray thus: 'to me the broad brow seems to express intellect. Certain lines about the nose and cheek betray the satirist and cynic; the mouth indicates a child-like simplicity – perhaps even a degree of irresoluteness, inconsistency – weakness in short, but a weakness not unamiable.' And George Eliot, who wished to uncover the natural laws of the mind ('character is based on organisation') as she wished to make the novel a species of natural history, and whose head, $22\frac{1}{4}$ inches round, was analysed by the phrenologist Charles Bray, is the most scientific of all. In an essay on women in France she explains why the female intellect manifested itself first in the Gallic race by reference to its physiology – 'the small brain and vivacious temperament which permit the fragile system of woman to sustain the superlative activity requisite for intellectual creativeness; while, on the other hand, the larger brain and slower temperament of the English and Germans are, in the womanly organisation, generally dreamy and passive.' George Eliot found Dickens's head undistinguished – 'the anterior lobe not by any means remarkable' – and his attitude to character is, indeed, quite unscientific, delighting not in organisation but in states of dream, trance, the irrational – on his first American trip he magnetised Kate into hysterics and then into a magnetic sleep. The science of character had a slight influence on painting – in 1864 Mulready exhibited a series of twelve heads drawn with regard to the influence of the zodiacal signs on the physical construction of those born under them; his father-in-law, John Varley, had written *A treatise on zodiacal physiognomy*, joining astrology with phrenology.

It seems to be safer for literature to become pictorial than for painting to become literary. The Victorian painters faithfully adapt the methods of the novelists, yet the result is much less good.

Perhaps it is a case of Lessing's rule of propriety – the *Laokoön* prescribes the proper areas to be inhabited by poetry and painting: poetry deals with actions, painting with bodies, the one with parts, the other with wholes, the one with sequences in time, the other with juxtapositions in space. But the Victorian case is not so simple as this. For Lessing, emotional expression must be muted in the visual arts, for these have dedicated themselves to the representation of ideal beauty, which is damaged by concession to any momentary intensity of pain or pleasure: the Greek artist conceals expression as a sacrifice to beauty. The material limits of his art allow him a single moment only, which he must make eternal, so it can have nothing transitory in it. This is an austerely classical position, however, and the Victorians are romantics – for them painting is but another name for feeling, and they have none of Lessing's scruples about the propriety of emotion in art. Their problem is not expression but narrative. They conceive of the passions not, as Lessing does, as eruptions briefly disturbing the lucid classical balance of the mind, which do not deserve to be frozen into the immortality of art, but as forces which spin a plot, as they do in novels: our sentiments involve us with other people, our emotional choices lead us towards fulfilment or disaster in life, our actions bespeak our emotions. How can the sequence of actions, which give novelistic reality to sentiments, be suggested in painting, which has only a moment? The Victorians settle for leaving the sequence to our conjecture. They provide clues – the title, a note in the catalogue, moral warnings in the furniture or the pictures on the wall, literary evidence in the form of a letter – and leave the spectator to construct the narrative. And this is surely why the paintings are so inferior to the novels: they depend over-much on our projection of ourselves into the situation, on our creation of a history for the emotions they exploit; the painter does not need to do the novelist's hard work of characterisation and justification, because he can rely on the co-operative, inquisitive, solicitous spectator to do it for him. Nor need a painting be good, so long as it is suggestive – it will not be judged as art, but interrogated as narrative. It exists merely to provoke a train of thought which soon becomes independent of it; we are left to write the novel it hints at.

Henry James – whose art criticism is significant, in that it

stresses the formal qualities neglected by the genre painters, and encourages the same changes in painting he himself effected in the novel – notices this attitude in the viewers at the Academy in 1877. The observers eagerly huddle around paintings in order to discuss the subjects, to project themselves into the stories. 'I remember a remark made as I stood looking at a very prettily painted scene by Mr Marcus Stone, representing a young lady in a pink satin dress, solemnly burning up a letter, while an old woman sits weeping in the background. Two ladies stood near me, entranced; for a long time they were silent. At last – *"Her mother was a widow!"* one of them gently breathed. Then they looked a little while longer and departed. The most appreciable thing to them was the old woman's wearing a widow's cap; and the speaker's putting her verb in the past tense struck me as proof of their accepting the picture above all things as history.' James's own fastidiousness of course seals his novels off from contact with the sympathy and curiosity of his readers; he is the novelist of what he calls 'the plastic obligation', of respect for the form – an obligation shirked, he felt, by Millais, who preferred to please the public by amusing or edifying. In James the rigour of art chills the anxious sentimental self-projection of the readers; but neither do the earlier Victorian novelists invite it – they keep the reader at a distance by their sense of inescapable fact, of the existences of other people which impinge upon our own and limit our freedom and fantasy; dreams and fantasies are chastened, and, like Catherine Morland finding the laundry list, the reader is returned to prosaic truth. The narrative paintings abuse the example of the novel, because they draw on a momentary compassion or disapproval or concern without enforcing its consequences, as the novel does by keeping us with the characters, compelling us to suffer and discover with them. The paintings deal with a moment – a child's sick-bed, the receipt of bad news, the discovery of infidelity – but leave the causes and consequences to the guess or day-dreaming wish of the spectator, who can ingeniously play with the narrative possibility but feels no real concern because he has no sense of the facts of the case. His response is a trivial and patronising one – James's two ladies solve the mystery and leave; they can escape, while the readers of a novel must suffer through to the promised end. The ladies have the pleasant self-sufficient sense of having felt nobly and charitably,

but they are excused from having to pay for this in close or prolonged attention, or from having to assume responsibility. The Victorian narrative pictures are machines for evasion: they elicit sympathy but guarantee to keep it hypothetical and harmlessly perfunctory. They give the spectator the illusion of having behaved well; they flatter him that he has felt finely.

Their dishonesty derives from their momentariness, whilst the honesty of novels comes from their sheer wearying duration. The sense of exhaustion we feel in the course of reading a Victorian three-decker is an essential part of its moral effect on us: it is a milder but more prolonged version of the sensation Keats felt when abandoning the golden-tongued enchantments of Spenser and settling himself to read *King Lear* again:

> once again the fierce dispute
> Betwixt damnation and impassion'd clay
> Must I burn through; once more humbly assay
> The bitter-sweet of this Shakespearean fruit.

The careful attention and just sympathy which are required of us by a novel, the inescapable sharing of the predicaments of the characters it imposes on us, our long acquaintance with them, the sheer amount of work we have to do, reading and considering and deciding, to get through the novel – all these things are part of what the novel teaches us. It turns its material condition, its length, to moral advantage, whereas painting converts its material condition, its confinement to a moment, into an excuse for evasion. In *Shirley* Charlotte Brontë says she intends to enrol her heroine in 'the school of Experience', to make her learn its 'humbling, crushing, grinding, but yet purifying and invigorating lessons', and for the reader as well the process of reading the novel is an induction into this arduous, conscientious school. In reading about Dorothea Brooke we grope ahead, with her, through 'dim lights and tangled circumstance', and our reading teaches us the same lessons her fictional experiences teach her: we too are ground, with Isabel Archer, in the very mill of the conventional. Charlotte Brontë prescribes another difficult course for her hero and for us in the preface to *The Professor*: her publishers wanted her to enliven the grey dullness of the action with some strange and startling turns of event, but she insisted that 'my hero should work his way through life as I had seen real living men work theirs – that he should never

get a shilling he had not earned – that no sudden turns should lift him in a moment to wealth and high station. . . . As Adam's son he should share Adam's doom, and drain throughout life a mixed and moderate cup of enjoyment.' The trials she inflicts on her hero are inflicted as well on the reader: he too must mount the Hill of Difficulty, he too must accept the sober truth and not crave magical release from circumstances or escape into the excitements of fantasy; as another son of Adam, he is made to work in reading of the work the hero does.

Hero, novelist and reader are all workers; but the viewer of a Victorian picture does not earn his insight in this way: it is vouchsafed him in a moment, and for this reason it is meretricious.

3. THE CITY AND THE PICTURESQUE

THE narrative pictures are, like the novel, a licensed invasion of privacy; they belong to a phase of civilisation and of art which has retreated from the ideal of action to that of sentiment, from public achievement to the fugitive and cloistered virtue of domestic intimacy, and this chapter deals with a further aspect of this recoil into the private life – Dickens's imaginative transformation of London. For Dickens's city is not a rational, daylight, communal place, but a phantasmagoria of dreams and fears, a city of dreadful night; and it is not a public place, but a fiercely private one, its inhabitants not connected with one another but sealed off in secret shelters, like timorous animals. And this idiosyncratic treatment of the city is echoed in a very Dickensian work, published in 1872, *London: A Pilgrimage* by Blanchard Jerrold with illustrations by Gustave Doré. For Doré's illustrations cultivate the Dickensian art of making the prosaically ordinary fearfully strange, of finding in the modern city all the weird hauntings of the Gothic novel, whereas Jerrold's text – a series of genre paintings in prose – introduces the notion of the picturesque, that special Victorian compromise between the disturbingly real and the consolingly ideal, which will be followed into art and literature.

For Doré, as for Dickens, London is Gothic. The gloom of the spectral engravings he contributed to Jerrold's book, with sickly light glimmering through thick black, suggests a way of seeing the subject. London deserved its fogs: they made a modern city Gothic, involving it in a murky half-light through which misty shapes can loom. Classical architecture needs sun – it is an art of sharp edges and gleaming surfaces, of lucidity; but Gothic with its alpine steepness and cavernous recession is suited to a dim, obscuring light. The fog which envelops London at the beginning of *Bleak House* is a romantic medium, blurring the real into the mysterious; it is the urban equivalent to the forest gloom which so stimulated the German romantic imagination. Romanticism responds to dirty

weather: Ruskin has the greatest contempt for a critic who said, looking at a Copley Fielding picture of a rainy, peaty moor, 'But, Ruskin, what is the use of painting such very bad weather?'

Fog and mist create a Gothic atmosphere in Doré's illustrations to *The Ancient Mariner*; the masts and rigging of the phantom ship to which the mariner is tied look like church-spires, with all the vertiginous terror of Gothic, and the ship arrives in a port built in the Gothic manner of Strasbourg and Mont St Michel, while the mariner stops one of three in a dim forest which recalls Grünewald. Fog dissolves the real and inspires that nervous relation to the world about us which, in contrast with the lucid calm of the classic, is the origin of the Gothic. Dickens's November fog leaves things numinously suspended: 'Chance people on the bridges peeping over the parapets into a nether sky of fog, with fog all round them, as if they were up in a balloon and hanging in the misty clouds'; it is an urban and polluted variety of the tinted steam of Turner, which melts objects into an atmospheric storm and has things hover through the fog and filthy air. Doré's engravings, involving the city in a ghostly chiaroscuro, suggest something similar – the image is not a black mark confidently made on a white page; instead it grows as a faint, hesitant gleam of light through a dense background, as Dickens describes gas looming through fog. This pilgrimage of Jerrold and Doré through the city is, like those of Spenser or Bunyan, a journey through a place fraught with perils, although here the tenebrous Gothic landscape of danger and temptation is not natural (Spenser's entangled forests with their diverging paths) but urban and man-made.

Doré's receding tunnel-like perspectives do suggest sinister forests; buildings have been transformed into nature. Architectural fantasy – the vision of nature reclaiming what men have feebly attempted to civilise and control, or of towering human constructions overawing even the forces of nature – is a powerful imaginative stimulus to the romantics, and one compelling fantasy was that of the sunken forest, the subterranean cathedral or *cathédrale engloutie*. The cathedral nave could suggest over-arching forest aisles, the columns multiplying into leaves and branches; romantic buildings take root in the earth, opening into cavernous depth – Hugo in *Notre Dame de Paris* says that there was as much of a medieval building within the ground as above it: 'the subterraneous

vaults of an edifice formed another edifice, in which you descended instead of ascending; and the underground stories of which extended downwards beneath the pile of extended stories of the structure, like those inverted forests and mountains which are seen in the liquid mirror of a lake, underneath the forests and mountains on its borders.' A building becomes an organism; and it becomes a dream – the sunken prisons and sepulchres, the caves and tunnels Hugo dreams of turn the rational space of architecture into mental space, space to be imaginatively explored.

This happens as well with the Dickensian city. It is a place of dreams: 'A solemn consideration,' Dickens reflects in *A Tale of Two Cities*, 'when I enter a great city by night, that every one of those darkly cluttered houses encloses its own secret; that in every beating heart in the hundreds of thousands of breasts there is, in some of its imaginings, a secret to the heart nearest to it!' The paradox of Dickens's city is that the people it jostles into proximity are so remote from one another, like the three passengers in the mail-coach at the beginning of *A Tale of Two Cities*, or the strangers in *Bleak House* who come to be inexorably linked only by contagious disease. Because 'every human creature is constituted to be that profound secret and mystery to each other', the city frustrates the society and community it is meant to promote; it thrusts people together in crowds, but at the same time makes them anonymous. The city falls apart into a multitude of homes, cosy interiors in which the characters shelter, raising drawbridges, like Wemmick in *Great Expectations*, against their surroundings.

Huddled in shelter, burrowing into their privacy, these people turn the city into a warren, a series of caves and hiding places secretly connected; and this subterraneous quality of Dickens's London recurs in the pilgrimage of Jerrold and Doré. Theirs is a night journey, and, it seems, as they negotiate dim streets in rookeries or thread between gloomy warehouses, a journey underground, like the romantic quests of Alastor or Childe Harold, whose journeys are through mental space, an inner faeryland, towards secret goals within themselves. They travel along the Thames as Wordsworth travels on the underground river of time and memory. The landscape is real, but transforms itself into fantasy. Jerrold's description of London as 'the wonderful and wonder-working Babylon' is more than a cliché, for, thanks to

Doré's illustrations, it does come to seem like one of the dreamy apocalyptic cities of John Martin. Doré admired Martin, and the two were linked by Théophile Gautier in *Souvenirs du siège* in 1871, the year of the publication of *London*: he says that Doré's bastions and defensive works have the grandiose quality of a Martin engraving. Doré's London, as much as Martin's Babylon or Sodom or Pandemonium, is a product of romantic fantasy, a place of glooms and dizzy abysses, volcanically restless. Martin's cavernous depths were possibly suggested by railway excavations, and they thus directly anticipate the underground tunnels of Doré or his 'Over London – By Rail', in which the arches and curving terrace recall the colossal, oppressive architecture of Martin, liable at any moment to erupt or crumble. The people hanging from windows and moving about in their back yards in the narrow alley between the receding curve of the terraces are like the swarms of terrified figures in the dramatic and endless perspective of the columned aisles in 'Belshazzar's Feast'. Both Martin and Doré use architecture to draw the eye into immense distances: a romantic painting is a magic casement opening into mysterious depth or exotic distance. Hence the fondness for tunnels, as in Martin's illustration of Milton's Sin and Death building their causeway, which uses an infernal variant of that funnel-like structure through which the souls in Bosch's painting in the Ducal Palace in Venice ascend into the empyrean, but which suggests as well the Thames tunnel and Doré's London underground tunnels. A tunnel is a telescope, focusing the very remote.

The eighteenth century caprice, as practised for instance by Guardi, is a witty and knowing joke about architecture, superimposing buildings, altering familiar vistas, or showing them in melancholy ruin; but Martin and Doré use architectural fantasy to create nightmares. Doré applies Martin to London again in the scene of the street-block at Ludgate Circus, which has another train on the viaduct and beneath it a Martinian tunnel packed with carriages and pedestrians toiling up the hill, the confusion of this marshalled into a sharply receding perspective; and the spires jumbled together at the top of the hill recall Martin's cliff-like rows of crumbling palaces in the many illustrations of the fall of the doomed Biblical cities. Doré excites some of Martin's vertical fears in an illustration on page 131, in which St Paul's dome shines above

dark cluttered irregular slum rooftops: here, between the two rows of houses, there is a steep gorge crossed by rickety bridges, an urban equivalent of the cliff-hanging dangers of the Alps or the gorge in Martin's illustration to 'The Bard'. On pages 25 or 116 slum alleys are lengthened into steep dark sinister tunnels, while the warehouse opposite page 114 has a little of the dizziness of Martin's picture of Sadak attempting to pull himself on to the rocky ledge amid the torrent. The wall, with ledges jutting from it and figures peering down from these, seems to drop into an unplumbed depth, into which the bales and barrels are being lowered; and light enforces the sense of steepness and vertical drop – a sickly beam falls on the wall and the topmost ledge, outlining one figure perched there dangling his feet over the abyss, but below all is darker, and the brick wall seems to recede as well as to drop.

The boldest architectural fantasy occurs in Doré's final plate of Macaulay's New Zealander, sketch book on his knee like a picturesque artist in the Campagna, lolling on an outcrop of rock and looking across the river to the ruins of the dome of St Paul's and the moonlit wastes of warehouses. Throughout, the city is seen under the gaze of fancy, which transforms it into either a picturesque idyll, as in the genre paintings, or, as in Dickens, into a hellish gloom of tunnels and passages for malevolent animals; and it is seen as an organism, not in competition with nature but part of it, so that, in ruins, it merges again into nature, with trees surrounding the commercial wharf. What terrified Gray

> Purg'd by the sword and beautifyed by fire,
> Then had we seen proud London's hated walls,
> Owls might have hooted in St Peters Quire,
> And foxes stunk and litter'd in St Pauls.

has become a pleasing dream. London in the romantic mythology is made to join Rome as Goethe sees it, the classical architectural forms muffled and decayed into Gothic obscurity and chaos, or Rome as Piranesi saw it, terrifyingly monumental, reducing its inhabitants to pigmy size; or Martin's collapsing biblical cities, or Lytton's Pompeii, or the shimmering insubstantial mirage of Turner's Venice – cities transformed into dreams, made possessions of the imagination, places not to be lived in but to be imaginatively explored.

Significantly, Jerrold and Doré began their exploration in the East End, attracted not to Nash's wide thoroughfares but to the labyrinthine rookeries and treacherous mazes in which the city seems to have become a part of the animal and vegetable world again. In the Whitechapel chapter Jerrold borrows one of Dickens's favourite journalistic subjects, the tour of the thieves' kitchen, and there are parallels as well to Saffron Hill in *Oliver Twist*, with the sullen threatening men in the open doorways or the stealthy movements of the inhabitants in their burrows: 'we plunge into a maze of courts and narrow streets of low houses – nearly all the doors of which are open, showing kitchen fires blazing far in the interior, and strange figures moving about.' After the Whitechapel Police Station the cab has to be dismissed, for they plunge into a maze of 'strange, dark byeways', threading 'an extraordinary tangle of dark alleys' with flickering lamps to mark the corners and more low burrow-like houses opening on to them; it is an underground journey as well as an underworld one, with ebon walls pressing on them so that two men can just walk abreast, 'black pools of water under our feet – only a riband of violet grey sky overhead!' Even the Garrick Theatre is a maze in the earth: they 'penetrate its gloomy passages'. Shaking his head at the indecencies of an earlier generation, Jerrold remarks, 'I suppose that in the old times – that is, some thirty years ago – men had a decided taste for the underground. To feel most at ease, like the mole, they must work their way under the earth's surface. For in those days, cellars and shades and caves were the chosen resorts of roystering spirits of all degrees', dark kitchens, Holes in the Wall, riverside resorts as near the level of the Thames as could be reached, with dirt and gloom the main attraction, rather like the dropsical Six Jolly Fellowship-Porters in *Our Mutual Friend* which impends over the water. Charles Knight, in a book on *London* in 1841–4, had already written of the poor as subterraneous creatures, inhabiting, quite literally, an underworld. He writes, for instance, of the cellar-dwellers in St Giles's who enter their burrows by trap-ladders, as animals, quietly and purposefully going about their mysterious business; the sociologist becomes a zoologist (as George Eliot wished to make the novelist a scientist, a natural historian): 'they appear a short-winded generation, often coming, like the other, to the surface to breathe. In the twilight which reigns at the bottom of

their dens you can sometimes discern the male busily cobbling shoes at one side of the entrance, and the female repairing all sorts of rent garments on the other. They seem to be free feeders. . . . They have the appearance of being on the whole a contented race.' The homes of these lower specimens look like rat-holes; or the St Giles maze appears to be a simple block of stone 'eaten by slugs into innumerable small chambers and connecting passages.' Jerrold is bored by the open, the imposing, the planned: 'Of all the streets north or south of Piccadilly, Regent Street, albeit the most pretentious – the handsomest – designed as it was as a royal way from Carlton Place, is the least interesting. The Piccadilly side streets – even to the smallest, are full of delightful story. . . .' This maze, this subterranean world of crevices, hollows, low hiding-places, is the world of Dickens's characters, burrowing into themselves away from the light and other people, holed up in a weird privacy.

For the Dickensian city is made up of interiors, not of public places. His good people are cloistered in their homes, which they turn into castles or temples; or they often seem like little animals which carry their homes about on their backs. *Our Mutual Friend*, for instance, develops through contrasts between various interiors: the hideous boastful solidity of the Podsnap plate, the brand-newness of everything in Stucconia, the crazily infirm giddy interior of the Porters, Venus's macabre shop, the bower half fashionable and half comfortable. The exuberance of the Victorian interior derives from the split between the prosaic and ugly environment of work and the haven of comfort and relaxation of the home, devoted to dream and pleasure. The Furniture Section of the Great Exhibition boasted an easy chair in papier-mâché called the 'Day-Dreamer' which was decorated at the top with two langorous winged thoughts. Wemmick in *Great Expectations* tells Pip, 'Walworth is one place, and this office is another. . . . They must not be confounded together. My Walworth sentiments may be taken at Walworth; none but my official sentiments may be taken in this office.' Wemmick's home, flying the Union Jack, becomes a castle. Other Victorian homes became temples: in 1851 Class XXVI (Furniture) was thought to offer the most magnificent evidence of national prosperity, and yet the japanned goods and papier-mâché, the rich carving and upholstery remove the furniture from the realm of practical use – as the cutlery on display was too weighted

71

with decoration ever to be used at table – into that of art, and pieces of furniture become cult objects, religious icons. Hence the application of Gothic to domestic articles: Pugin's ecclesiastical vessels or his medieval stove, or the ceramic jug manufactured by Messrs T. J. and J. Mayer, on which a Virgin and Child are seated beneath a Gothic pinnacle. The home is not only castle and temple, but also museum, a repository for objects which have become exhibits, as at Vivian-place in Tennyson's *Princess*:

> And on the tables every clime and age
> Jumbled together; cells and calumets,
> Claymore and snowshoe, toys in lava, fans
> Of sandal, amber, ancient rosaries,
> Laborious orient ivory sphere in sphere,
> The cursed Malayan Crease, and battle-clubs
> From the isles of palm . . .

Bric-à-brac is elevated to moral symbolism in 'The Awakening Conscience': the embossed books are suspiciously unread, as Ruskin saw, the moulded papier-mâché bindings suspiciously new, tangled wools of embroidery lie discarded on the floor, and the gilded tapestry on which thievish birds prey upon corn and vine left unguarded by slumbering watchers contains an allegorical warning. Rossetti inscribed these verses on the frame of 'The Childhood of the Virgin Mary' (Tate Gallery), allowing its contents to be decoded:

> These are the symbols. On that cloth of red
> I' the centre is the Tripoint, perfect each
> Except the second of its point, to teach
> That Christ is not yet born. The books (whose head
> Is golden Charity, as Paul hath said)
> The virtues are wherein the soul is rich;
> Therefore on them the lily standeth, which
> Is Innocence, being interpreted.

The Victorian interior, with its covers, its sheathing and padding, its antimacassars and bindings, insulates its inhabitant from the rude shocks of the world outside – the Queen's railway saloon, which was furnished like a drawing-room, was thickly padded with quilted silk to hush noise and protect her from vibration. The interior is a fortress, defending the private life against the public world. It is presided over, as Ruskin says in *Sesame and Lilies*, by

the angelic woman, whose only contact with the rough open world is through her husband who must do battle in it all day but returns to this haven to be healed at night: home is 'the place of Peace; the shelter, not only from all injury, but from all terror, doubt, and division . . . a sacred place, a vestal temple, a temple of the hearth watched over by Household Gods.' So tightly is the home drawn around its inhabitants, it becomes a case, an exoskeleton. The character of the occupant flows into his possessions, as Locke said property was an extension of one's person. Often, in Dickens, this produces a rather horrid animism – Harmon's house, in *Our Mutual Friend*, for instance, seems to have wasted on account of his miserliness. Everything in it has a spare look. The bedroom furniture ominously mimics its owner's convulsions: there is a 'tight-clenched old bureau, receding atop like a bald and secret forehead', a table with twisted legs, chairs whose colours have faded without giving any pleasure to the eye, and a grisly fourposter bed like a gaol cell, which recalls a funerally over-decorated Austrian bedstead in zebra wood exhibited in 1851, with a high footboard imprisoning its sleeper, and suffocating airless draperies. 'A hard family likeness was on all these things.' In *Dombey and Son* Dickens deciphers or detects something unwholesome and unfelt, an air of guilty pretence, in the opulent furnishings of Carker's villa, as if he had given an expression of himself to the things he lives with; and the signs are much the same as those fastened on by Ruskin in his comments on the room of Holman Hunt's sinful couple – both Ruskin and Dickens exhibit a Holmesian hypersensitivity to interior decoration: 'Is it that the carpets and the cushions are too soft and noiseless, so that those who move or repose among them seem to act by stealth? Is it that the prints and pictures do not commemorate great thoughts or deeds, or render nature in the poetry of landscape, hall, or hut, but are of one voluptuous cast – mere shows of form and colour – and no more? Is it that the books have all their gold outside, and that the titles of the greater part qualify them to be companions of the prints and pictures?' The interior may be suggestive even when empty: thus in 1853 Henry Wallis painted 'The Room in which Shakespeare was born', now in the Tate, in which Shakespeare is evoked by the objects ranged about the large empty room, which glows with that fond honey-coloured light which is the lambent expression of

Victorian sentiment. Prints and bound volumes sit on the chairs, a death-mask and a pair of small busts are placed between a vase of flowers on the window sill, a pen is propped in an ink well on the desk. The vacant space gaping in the foreground invites the viewer to people it. Shakespeare is there; but, as surely as Harmon, he has vanished into his possessions, as Daphne was transformed into a tree. Henry James in his study of Hawthorne lamented the absence in America of any of the traditional institutions, abristle with nuance, which could stimulate the imagination of the novelist; Dickens wrote to Forster from America of an equally important imaginative deprivation – 'the bedrooms are indeed very bare of furniture'.

The interior is not only suggestive; it does also offer moral comfort. In *Our Mutual Friend* Wrayburn preaches Mortimer a sermon on the moral influence of housekeeping, and methodically runs over the objects needed to stock a kitchen, which are presented with the loving enumeration of a catalogue of ships or warriors in an epic: miniature flour-barrel, rolling pin, spice box, shelf of brown jars, chopping board, coffee mill, crockery, saucepans, roasting jack, kettles, dish-covers. The catalogue becomes an idyll: the mind rests in delighted contemplation of these useful, pleasant things, symbols of domestic cosiness.

This imaginative transformation of the city into a multitude of secret, sheltering interiors has a parallel in Mayhew's monumental study of the street folk of the city, *London Labour and the London Poor*, published in 1861. Mayhew calls this a 'cyclopaedia' – its bias is scientific; Jerrold's and Doré's work, on the other hand, is a 'pilgrimage' – its bias is romantic, a romance quest in which the familiar flowers into the strange and exotic. But Mayhew's statistics as much as Jerrold's genre paintings and Doré's spectral engravings celebrate the romance of London, despite its ugliness and misery; both are Dickensian. One of the edifying themes which emerges from Mayhew's documentation is the very Dickensian contrast between the fearful exposure and predatoriness of the streets and the snugness of the home, or between the sanctities of the real home and the discomforts and immorality of the false homes in which his street folk, like Doré's refugees opposite page 180 or the shivering outcasts in Fildes's painting of 1868, take shelter – the casual wards, or cheap lodging-houses. This contrast between exposure and

cosiness, shivering and warmth, exterior and interior, marks Dickens's novels: chapter XII of *Our Mutual Friend* begins with the desperate, harried movement of sawdust whirling, wind sawing, shrubs wringing their hands, men and bits of paper whirled by the cold wind in the gloomy desolation of London. Then there is a recoil and the city contracts to the sitting-room where Eugene and Mortimer are smoking by the fire. The black shrill gritty unbearable exterior is comfortingly shut out. Yet when Riderhood arrives, they are drawn out again into the exposure of the streets and flayed by hail, until they reach the Porters Snug. This is called Cosy, and it lovingly enfolds them: 'Cosy seemed to leap out of a dark sleep and embrace them warmly the moment they passed the lintels of its hospitable door.' Then they are again forced outside, to watch on the river-bank in the raw cold. The idea of extrusion, being turned out of doors, is terrifying to the Victorians: Ruskin shudders to read in the detail of the hem of the adulterous woman in 'The Awakening Conscience' the warning that 'soon its pure whiteness may be soiled with dust and rain, her outcast feet failing in the street . . .'

Mayhew as often as possible follows his subjects from the streets to their homes, and once there in his unsophisticated way he is, like Poe, a physiognomist of the interior, eagerly seeking clues to the secrets of the inhabitants in their furniture and ornaments. He is anxious to see the room in which the half dozen boy sweepers sleep with their landlady and her daughter and grandson, 'so that I might judge of their peculiar style of housekeeping, and form some notion of their principles of domestic economy.' He finds that 'the old woman who kept this lodging had endeavoured to give it a homely look of comfort, by hanging black-framed pictures, scarcely bigger than pocket-books, on the walls', sacred subjects and jolly sailors. Or there are the 'few sticks' of the wooden-legged sweeper: mantelpiece ornaments such as bead-baskets, black profiles of heads which, in a Dickensian phrase, 'had lost their owners many a year', a horse-shoe nailed over the door and a scripture-piece serving 'to keep the wall from looking bare'. Or the medley of objects gathered by an old and poor couple: a lithograph of a horse, a Hogarth etching, a stuffed bird in a wooden case, a piece of painted glass, china ornaments. The room of the fly-paper maker is 'so poorly furnished, that it was evident the trade was not a

lucrative one. An old Dutch clock, with a pendulum as long as a walking-stick, was the only thing in the dwelling which was not indispensable to the calling. The chimneypiece – that test of "well-to-do" in the houses of the poorer classes – had not a single ornament upon it.' Commonly there are only boxes and deal tables for furniture: ornament seems more important than furniture, because ornament has a narrative content which consoles. As we can read pictures, so we can read buildings, and Ruskin enjoins us in *Seven Lamps of Architecture* to approach architectural ornament in this way: 'Its true delightfulness depends on our discovering in it the record of thoughts, and intents, and trials, and heart-breakings – of recoveries and joyfulnesses of success: all this *can* be traced by a practised eye.' Buildings have a novel dormant within them, waiting to be let out by a sympathetic viewer; so do familiar things, which, however shoddy, can console, and the Victorians release the genii from these as well, and take comfort from them. Newman, who kept an old blue cloak for years, confessed, 'I have so few things to sympathise with me, that I take to clokes'; and Dickens published in *Household Words* a piece by Mary Boyle called 'My Mahogany Friend' about a loquacious hat-stand which consoles the narrator when he is crossed in love. This man has cultivated the art of listening to the confidences and stories 'of what we commonly call inanimate objects' which is the basis of Victorian pictorial symbolism.

Sentimentality and symbolism hallow objects, tame and domesticate them. This is a necessary steadying process for the Victorians, who often seem deeply nervous, afraid of the things about them and desperate to soothe and quieten them. Hence the strange animism of Dickens. David Copperfield senses things as either comfortingly and shelteringly for him – the fairytale house at Yarmouth, the pulpit like a castle which would have been so good to play in, warm and fleshy Peggotty – or angularly, menacingly against him – Miss Murdstone's metallic black boxes, the new dog, the prayer-book with which he is poked into piety in church. Things seem an assault on him, conspiring to baffle and entangle him as in a dream: the five thousand double Gloucester cheeses, the two men between whom he is squeezed in the coach, the lady's malign basket, the eruption of the Gooroo man. Sentimentality charms these potentially aggressive, painful things into acquiescence

and friendship; it enlists them as protectors. This is the reason for the frail magic of the domestic ornaments in the dwellings of the street folk, and for the cult of the interior. In a similar spirit in *Our Mutual Friend* Dickens transforms the Children's Hospital from an institution into a home, a shelter, by comforting, almost ritualistic iteration of the adjective 'little': 'Johnny had become one of a little family, all in little quiet beds (except two playing dominoes in little arm-chairs at a little table on the hearth): and on all the little beds were little platforms whereon were to be seen doll's houses, woolly dogs . . . , tin armies, Moorish tumblers, wooden tea-things, and the riches of the earth.' Like the interior it describes, the adjective 'little' miniaturises, muffles and sheathes things and so makes them manageable and painless.

Sentimentality was to the Victorians what symbolism was to the romantics. Both are intuitive, emotional ways of linking sense and soul; the intimations of immortality, the waking dreams of the romantics become the higher feelings of the Victorians. Keats's nightingale not born for death or Shelley's blithe spirit lead to Landseer's dogs with their soulful weeping eyes, Wordsworth's solitaries to Millais's blind girl; in the first case the mysterious affinity between artist and subject is symbolic, in the second sentimental. The sentimentality is embarrassing because less confident, wished upon its object rather than discovered in it. Symbolism is a matter of guess, hint, dubious foreboding – 'do I wake or sleep?'; but sentimentality depends on pretence. The romantics are content with their open questions, with passing spots of time, sadly limited and uncertain, but the Victorians employ sentimentality to evade uncertainties, to escape from disturbing truths. Courbet said he couldn't paint an angel because he had never seen one; Burne-Jones painted them not although but because he knew he would never see one – he defiantly said that the more materialistic science became, the more angels he would paint. The Victorians had to cope with more evidence against their vision than the romantics had to – the scientific evidence which drove spirit out of nature – and they could only cope with it by pretending, sentimentally, that it did not exist.

They had the same difficulty in society, and here the mode of evasion was the closely allied one of the picturesque. The hard prickly unpleasant facts of poverty and ugliness are here softened

by being fondly resolved into a picture; it is as if the troubles and problems are coated with a layer of varnish which mellows them, distances them, transforms them into a Flemish idyll. The picturesque was a way, like sentimentality, of protectively putting a distance between oneself and the problematic object. The evasion appears at its most obvious in the desire to swathe the manifestations of industry in conciliatory, flattering poetry, as Mucha wanted to camouflage electric wires with glass beads. The Thames embankment was an eyesore during the day but, wrote Whistler, 'when the evening mist clothes the riverside with poetry . . . the poor buildings lose themselves in the dim sky, and the tall chimneys become campanili, and the warehouses are palaces in the night.' Dickens is rather sharp about this sort of picturesque condescension in *Hard Times*: it is only the travellers by express-train, who are passing quickly by, who think that the lights in the Coketown factories make them look like fairy palaces. And Ruskin in the fourth volume of *Modern Painters* worries about the pain and decay behind the picturesque appearance. He wanders along the Somme through a scene which has all the elements of the picturesque according to Salvator Rosa, shaggy cottages sloping into the slime, rustic mill-wheels and a Gothic church whose buttresses are founded in the stream; he finds it 'all exquisitely picturesque, and no less miserable. We delight in seeing the figures in these boats pushing them about the bits of blue water, in Prout's drawings; but as I looked today at the unhealthy face and melancholy mien of the man in the boat pushing his load of peats among the ditch, and of the people, men as well as women, who sat spinning gloomily at the cottage doors, I could not help feeling how many suffering persons must pay for my picturesque subject and happy walk.' Scott in *The Bride of Lammermoor* notices that old Alice's hut 'had of late been rendered more comfortable, and presented an appearance less picturesque, perhaps, but far neater than before.' Similarly, Dickens wrote to Forster from Naples that the condition of the people was 'abject and shocking. I am afraid the conventional idea of the picturesque is associated with such misery and degradation that a new picturesque will have to be established'; or from Edinburgh, 'I am sorry to remind you what fast friends picturesqueness and typhus often are.' And Mayhew criticises Lamb for throwing a halo of poetry over the child chimney-

sweepers, calling them with picturesque evasiveness 'dim specks', 'innocent blacknesses', 'young Africans of our own growth' and likening them to martin larks 'in their aerial ascents not seldom anticipating the sunrise'; against Lamb's fantasy he sets the grim, dingy, unattractive reality of 'the present race of sweepers'.

The picturesque is a way of flattering the real; it makes the desolation of a landscape pretty, resolves its irregularities into a pleasing prospect. It arises from appreciation of the country; but Jerrold and Doré apply it to the city. Doré presents Macaulay's New Zealander as a sketcher admiring the ruins of London, and in his illustrations to Jerrold's text he transfers the picturesque sketch from a rural to an urban setting, using a Claude glass, as it were, to make the ugliness of London charmingly characteristic and therefore picturesque. 'London an ugly place, indeed!' Jerrold exclaims. 'We soon discovered that it abounded in delightful nooks and corners: in picturesque scenes and groups; in light and shade of the most attractive character. The work-a-day life of the metropolis, that to the careless or inartistic eye is hard, angular, and ugly in its exterior aspects; offered us pictures at every street-corner.' The distance and detachment of the picturesque observer is revealed in Jerrold's statement in the Preface that he and Doré are wanderers and not (like Mayhew) historians: they are merely making an excursion in search of the picturesque and typical, as Shelley had done to Italy or Keats to the lakes and Scotland, and this absolves them from having to worry about what they saw or to judge it. They appreciate, they don't inquire too closely.

For the picturesque is linked with a certain bland cheerfulness, a patronising determination to find things placid and lovable at all costs. When in *Adam Bede* an idealist sniffs at the clumsiness and ugliness of the people in Dutch pictures, George Eliot purrs in reply, 'bless us, things may be lovable that are not altogether handsome, I hope?' She insists on the truthfulness of the Flemish painters, but is anxious to separate this from the grimness and bleakness of naturalism. As the painter H. T. Wells had distinguished his art from that of the photographer by saying that a picture was truth but 'truth lovingly told', so George Eliot sees the truth of the genre paintings as suffused with picturesque satisfaction and placidity: all the figures with quart-pots in their hands wear 'an expression of unmistakable contentment and good-will'.

Yet it is the Victorians who turn the genre scene into an idyll of contentment, as in Thomas Webster's 'Village Choir' (1847) or Wilkie's 'Grace before Meat', which when shown at the Royal Academy in 1839 had appended to it these verses by the Countess of Blessington:

A lowly cot where social board is spread,
The simple owner seated at its head;
His bonnet lifts and doth to Heaven appeal,
To grant a blessing on the humble meal!

Poverty is made to seem a noble and dignified state, varnished over with contentment, modelled into a touching scene, in a Victorian rather than a Flemish way, for the older painters deliberately resist the imposition of a sentimental or picturesque shape on experience. The centres of Brueghel's paintings, for instance, are often displaced – the bride who ought to be the centre of attention sits nervous and isolated while those about her gobble the food unheedingly; a religious procession straggles through the corner of a village given over to roystering; in the distance Christ picks his way towards Calvary through a crowd which is involved in its own pleasures; Icarus falls into the sea but the ploughman doesn't look up – as a warning that life in its brutal, accidental, indifferent way is resistant to the sentimental morals and picturesque serenity we wish upon it. The village wedding George Eliot describes is more like that painted by Sir Luke Fildes than that of Brueghel.

The picturesque is for Jerrold a way of cheering oneself up by cultivating pleasant associations: from Leigh Hunt sitting in St Giles's and admiring the pigeons he learns to avoid despair by fixing the mind on thoughts less grim. Hunt's notions of happy association derive from country rambling and the indulgence of a romantic pathetic fallacy; here they are oddly applied to the miseries of the urban poor, and invoked as a relief. The ugliness and disarray compose themselves into a scene; art glazes and frames life, and makes it an object for self-possessed contemplation. At Covent Garden, 'these Irish women, these fresh-coloured Saxon girls, these brawny Scotch lasses, in their untidy clothes and tilted bonnets, who shell the peas, and carry the purchaser's loads, and are ready for any of the hundred-and-one jobs of a great market; fall into groups wonderfully tempting to the artist's pencil.' Jerrold suggests the pea-shellers to Doré as a subject, but he refuses because

it would be nothing without colour. Claude Lantier, the realist artist of Zola's *L'Œuvre*, who turns from the medieval dreams of the romantics to make art from carrots and turnips, also finds a *tableau tout fait* in a group of workers gulping down their midday soup beneath the iron and glass roof of Les Halles. But Zola's naturalism is very different from the cosy realism of the Victorians; and the picture to set beside Jerrold's description might be Phoebus Levin's 'Covent Garden', 1864, in the London Museum. This suggests Dickens's description of the market in *The Uncommercial Traveller* as 'as good as a party'; it is a celebration of plenty and prosperous contentment, vegetables in lavish piles, porters carrying loads as if they were platters at a banquet, appreciative gentlemen (connoisseurs of the picturesque like Jerrold, perhaps) sampling the fruit, over all of which plays a golden light which embalms the figures and makes even the dirt shine in tranquillity. This light suggests the doting affection of the Victorian for simple, noble things – the spinning-wheel and stone jug of George Eliot's mob-capped old woman, 'those cheap common things which are the precious necessaries of life to her' – which is so unlike the non-committal, unpossessive realism of the Dutch painters. Levin's painting, like those of Frith, and like the Victorian parlour, expresses a certain *horror vacui*: not a corner is left empty, not a person left without something to do, because there can be no suggestion of want, scarcity or idleness. The loose ends and accidents of experience, to which the Dutch painters defer, are conscientiously excluded.

'We are not prone to the picturesque side of anything,' Jerrold complains. Along the river in the east all is jumble and confusion, but west of the Temple with a graceful pliancy several elements 'combine into a picture, with barges and boats for foreground' – nature acquiescently makes itself picturesque, doing the artist's work of selection and composition for him; it responds to his 'seeing-beauty spirit' as Mrs Gaskell called it. Again, people on their way to the boat race present 'extraordinary groups, and combinations to the artist', or in Carter's Lane there are 'tumultuous episodes of energetic, money-making life, in the most delightful framework' – life obligingly frames itself. For the Victorians, art tranquillises and soothes; ugliness is not truth but merely the irritating perversity of the artist – Henry James decried a painting

of Jan Steen's by saying, 'Never was a certain redeeming grace more brutally dispensed with. This is more than an ugly picture; it is an offensive act. It makes one think more meanly of the human imagination.' The redeeming grace of art is to ignore what is disturbing and to seek out what is noble and touching; it does not tell the unpleasant truth about life, but rather writes it a flattering testimonial. Sir Hubert Herkomer praised his fellow-painter Frank Walker for this gently deceitful way of tincturing reality with sentiment: 'In Walker we have the creator of the English Renaissance, for it was he who saw the possibility of combining the grace of the antique with the realism of everyday life in England. His navvies are Greek gods, and yet not a bit less true to nature. True poet that he was, he felt all nature should be represented by a poem. The dirty nails of a peasant, such as I have seen painted by a modern realist, were invisible to him. Nor did he leave out the faces of the peasants in order to produce grandeur, as the French Millet did. He started with some definite poetic notion, and nature came to his aid as the handmaid of the poet, without assuming the shape of instantaneous photography.'

Victorian novelists invite the pictorial analogy. The first works of Dickens were called sketches, those of George Eliot scenes; each adopts a pictorial mode, the one peculiar to the city, the other to the country. The *Sketches by Boz* were acclaimed for their presentation of 'the romance, as it were, of real life' (*Spectator*) or their 'bringing out the meaning and interest of objects which would altogether escape the observation of ordinary minds' (*Examiner*). If Dickens was praised for transforming and even disfiguring the humdrum, George Eliot was praised for honest fidelity to it: the reviewers said that the excellence of *Scenes of Clerical Life* lay in their 'adherence to probability', their 'quiet truth', the 'steadfast faith in the power of truth and disregard of conventions' and of 'circulating-library principles'. The sketches are about fragmentariness in the town, the scenes about relationship – the painful inexorable working out of human responsibility – in the country. A sketch is a swift and unfinished thing (though in the romantic view a work could be complete without being finished; a fragment was more vital than a finished design), exhausting itself in its immediacy, an outburst of energy which snatches at its object rather than lovingly encompassing it; a scene, on the other

hand, deeply studies and ingests its object, modelling it fully. The one follows the frenetic rhythm of the city, the other the tranquil rhythm of the country and its fatalism, to which Ruskin paid tribute: 'the divine laws of seed-time which cannot be recalled, harvest which cannot be hastened, and winter in which no man can work.'

The sketches are notations, bewildering and exciting in their disconnectedness and brevity; the scenes, however, work out systematically all the implications of their situations. Each of George Eliot's tales moves back a full generation to depict the determining circumstances; with its epilogue, 'Amos Barton' actually narrates events over a full generation. The filaments of gossip, a controversy over a new curate, which unify George Eliot's Shepperton have a parallel in the sketches, but Dickens's parish is a smaller version of his city, lacking the communal sense of George Eliot's: its self-engrossed inhabitants are not related to one another, as Janet comes to be to Tryan, or as the irregularity of Amos's behaviour is taken up and discussed by the women. The typical Dickensian citizen is the good old lady who only ever visits within the distance of the next door but one on either side; and her kindness appears less in the good works she is said to perform in the parish than in the nervously neat and proper organisation of her solitary household. George Eliot's scenes are written in dialogue, as people communicate, but Dickens, watching people react to each other with dreamy arbitrariness and illogic, sees the whole farce as silent, with people colliding rather than relating, never explaining themselves, madly at cross purposes: after the silkworms incident 'the old lady went to the sea-side in despair, and during her absence he [the half-pay captain] completely effaced the name from her brass door-plate, in his attempts to polish it with aquafortis.' The erasure of a person's name from his door-plate exactly sums up Dickens's view of the city. People in a city are superfluous – ' 'Tis strange with how little notice, good, bad, or indifferent, a man may live and die in London' – and self-enclosed – 'if they happen to overtake a personal acquaintance, they just exchange a hurried salutation, and keep walking on either by his side, or in front of him, as his rate of walking may chance to be. As to stopping to shake hands, or to take the friend's arm, they seem to think that as it is not included in their salary, they have no right to do it.'

Cities are for sketches because anything more than a momentary glimpse is impossible. Impressionism, with its flashes and sudden collisions, is an urban art, changeable, nervous, ephemeral. Jerrold says that the views in a city are 'brilliantly accidental', or 'brilliant accidents of form and colour'; or there are 'momentarily varying combinations and activities of the shore'. In Thames Street 'the picture changes at every hundred yards. At every corner there is a striking note for the sketch-book.' The *Sketches by Boz* are impressionistic. George Eliot uses the scenic method because in her settled parish the human sanctities, though violated, always reassert themselves; things move with the regularity of nature; she has confidence in the community and can therefore paint it. A country scene is a still life, a city scene always moving.

Jerrold and Doré are in fact true to the choppy, sketchy rhythm of the city, but more often wish to resolve the urban hurly-burly into something like the idyllic calm of the pastoral scene. There are many odd momentary glimpses in their trip along the river: the Tower appears through tangles and tiers of ships, the Pool through chinks of yard doors and wharf poles, the dome of St Paul's down a little shabby alley. But usually Jerrold organises the sketches into what he calls 'comprehensive pictures'. Billingsgate, for instance, on which Dickens partly wrote a piece for *Household Words*, with salmon twinkling like silver harlequins and savoury steams curling up from appetising dishes, is for Jerrold 'one of those picturesque tumults which delight the artist's eye'; or the Borough with its inn-yards 'makes an attractive study; showing us (for the hundredth time) that on which I insisted when first we set forth on this pilgrimage – viz., that London is full of pictures.' At a distance even the dreary becomes picturesque, and in Whitechapel even the overhanging houses contribute to the Georgic sense of plenitude and productivity: 'the infinitely various lines and contrivances of shops and stalls, and gaudy inns and public houses; the overhanging clothes, the mounds of vegetables, the piles of hardware, the confused heaps of fish. . . .' For Mayhew as well, on a tour of the treacherous rookery of St Giles's, the low and sordid Church Lane deferentially composes itself into a scene: 'From the windows of the three-storied houses in Church Lane were suspended wooden rods with clothes to dry across the narrow street, – cotton gowns, sheets, trousers, drawers, and vests, some ragged and patched, and others

old and faded, giving a more picturesque aspect to the scene, which was enhanced by the dim lights in the windows, and the groups of the lower orders of all ages assembled below, clustered around the doorways, and in front of the houses, or indulging in merriment in the street.' The picturesque insists on a certain good-humour and contentment, and Jerrold writes of 'a valiant cheeriness full of strength. The humours of the place are rough and coarse ... but there is everywhere a readiness to laugh' – this is the rough joviality wished upon the street folk in the paintings of Frith, or in Houghton's 'Holborn in 1861', which is full of bouncing, brawling, climbing children.

Jerrold refers to Billingsgate as a 'picturesque tumult', a phrase which might serve to describe the crowd paintings of Frith; again, at the boat-race he has a Frith-like appreciation of the 'astonishing and picturesque varieties' of boys; and his account of the festive spirit of the crowds at the boat race and the Derby is interestingly related to the intentions of Frith in his large paintings of modern life. The crowds of eighteenth century art are mobs: they display the monstrous variety of human deformity, the gross disparities of the human type, and the fearful rowdiness of large groups, as in Hogarth's election meeting or his scene of military indiscipline as the troops of George II set out for Finchley, or Rowlandson's Vauxhall or his water colour of an overturned coach. The eleventh plate of Hogarth's 'Industry and Idleness' presents the mob on holiday at Tyburn Fair, at its most turbulent and outrageous, and the individual anecdotes detail the ugliness and savagery of the scene: the Newgate Ordinary looking on indifferently from his coach, the man swinging a dog by the tail about to hurl it at the chaplain, the ballad-seller crying her wares while her baby waves at the condemned apprentice; everywhere there are small scenes of petty theft, drunken affray, cruelty and violence, which accumulate to make the crowd seem literally a many-headed monster: it is one in its destructive energy, which surges through the print in baroque convulsions of light and shade, yet this is directed at no single object but breaks out in little eruptions at every point. It has a hellish animation, just as Lamb said that in 'Gin Lane' even the tenement walls seem to reel – oranges tumble from boxes, sticks flail, fists shake, everyone pushes, everyone is fighting. The Hogarthian attitude to the crowd survives in Dickens's historical

novels; although in *A Tale of Two Cities* his model was Carlyle's *French Revolution*, which dethrones the traditional heroes of epic and tragedy and celebrates in their stead the energies of the mob, Dickens fears precisely what Carlyle lauds, and takes refuge in the private life, the shelter of the home and domestic happiness. *Barnaby Rudge* deals with a Hogarthian crowd, with the same horrified fascination; and while the crowds maraud and riot in the city, Dickens's characters are kept scrupulously apart, locked up (Dolly and Emma), in hiding (Hugh and the vintner) or in flight (Barnaby and his father).

The crowds of Frith and Jerrold are very different. Frith went to the Derby in 1856 with a photographer called Howlett whom he stood on the roof of a cab and ordered to photograph 'as many queer groups of people as he could', but in the finished painting there is none of Hogarth's scabrous oddity nor the violent explosions of his subordinate groups. Frith prided himself on his ability to form a crowd into a unified and orderly society – 'I cannot say I have ever found a difficulty in composing great numbers of figures into a more or less harmonious whole.' Likewise, William Mulready, in a sketch book in the Victoria and Albert Museum, writes of the secret of '*A Well Ordered Multitude*, one, divided, subdivided and further divisible upon further research' as a means of softening life, discovering in it (or perhaps wishing upon it) a contented unity and fixity. Hogarth follows Brueghel in displacing the centre of the picture, and the raised finger of the chaplain admonishing the condemned apprentice is, like Brueghel's stumbling Christ, pushed into the distance by the brutal rollicking of the crowds; Frith appears to do the same, for the grand stand is far off, there are few horses and jockeys, no-one seems interested in the race, but the effect is quite different, for he does authoritatively establish a 'principal incident'. This is the anecdote of the young acrobat who turns away from his father to gaze hungrily at the hamper being unpacked by a footman, and it imposes a sentimental shape on the painting, it involves us in unriddling the feelings of the participants. There is plenty of Hogarthian evidence of rapacity and deceit – a thief is stealing a bottle from under a carriage, and a thimblerigger is looking for a fresh victim – but because everything is narrated with loving particularity, instead of sketched in with satiric violence, the scene has a settled tranquillity. It has the

curious still, quiet, suspended quality of the Victorian narrative painting – it wishes to unfold a series of events but because paintings, unlike poems, are restricted to a single moment of time, everything hangs poised, like the figures on the Grecian urn. The tumbler turns away; a small boy drops a coin into the hat; the wife of the besmocked rustic draws him away from the trickster with the pea and thimbles; a fortune-teller importunes a young woman with a parasol who looks haughtily away. Nothing is disturbing because we do not see, in the paintings, the consequences of any of these actions; life is frozen into an idyll. For all their multifarious activity, Frith's paintings – 'Derby Day' and those of Ramsgate and Paddington – are like huge still-lifes. They are full of character and incident: when this picture was exhibited in 1858, one of the princes said, 'Oh, mamma, I never saw so many people before!' to which the Queen replied, 'Nonsense, you have often seen many more' – 'But not in a picture, mamma.' And yet the life they contain is composed into a tableau, unspontaneously posed and premeditated, life without motion and without loose ends, tamed into placidity. The realism is pondered and studied. Frith used not only photographs, but drawings from models who in many cases followed the professions of the characters in the picture; J. F. Herring senior and Landseer helped him with anatomical sketches of horses. To recur to the distinction between the art of Dickens and George Eliot, Frith worked up a number of sketches into a scene. Indeed, the painting has the painstaking, researched quality of George Eliot's realism. Just as Frith devoted to it 'fifteen months' incessant labour', so she trusted not at all to memory or impression, but did as much homework for *Adam Bede,* which derives from her own childhood, as for *Romola,* studying Methodism, finding out when the flowers bloomed in July or the beans were picked in September 1799, taking notes on the signs of weather, bread prices, Jenner's vaccination and the Derbyshire lead-mines.

In contrast with the scenic tranquillity of Frith, Dickens's account of the 1851 Derby, appended to an article by W. H. Wills in *Household Words,* has all the inchoate liveliness of the sketch: cabs and waggons become entangled, canvas-booths flutter, the sequinned boy tumbler 'lives principally upside-down', hampers fly open, everyone jumps on to these to catch a glimpse of the race,

pigeons fly off with news of the result. Jerrold is much closer to Frith, and indeed as in the painting reality is framed and the bustling enjoyment of the crowd genially made characteristic and idyllic, so for Jerrold the Derby is a pastoral. 'It gives all London an airing, an "outing"; makes a break in our over-worked lives; and effects a beneficial commingling of classes.' The Derby is an idyll because it heals and harmonises: the shoe-black and the richest and happiest are joined together, a peer casts sticks at coconuts, three throws for a penny, and 'all classes are intermingled for a few hours on the happiest terms'. This temporary softening of antagonisms suggests those evasive endings of Victorian novels in which a change of heart or a happy marriage are offered as solutions to social divisions: the union of the iron-master Rouncewell and Rosa in *Bleak House*, which peacefully unites industrialism and aristocracy, or that of Margaret and Thornton in *North and South*, which magically arranges an accord between the civilised sensibility of the south and the Teutonic energies of the industrial north.

Maclise had painted in 1838 a picture now in the National Gallery of Ireland, 'Merry Christmas in the Baron's Hall', which depicts the ruddy, jocund, harmless and orderly enjoyments of a Jacobean holiday, and the moral, very similar to that implied by Frith, is enforced in a poem, 'Christmas Revels':

> An honest mirth flows all around
> Razing distinctions to the ground. . . .
> Large were man's thoughts, for notions vast
> Possessed his soul in days long past. . . .
> If those were barbarous ages then,
> Let us be barbarous again.

As Frith's Derby scene is glazed with self-satisfied enjoyment, so Maclise puts a smiling gloss over his holiday: the merriment is deferential, swirling around the central figure of the baron, but on a lower level of the room, closer to us, leaving him intact, above it, ensconced in a recess further in at table with his guests in the form of a Last Supper. He is the unmoved mover of the merriment, its centre, presiding over it, but withdrawn to a patronising distance. Maclise's pictorial composition expresses his idea of deference, with the baron on an inner stage, a sort of high table above the plebeian enjoyments of the floor. From this niche of self-possession he stares

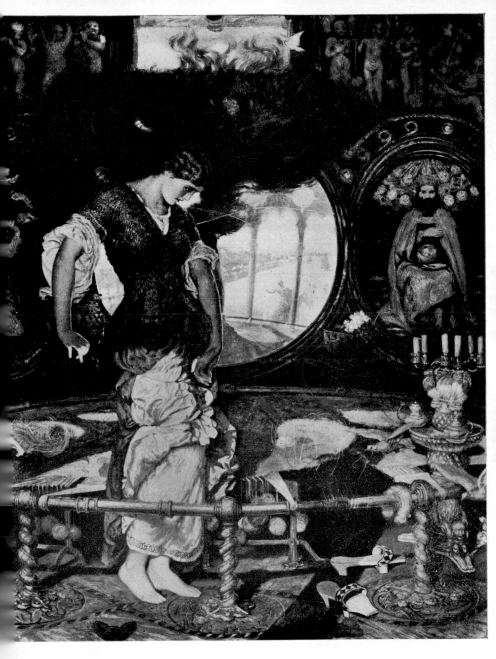

W. Holman Hunt 'The Lady of Shalott'

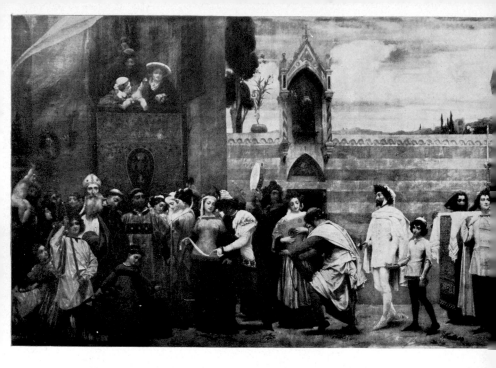

Lord Leighton 'Cimabue's celebrated Madonna is carried in Procession through the streets of Florence . . .'

W. P. Frith 'Derby Day'

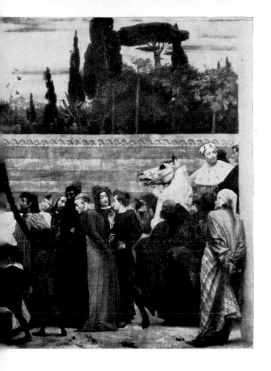

Two crowds: the carefully reconstructed procession of the historical novel, and the apparently chaotic yet orderly and picturesque throng at the Derby, which some Victorians saw as a modern substitute for a religious festival

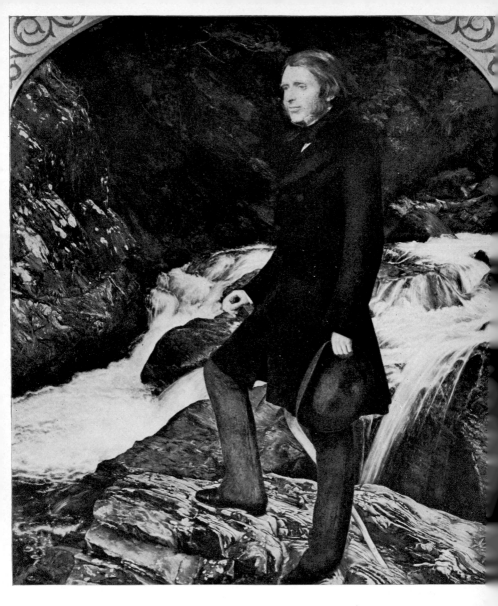

Sir John Everett Millais 'John Ruskin'—in a Ruskinian landscape

placidly out into the games of his dependants, the jester on his hobby-horse, the juggler, fiddler and mummers, the choristers and fortune-tellers; and some of his guests, hands proudly placed on hips, deign to look over their shoulders towards the floor as well. In the composition the baron appears to be framed by the rollicking groups in the foreground; but actually he frames them, places them as picturesque.

> The Baron with a courteous grace
> Then sits him down, in pride of place;
> And ready vassals near him stand,
> And watch his eye for a command.

As the Victorians transferred the picturesque from the country to the city, so Frith transfers this sort of Merrie England idyll from the past to the present.

Jerrold is anxious to protect the idyll from any taint of Hogarthian disorderliness: behaviour remains respectable, he insists, and no-one is ruined by betting. Similarly Frith leaves the causes of disturbance hovering, suspended: the thief's hand is about to close on the bottle, the two dogs are about to do battle, but nothing happens, as yet, to upset the harmony. And Dickens points out that 'There is plenty of smoking and drinking among the tilted vans and at the public-houses, and some singing, but general order and good-humour.' No-one is half-hearted at the Derby, Jerrold argues, and 'a brave, contentious spirit' pervades the crowd, as at the Oxford-Cambridge race, which he describes as an effusion of the combative spirit and keenness for the race of life. Jerrold sees the boat race as a spring festival and the Derby as the English equivalent of carnival – they are festive, saturnalian occasions on which people are released from work and the meanness of their surroundings; they serve the same purpose as the Dickensian Christmas, or the circus in *Hard Times*, providing an intermission, an interval of merriment in a bleak life which temporarily consoles and thus enables the question of a more permanent solution to be begged. 'I entertain a weak idea,' wrote Dickens with arch facetiousness, 'that the English people are as hard-worked as any people upon whom the sun shines. I acknowledge to this ridiculous idiosyncrasy, as reason why I would give them a little more play'; and he insisted in editing *Household Words* that the answer to the utilitarian spirit, 'the iron binding of the

mind to grim realities', was Fancy, as the answer to Coketown is Sleary's Circus. Here again the picturesque is consolatory; depressingly familiar things are to be suffused with romance, and thus made bearable. Art, like Christmas or the Derby, is to briefly release men from their sufferings.

Victorian literature and painting make work an artistic subject, and work, for Jerrold, is the key to London, and to its grandeur. 'There is a spectacle of moral grandeur' in the struggle of the distressed for an honest living, and their disdain of a criminal one; work in London is noble in its 'combativeness', its 'energy and earnestness' and its directness – the values which Mrs Gaskell's mill-owner Thornton calls Teutonic. He scoffs at the Grecian dream of leisured serenity and sensuous pleasure and substitutes for it a Gothic ideal of raw strength and muscularity: 'we do not look upon life as a time of enjoyment, but as a time for action and exertion. Our glory and our beauty arise out of inward strength.' This striving, strenuous spirit finds expression as well in the hammersmen of William Bell Scott's 'Iron and Coal', or the navvies who, within a frame inscribed with biblical injunctions to labour and travail, tear up Heath Street, Hampstead in Ford Madox Brown's 'Work'. For Mayhew, man is not an animal which thinks but one which works, and he classifies the human species into those who will work, those who cannot work, those who will not work and those who need not work, curiously placing prostitutes in the third group, because rather than working for their living they seduce the more industrious or thrifty to part with a portion of their gains. Jerrold enthuses about 'the marvellous story of London industry', and for him the city means activity, the unremitting labour which adds a new storey to another terrace, bulwarks to another frigate, and piles up tons of produce along the mighty shore; and the Victorian novelists also adore bustle, the busy activities of life.

Thornton sneers at the Greeks; Madox Brown claims that 'the British excavator' is as worthy of pictorial treatment 'as the fisherman of the Adriatic, the peasant of the Campagna, or the Neapolitan *lazzarone*'; Jerrold boasts that 'the ordinary daily labours of a City alderman . . . would fill the week of an Italian – and leave him exhausted on the seventh day.' Bell Scott thought Italian art cretinous, and southern peoples corrupt. Ruskin in

The Stones of Venice makes a sternly moral contrast between Grecian luxury and Gothic energy. For the romantics, the classical often means the lazy, a state of sensuous lassitude – Tischbein painted Goethe lolling among the ruins of the Campagna, Severn painted Shelley crouched in the foliage of the Baths of Caracalla; Keats comes upon Cupid and Psyche lying calm-breathing in the grass, like Leigh Hunt nymphs, and writes an ode to indolence with the epigraph, 'They toil not, neither do they spin'; Tennyson begins 'The Lotos-Eaters' with a swaggering epic gesture, but by its second line the poem has dozed off into a drugged passivity. For Ruskin, the Grecian is identified with sleep (as poetry was for Keats), the Gothic with work. He treats roofs as moral emblems: the animal vigour of the North expresses itself in erect work, the languor of the South in reclining or level work. 'Imagine the difference between the action of a man urging himself to his work in a snowstorm, and the action of one laid at his length on a sunny bank among cicadas and fallen olives . . . sleep would be to the one luxury, to the other death.' Spruce pines stand up straight, as do the steep gabled roofs of the North; the dark canopies of the stone pines of the South suggest a less taut, less aspiring and strenuous, more tranquillising outline. In *The Times* in the same year, 1851, Ruskin objected to the indolence of Millais's Mariana in the moated grange, saying that he was glad to see that she was weary of painted windows and idolatrous toilet-table, but arguing that had Mariana been painted 'at work in any unmoated grange, instead of idle in a moated one, it had been more to the purpose, whether of art or life.'

Thus the picturesque makes the form idyllic, and makes work heroic. Yet the painters, attempting to harmonise and reconcile, to form life into a comforting picture, encounter one problem which has relevance to the novel as well – the intractable ugliness of modern dress. 'In their poverty there is nothing picturesque,' Jerrold comments ruefully of the river-side porters: the shop-girls and barmaids 'compose no picture for the colourist', because the lower orders do not dress picturesquely (that is characteristically, in keeping with their roles or occupations), so that 'an English crowd is almost the ugliest in the world: because the poorer classes are but copyists in costume, of the rich', and in their 'base and shabby copyings of the rich, the poverty of the wearers has a

startling, abject air'. The exceptions are the followers of street trades, the characters of Mayhew, costermongers, orangewomen; some of the boys at the boat race are adorned in a 'rich picturesqueness of rags'; and the agricultural workers, like George Eliot's rustics at the Rainbow Inn, are still picturesque. Ford Madox Brown found the navvy's costume 'manly and picturesque', but Jerrold's dismay and distaste are the more usual attitude. Millais told Dr Urquhart that 'artists have to wrestle today with the horrible antagonism of modern dress; no wonder, therefore, that few recent portraits look really dignified. Just imagine Vandyck's "Charles I" in a pair of check trousers!' For Millais not only the cast-offs, the sadness and meanness of Petticoat Lane clothes which distressed Jerrold and Doré, but also the dress of the black-coated fraternity, were troublingly unpicturesque, uncharacteresque. Carlyle called Irving 'a man of antique heroic nature, in questionable modern garniture, which he could not wear!' 'Among our dresses,' Dickens wrote of the audience at the Britannia Theatre in Hoxton, 'there were most kinds of shabby and greasy wear, and much fustian and corduroy that was neither sound nor fragrant.' Mayhew notes in discussing the old clothes exchanges that 'the rags which the beggar could no longer hang about him to cover his nakedness, may be a component of the soldier's or sailor's uniform, the carpet of a palace, or the library table-cover of a prime-minister'; shoddy becomes a sort of organic matter, with the indestructibility of a low form of life, until it is re-absorbed into nature: 'There is yet another use for old woollen clothes. What is not good for shoddy is good for manure', and for corn and hops, 'so that we again have the remains of the old garment in our beer or our bread.' Doré has a Dickensian illustration of the home of a dealer in shoddy, his greasy treasure shining eerily with the same sickly light as his hair and beard, his children romping it, and the whole place enveloped in silvery cobwebs.

In *The Stones of Venice* Ruskin regrets the modern contempt for splendour of dress, which he sees as emblematic of beauty and honourableness and dignity of character; one reason for the consolatory power of romance is that it provides a defence for this magnificence which is disregarded in daily life and in the novel: 'half the influence of the best romances, of Ivanhoe, or Marmion, or the Crusaders, or the Lady of the Lake, is completely dependent

upon the accessories of armour and costume . . . deprive the *Iliad* itself of its costume, and consider how much of its power would be lost.' Like architecture, from the fifteenth century dress 'was rapidly degraded, and sank through the buff coat, and lace collar, and jack boot, to the bag-wig, tailed coat, and high-heeled shoe; and so to what it is now.' Hence the poetic costumes of Tennyson – white samite, mystic, wonderful, the lilac silks of *The Princess* zoned with gold which make the young men look 'rich as moths from dusk cocoons'. The arms of the heroes are lovingly described in epic because they wish to become as steely, firm and sturdy as their helmets and swords; Tennyson devotes such wistful attention to the accessories because these are more significant, more consoling, than the characters. The case is similar with Burne-Jones: his women become their draperies, so carefully studied from the Parthenon frieze, like those of Leighton or Alma-Tadema, and from Botticelli; their loose gently rippling smocks turn their bodies into a fragile willowy line, they become clothed with sadness and dreamy poetry, like Tennyson's

> Six hundred maidens clad in purest white,
> Before two streams of light from wall to wall.

The blandishments of colour and costume transform poems into bowers kept quiet, like the vestal temple of the hearth, for the harried Victorian, and paintings into magic casements opening into fairylands remote and forlorn. Rossetti in his Arthurian water-colours of 1856–8 employs heraldic colours, red, gold, blue and deep green, which have an equivalent in the garments and weapons of William Morris's *The Hollow Land*, 1856, which are removed, like the cutlery and plate of 1851, from the vulgarity of practical use to become art objects: 'they had on over their hauberks surcoats which were half scarlet and half purple, strewn about with golden stars. Also long lances, that had forked knights'-pennons, half purple and half scarlet, strewn with golden stars.' James Smetham, writing in 1860 on Rossetti's 'Wedding of St George and the Princess Sabra', describes the picture as an architectural fantasy, like the romantic dream-cities mentioned earlier in the chapter, which can be imaginatively explored – it is not only a bower and a casement, but also a Gothic maze of hidden entrances and sudden turnings, leading into a mysterious depth, as Lockwood edges from one room to another until he penetrates the furthest, and most

disturbing, recess of Wuthering Heights. He calls it 'a golden dim dream. Love "credulous all gold", gold armour, a sense of secret enclosure in "palace chambers far apart"; but quaint chambers in quaint places where angels creep in through sliding panel doors, and stand behind rows of flowers, drumming on golden bells, with wings crimson and green.' Smetham's exploration of the painting suggests Keats's description of the long poem as a 'place to wander in'. As one could go for walks in the landscapes of Claude and Hobbema, so one can travel in poems – 'Much have I travelled in the realms of gold,' Keats says of his reading; and in another poem on Homer he is

> one who sits ashore and longs perchance
> To visit dolphin-coral in deep seas.

He writes of *The Floure and the Leafe,* 'this pleasant tale is like a little copse'; *The Story of Rimini* provides a bower for the spirit of lover of poetry, as the thing of beauty does in *Endymion.* In a poem to Cowden Clarke verse is a stream on which the poet drifts, like the Lady of Shalott,

> scarce knowing my intent,
> Still scooping up the water with my fingers.

The Pre-Raphaelites doted on the costly substance of romance; yet spirit was involved as well, and religion, like romance, provided a refuge for the colour and beauty which had been expelled from ordinary life. Pugin sounds like Morris in his breathless, worshipful transformation of the equipment of ritual into objects of veneration: he speaks of cope chests 'filled with orphreyed baudekins; and pix, and pax, and chrismatory are there: and thurible and cross.' Ruskin in *The Stones of Venice* fulminated against those 'lured into the Romanist church by the glitter of it, like larks into a trap by broken glass; . . . stitched into a new creed by the gold threads on priests' petticoats', yet the attraction of ornament, vestment and colour was strong. In church objects, as in the exhibits of 1851 or in St Pancras Station, function is smothered in ornament; the studded, jewelled, massive richness of the thing, its loaded weight of decoration, crushes any thought of use – hence the electroplated and enamelled crucifixes, silver-gilt chalices, monstrances set with carbuncles, corded silk alter frontals, cloth-of-gold copes.

Time softens the hard edges of things and makes them picturesque – hence Victorian novels are set at a protective distance,

usually of thirty years or so, from the troublesome present. Costumes too soften, protect and conceal. Lamb points out that Hogarth's 'Gin Lane' appeared repulsive to many who could look with perfect equanimity at Poussin's 'Plague at Athens', because Athenian garments muffle and ameliorate the disease and death which are terrifying in St Giles's, and make them remote and pleasurable. Carlyle, writing on contrasts of costume in Scott, argues that this charm is temporary: 'Consider, brethren, shall not we too one day be antique, and grow to have as quaint a costume as the rest? . . . In antiquarian museums, only two centuries hence, the steeple-hat will hang on the next peg to Franks and Company's patent, antiquarians deciding which is uglier.' Yet for the Victorians time and costume do work together, soothing and reconciling.

Frith claims that in 1852, when he began his series of pictures from modern life, he abandoned the collection of mouldy costumes which was a requisite of the history painter; and yet the comments above on the still-life fixity and tranquillity of 'Derby Day' show him imposing on a contemporary subject the history painting's calm sense of a completed event, its comfortable retrospection. The researched fullness and conscientious detail of the painting suggest archaeology, the sort of exactness about classical interiors and decorations and customs which Alma-Tadema prided himself upon. Interestingly, costume did give Frith much difficulty: after exhibiting some Shakespearean scenes, he wished to illustrate scenes of modern life, 'but at that time the ugliness of modern dress frightened me', and the only Dickensian character he could bring himself to paint was Dolly Varden in *Barnaby Rudge*, whose cherry mantle and pink ribbons made her picturesque. In 1859, he chose a highway robbery from Macaulay's history because 'the dresses of the period were very picturesque'; in 1861, he was warned off the subject of Paddington because both Brunel's platform and the clothes of the travellers were held by his friends to be unpicturesque and therefore 'in no sense pictorial'. Yet for all his claims that he was possessed by a devotion to truth, Frith does turn modern life into a species of history painting: he began with sketches from the life, but composed the canvas with the aid of models, even hiring costumes – when the acrobats he had employed from Drury Lane to pose for 'Derby Day' proved unruly and inattentive (they were

too like real life, not enough like acrobats in a painting; they couldn't keep still), he borrowed their costumes and found professional models to wear them. Similarly, in 1851 when working on 'The Woodman's Daughter', Millais had his friend Combe get for him, from a little girl called Esther who lived in Lord Abingdon's park near Botley, a pair of old walking-boots, no matter how old, and added the following instruction: 'If you should see a country-child with a bright lilac pinafore on, lay strong hands on the same, and send it with the boots. It must be long, that is, covering the whole underdress from the neck. I do not wish it new, but clean, with some little pattern – pink spots, or anything of that kind.' What Millais wants are the boots and the pinafore, not the little girl inside them: the accessories are prettily rustic and picturesque, like the shaggy-maned cart-horse mentioned by de Quincey in his essay on Westmorland, whereas the children themselves would have been too disturbingly real, too dirty, too poor, too thin. A studiously literal surface of costume covers an idealised, sentimentalised idea.

In 1881 Fildes went to Wallingford to paint a village wedding in modern costume, but found it 'so ugly and *nasty*' that he could not carry it through, for the wedding clothes were 'Reading and Wallingford slop goods degrading in every aspect.' He was dismayed to find the rustics not acquiescing in appearing picturesque: they 'dress pictorially worse,' he wrote to his friend Woods, 'than the denizens of Scotland Road and Vauxhall Road in Liverpool.' Woods suggested that time would heal this, as it did for the Victorian novelists, and Fildes backdated the period, painting 'the quiet little village life with the coarseness and ugliness of immediately modern times pressed out of it, and yet not put back far enough for people to say I am not painting my own time. I am painting what I remember as a youngster among the people I used to know.' This exactly suggests the thirty years since of the novelists, who retreated to this distance because it allowed them to suffuse their subjects with recollections of their childhood, looking both backwards and inwards, as George Eliot does in her rural novels. Charlotte Brontë insists on moving *Shirley* back to the beginning of the century: 'present years are dusty, sunburnt, hot, arid; we will evade the noon, forget it in siesta, pass the mid-day in slumber, and dream of dawn.'

There is a curious, nervous duplicity to the Victorians: they boast of their realism, and their art has a painstaking accuracy; yet they reserve the right to back away into romance and its consolations if the real becomes too disturbing. They are exhaustively literal: we can read the newspaper page in the corner of Scott's 'Iron and Coal', and for 'The Order of Release' in 1853 Millais obtained a genuine order signed by Sir Hildegrave Turner, whose son was surprised to recognise his father's signature when the picture was exhibited. And yet fact is injected with sentiment, with moral prompting, as if devotion to realism in small matters licensed evasion in larger ones. Their realism is loving – but it is a possessive, suffocating love which holds its object in thrall. The paintings of Holman Hunt display this strange combination of fact and sentiment. He establishes a literal surface with extraordinary patience and perseverance: he travelled to the Dead Sea for 'The Scapegoat' and brought back salt and mud from Oosdoom to stand the goat on in a tray in his studio; for 'The Light of the World' in 1851 he worked outdoors at night at Worcester Park Farm, painting contorted apple tree trunks; all the figures in 'May Morning on Magdalen Tower' are identified as Oxford contemporaries, and he even introduces the William III bowl which is the college's oldest piece of plate. Yet fact is impregnated with sentiment, thanks to his use of colour. Colour and light in romantic painting release objects from the material world, as in Turner, into an airy realm of spirit; in Holman Hunt colour and light introduce a morbid spirituality which absorbs the laboriously literal matter of the paintings into a private world of religious fantasy. Hence the lurid searing colour and light which make 'The Scapegoat' so painful, the demonic phosphorescent glow of the moonlight and the lantern in 'The Light of the World', and the regenerative blushes of pink and blue in the May dawn sky. A less morbid, more joyful counterpart to this colour of Holman Hunt's is the polychrome exuberance of Butterfield's All Saints', Margaret St, pulpit: an awkwardly bulky shape, like the figures which Dickens found so repulsive in Millais's 'Christ in the House of His Parents', restlessly patterned, happily mingling different rocks and marbles, pink, green, grey, red and blue. Butterfield employed colour in architecture as a romance consolation, a respite from the grey and black grimness of the industrial town.

The sentimental transformation of fact has an interesting parallel in the Victorian delight in number and quantity. For number can become the basis of an idyll. Sheer quantity, fullness, the *horror vacui* of the Victorian parlour, contribute to the calm, self-satisfied spirit of the crowd pictures of Frith; they delightedly contemplate and frame the plenitude and prosperity of things. There is a tradition of this, which begins perhaps with Robinson Crusoe, who affirms his identity and marks his progress by periodic inventories, who organises his spiritual life on the analogy of a commercial ledger with miseries as debits and consolations as credits, and whose realism amounts to smug taking of inventory – everything is counted, named, taken over; he keeps his accounts in order. Trollope, similarly, looks back contentedly at the end of his autobiography on the quantity of work done, and, to set right his account with God and the world, lists his books and calculates the grand total of his earnings from them: £68,939 17s 5d.

Thus for Jerrold and Mayhew it is number, quantity, multitude which organise the anarchic, swarming energies of London into a comfortable serenity. Jerrold writes of 'the shipping-littered Thames', the docks with 'every known bunting', 'four thousand feet of river frontage of St Katherine's Docks', 'the thousand and one details of spars and ropes', 'the immensity of commerce that counts warehouses by the mile and goods by the hundred thousand tons'; he mentions twenty-five thousand hogsheads of tobacco, sixty to seventy thousand pipes of wine. 'The London docks alone receive something like 2,000 ships a year. They include one wine-cellar seven acres in extent!' Mayhew makes statistics picturesque, a tribute, like the bulging lists of Dickens, to the inexhaustible plenty of life. His survey combines science – he is anthropologist, sociologist and taxonomist – with sermon and realistic description; he sees London as, in contrast with the blackened north, a myriad, teeming, fantastic, contradictory emporium of variety, and he revels in its picturesque oddities. Yet in this rich squalid under-growth he discovers an order, a sort of Linnaean classification of its burgeoning forms of life – for instance his minute differentiations of the activities of the street folk – which enables him to find a path through the jungle. As with Frith's crowds, what appears to be an ebullient mass, a loose baggy monster, is carefully plotted, with everyone related to everyone else, so in what seems to be an

anarchic tumult Mayhew discovers a minutely complex social system, with pecking orders, divisions of responsibility and jealously guarded specialisms (for instance the different kinds of thieves, area and lobby sneaks and attic or garret thieves, etc.). Quantification, enumeration, rigging up statistical tables, are for Mayhew a way of organising his crowds and of celebrating their boundless productivity, as Frith interests himself in the infinite varieties of grouping and interrelationship, the resilience and irrepressible inventiveness of people. Thus Mayhew calculates that £203,115 is spent each year on street eatables and drinkables, and points out that the street-sellers, though a proscribed class, have a turn-over of millions a year. Number represents a sort of fertility: after a breathless catalogue of the contents of a 'swag' barrow, he concludes 'On one barrow were 225 articles'; or boasts that 'the extent of individual travel performed by some of the omnibus drivers is enormous. One man told me that he had driven his "bus" seventy-two miles (twelve stages of six miles) every day for six years, with the exception of twelve miles less every second Sunday, so that this man had driven in six years 179,568 miles.' Or about the long-song-sellers: 'The songs, I am informed, were often about 2½ yards, (not as to paper but as to measurement of type); 3 yards, occasionally, at first, and not often less than 2 yards.' There even seems to be cause for thankful satisfaction in the calculation that every year fifteen million cubic feet of house-refuse is annually deposited in the cess-pools of the metropolis. In the midst of such foison and abundance, it comes to seem odd that so many should be desperately needy: 'The gross amount of trade done by the London street-sellers in the course of the year is so large that the mind is at first unable to comprehend how, without reckless extravagance, want can be in any way associated with the class.'

The fascination of the romantics with natural objects and their vital forces is transferred by the Victorians to man-made things, tokens of human energy and ingenuity. Mayhew takes as much pleasure as Dickens in miscellanies, listing the litter of objects for sale in swag-shops or the chemical articles – blacking, corn salves, grease-removers, plating-balls, rat and beetle poisons, detonating-balls, cigar-lights, and so on – or the proliferation of China ornaments sold in the streets. Iron Jack's stall, pitched near one of the East India Company's huge warehouses in Petticoat Lane, is a

good example of this frenzied preoccupation with things, no matter how ignominious and valueless: 'Here towered the store-house of costly teas, and silks, and spices, and indigo; while at its foot was carried on the most minute, and apparently worthless of all street-trades, rusty screws and nails, such as only a few would care to pick up in the street, being objects of earnest bargaining!' The boastful protuberance of Victorian ornament expresses a similar pride in things, which are splendidly gratuitous, scoffing at utilitarian values – for instance, the bristling terrors of the sportsman's knife produced by J. Rodgers and Sons in 1851, which has raying out from an ornamented base no less than eighty differently decorated blades and instruments; or the fearful encrustations of the fender described by Pugin: 'a sort of embattled parapet, with a lodge-gate at each end; at the end of the poker is a sharp-pointed finial, at the summit of the tongs is a saint.' Things invade Victorian paintings and protrude in a similar way: all the objects scattered throughout Martineau's 'The Last Day in the Old Home' are proleptic, from the racing prints and notebooks which indicate the reason for the family's impoverishment to the possessions tagged with lot tickets and the bundle of keys tearfully surrendered by the old woman. Things do more of the work of narrating than do the people; the viewer becomes a detective assembling these clues so as to determine the cause of the distress and the identity of the culprit.

Mayhew's approach to his subject is scientific, and yet it has much in common with the romantic and fantastic style of Jerrold and Doré. He deals with the manners of the street folk anthro-pologically, as Merimée does with the violence of the Andalusian milieu of *Carmen*: the costermongers, for instance, are a nomadic tribe, indifferent to the sanctities of home, who 'strongly resemble the North American Indians in their conduct to their wives'; or in the fourth volume the study of prostitution in London is prefaced by an exhaustive account of the same problem in other states, which with Victorian confidence are divided into ancient, barbarous, semi-civilised and civilised. Oddly, though, the science evokes a sort of romantic exoticism: the street folk become a primitive and predatory race swarming in thickets and rookeries beneath the settled and comfortable level of ordinary society. Like an explorer, Mayhew analyses the different exotic sub-species in his underworld, and he is particularly interesting in marking the subtle boundaries

between one species and another – for instance, between the closely similar rag-and-bottle and marine-store shops: 'the marine-store shopkeepers (proper) do not meddle with what is a principal object of traffic with the rag-and-bottle man, the purchase of dripping, as well as of every kind of refuse in the way of fat or grease. . . . The rag-and-bottle tradesman will readily purchase any of these things [miscellaneous articles, from books to bird-cages] to be disposed of as old metal or waste-paper, but his brother tradesman buys them to be re-sold and re-used for the purposes for which they were originally manufactured.' Each species goes about its self-involved and idiosyncratic pursuits regardless of the others about it, scurrying along its own track; and the suggestion of animal life recalls Dickens, whose characters cower with mouse-like timidity in their domestic holes or haunt the city like secret nocturnal beasts. In a comparably Dickensian way Jerrold and Doré make the familiar strange: Jerrold insists that the pilgrimage is a journey into the exotic and unknown, and the natives of Whitechapel regard the intruders as the Japanese did the first Europeans in Jeddo; 'We were as strange to them as Chinamen,' he says at one point, and later compares himself and his companion with prospectors in Alsatia. In Spitalfields or Houndsditch, he argues, the West End Londoner is as completely in a strange land as any traveller from the Continent; and he delights in revealing hidden worlds just beyond the known – the Town of Malt, or the thieves' kitchens lying behind the fashionable streets.

Jerrold's chapter on humble industries deals with the social stratum investigated by Mayhew, and from which Dickens draws many of his grotesques, who are individualised by occupation as much as by personal oddity. The work Dickens's characters do does not involve them with others, sending out filaments of relationship into the community, as do Silas Marner's weaving or Adam Bede's carpentry. Whereas George Eliot, like Wordsworth with the sheepfold in 'Michael', gives her rural characters age-old, biblical occupations as a means of universalising them, for Dickens the work they do marks their queer uniqueness, their isolation from their fellows – the grisly wares of Mr Venus, the doll's dresses Jenny Wren makes, Fagin's handkerchief-stealing, Pecksniff's transformation of architecture into a nonce game: 'There are a cart-load of loose bricks, and a score or two of old flower-pots, in

the back yard. If you could pile them up, my dear Martin, into any form which would remind me on my return, say of St Peter's at Rome, or the Mosque of St Sophia at Constantinople, it would be at once improving to you and agreeable to my feelings.' Victorian work exalts drudgery to the holy and ideal; God becomes the Six-Day Worker and Romney in *Aurora Leigh* says

<blockquote>

I count that Heaven itself is only work

To a surer issue.

</blockquote>

But Dickensian work is the crazed, delighted pursuit of a personal fantasy; and in Mayhew there are occasional glimpses of something like this – for instance, the doll's-eye maker, who makes the grim Malthusian comment that 'the annual increase of dolls goes on at an alarming rate' and presents to Mayhew two boxes of his wares: 'The whole of the 380 optics all seemed to be staring directly at the spectator, and occasioned a feeling somewhat similar to the bewilderment one experiences on suddenly becoming an object of general notice.' His occupation endows him with a Dickensian whimsicality: 'a great many eyes go abroad,' he says, and he has a lady customer who has been married three years and whose husband 'doesn't know that she has a false eye to this day'.

For Mayhew, multifariousness is the mark of the city: the incongruities jostled together in his description of the markets; the astonishing variety of the modes of conveyance, all enumerated, of the costermongers and other street-sellers; or the dog-finder's autobiography 'which shows the variety that often characterises the career of the "lucker", or street-adventurer.' Variety means incongruity: 'we appear to delight in violent contrasts,' says Jerrold, with Devil's Acre next to Westminster, or the low alleys behind Regent and Oxford Streets. From Lloyd's 'we travel East, and at once come upon speculators of another world, merchants for whom nothing is too small, too mean, or repulsive. The violent contrasts of London life struck Addison – as they still strike every close observer. But in his day the contrasts were not so crowded together as they are now.' This is the city of Dickens, in which contrasted lives are thrust into startling proximity and yet remain sealed off from contact with one another.

The heterogeneity of London is an important imaginative stimulus for Dickens. The justification for violation of genre and classical constraints which the romantics found in nature Dickens

found in the city. The romantics rescued Shakespeare from neo-classic charges of barbarous irregularity and shapelessness by arguing that nature too was wayward, that Shakespeare's multitude of materials was more vital, more lively, more like natural force, than the graceful man-made symmetries of classicism. Shakespeare is a romantic, Coleridge claims in a lecture of 1810, because he exemplifies the Romance spirit which, if compared with Latin, is 'less perfect in simplicity and relation, . . . but yet more rich, more expressive and various, as one formed out of a chaos by more obscure affinities of atoms apparently heterogeneous.' This suggests at once the Dickensian city, with its unruly liveliness, its chaos of atoms mysteriously linked, for Dickens as much as Shakespeare repudiates the classical filtering of life through genre. Johnson in the Preface of 1765 refers to the tragi-comic inclusiveness of Shakespearean drama 'in which, at the same time, the reveller is hasting to his wine, and the mourner burying his friend' – and in the streets of Dickens's city, mourner and reveller do actually bump into one another. A novel like *Martin Chuzzlewit*, in fact, is jerked onwards by chance encounters in London streets: 'I wish I may die,' says Tigg when he sees Martin at the pawnbroker's, 'but this is one of the most tremendous meetings in Ancient or Modern History'; Martin writes to Tom Pinch, 'you will be surprised to hear that I am to be accompanied by Mark Tapley, upon whom I have stumbled strangely in London'; 'Why, my goodness, Mr Pinch!' cries Charity near the Monument. 'What are you doing here?'

Dickens invites comparison with Shakespeare's mourner and reveller in chapter 17 of *Oliver Twist*: he justifies his abrupt alternations of tragedy and comedy by pointing out that 'the transitions in real life from well-spread boards to death-beds, and from mourning weeds to holiday garments, are not a whit less startling.' Abrupt change is a city rhythm, the rhythm of the sketch as apart from the scene, but Dickens refers as well to the streaky bacon[1] of 'good murderous melodrama'. Melodrama is somehow associated with the city: for Wordsworth in Book VII of *The Prelude* its strident unreality seems to be an image of the anonymity and shifting pantomimic excitements of the city; Jerrold is rather

[1] This phrase was adapted in Oxford to ridicule another Gothic phenomenon, the zebra stripes of Butterfield's Balliol chapel.

horrified by the music halls and depressed by the poverty and bawdiness of their audiences, and Ruskin, making a count of the gratuitous deaths in *Bleak House,* argues that the virulent, ardent exaggerations of melodrama evince the poisoned moral condition of the city-dweller – the monotony of urban life can only be relieved by ever more horrifying injections of this artificial excitement. Wordsworth in the 1800 preface to *Lyrical Ballads* had noted 'the encreasing accumulation of men in cities, where the uniformity of their occupations produces a craving for extraordinary incident', a 'degrading thirst after outrageous stimulation'.

The novel is, like Shakespearean drama, romantic in its swelling beyond the confines of genre, its commingling of tragedy and comedy; and Dickens finds a warrant for this in the chaos of city life and in those popular entertainments which, as the Punch-man tells Mayhew, mix comedy, tragedy and sentiment. For Punch, he argues, is not purely a tragedy: it is a drama with comic and sentimental parts too, and he resents any attempt to make it too uniform – 'Some families where I performs will have it most sentimental – in the original style; them families is generally sentimental themselves. Others is all for the comic, and then I has to kick up all the games I can. To the sentimental folk I am obliged to perform werry steady and werry slow, and leave out all the comic words and business. They won't have no ghost, no coffin, and no devil; and that's what I call spiling the performance entirely. It's the march of hintellect wot's a doing all this – it is, sir.' The case for the calm lucidity, the elevated grace of classicism is given, damagingly and amusingly, to Mrs Jarley, the proprietress of the waxworks in *The Old Curiosity Shop*, who disdains Mr Punch and resents any suggestion that her art might be funny: 'It isn't funny at all. It's calm and – what's that word again – critical? – no – classical, that's it – it's calm and classical. No low beatings and knockings about, no jokings and squeakings like your precious Punches, but always the same, with a constantly unchanging air of coldness and gentility; and so like life, that if wax-work only spoke and walked about, you'd hardly know the difference. I won't go so far as to say, that is, I've seen wax-work quite like life, but I've certainly seen some life that was exactly like wax-work.' Dickens described the Rue Richelieu theatre, in which the French neo-classical drama was ensconced, as 'a kind of tomb, where one went,

as the Eastern people did in stories, to think of . . . dead relations'; classicism is either a mortuary or a wax-works, and indeed there is some sense in Mrs Jarley's description, for the antique figures of Lord Leighton's paintings are like effigies. The statuesque fixity, the noble repose which Winckelmann admired in the classical has in them collapsed into a lifeless, waxen pallor. A similar connection between the classical and the cadaverous seems to be intended by Carlyle in his sneer at critics who thought Lockhart had made Scott appear too real to be heroic: 'Your true hero must have no features, but be white, stainless, an impersonal ghost-hero!'

Dickens is the least picturesque of the Victorians, and thus the truest to the rowdy, grotesque, chaotic life of London. George Eliot cultivates a uniform greyness of tone, a concentration on the middling qualities of characters with their spots of commonness, and presents this as the whole truth about them – but in its way this greyness is as picturesque as the brownness, the mellow Flemish Stradivarius colour, which Sir George Beaumont wished upon the rebellious Constable, and with which Wilkie glazed his genre scenes. Dickens's violent transitions and abrupt impulses resist this calming placidity, this picturesque uniformity; and he was for this reason the only Victorian fully able to meet in literature the challenge of the great new phenomenon of the age – the city.

4. DETAIL AND WORK

VICTORIAN ART is above all conscientious; its realism is a product of research and labour and devotion. James Collinson the Pre-Raphaelite said 'I have always tried to paint *conscientiously*'; in *The Professor* Charlotte Brontë sets the novelist the task of studying real life, and insists that he observe this duty conscientiously, learning for himself in the process the mental regularity, the rational avoidance of extremes, which she wishes to impress on her characters. Realism derives from and in its turn can inculcate good sense: 'she will determine,' Charlotte Brontë demands of one of her characters in *Shirley*, 'to look on life steadily, as it is; to begin to learn its severe truths seriously, and to study its knotty problems closely, conscientiously.' This is the moral purpose of that overstress on detail which Delacroix, in a letter of 1855, noted as characteristic of English painting: the binocular studies of nature made by the Pre-Raphaelites are matched by the close, untiring attention to human nature of the novelists. George Eliot's novels are possessed by a spirit of painstaking verification which recalls G. H. Lewes's description of the task of science as 'the systematic classification of experience': nothing is to be left to chance or imaginative whim or inventive sleight-of-hand, for to permit any loose ends or unclear details, to fail to provide the fullest information possible about character and situation, would be morally irresponsible in a universe where human fates patiently and stealthily converge, where every act creates an irrefragable pattern of consequences. George Eliot's omniscience as a narrator is imposed on her by her moral duty: if she is to assume responsibility for her characters, she must know everything about them. Impression must be verified by study – Mrs Humphrey Ward, meeting George Eliot at Mark Pattison's lodgings in Oxford, described her as 'desperately reflective'; and Henry James, reviewing *The Spanish Gypsy* in 1868, claimed it was not a genuine

poem because 'it lacks the hurrying quickness, the palpitating warmth, the bursting melody of such a creation. . . . We see the landscape, the people, the manners of Spain as through a glass smoked by the flame of meditative vigils.' His criticism is accurate but irrelevant, for George Eliot sees it as a necessity to purge all the messy chaotic liveliness of experience, to itemise and order it, to imprint the mind on everything, just as Watts said that a portrait was not a snapshot but must be considered and monumental – 'it is a summary of the life of a person, not the record of accidental position or arrangement of light and shadows.'

The recollection of emotion in tranquillity becomes emotion transformed into an object of study. Her reverence for exact detail – worrying about historical accuracy, consulting Frederic Harrison on the law of entail and the statutes of limitation for *Felix Holt* – is a tribute to the Comtean march of mind, which makes the novel rationalistic, a scientific form which makes experiments in life, and rules out any Dickensian enjoyment of the mystery of action and personality. Her concern for determining motive and apportioning blame, for establishing all the facts of the fictional case as in a court of law, leads to those appendices of *Shakespearean Tragedy* in which A. C. Bradley attempts to calculate Hamlet's age, or his whereabouts at the time of his father's death, or whether Emilia suspected Iago, or whether Lady Macbeth really fainted. Bradley's legalistic inquiries turn the plays into Victorian novels: dramatic delight in display and self-dramatising audacity is chastened into a novelistic preoccupation with the intricacy of motive; the defiant contradictoriness of Shakespeare's characters, their freedom to compromise themselves and to make themselves up as they go along, give way to a Victorian world in which everything is weighed and evaluated, in which nothing can be left in doubt because all facts have a moral relevance and a bearing on the tragic situation, as evidence of the large workings of natural law.

Mrs Barbauld referred in 1804 to Richardson's 'patient labour of minuteness', and labour and research come to be intimately involved with the novel for the Victorians – the dozens of books George Eliot read for *Romola*, her exhausting pursuit of Tuscan proverbs and details of clothing, her admission that she began the work as a young woman and emerged from her grubbing in 'vellum bound

unreadabilities' an old one; the cart loads of books waiting at Dickens's front door to be worked up into *A Tale of Two Cities*; Thackeray's claim that *Esmond*, 'my careful novel', had cost him as much trouble as Macaulay's *History*; Reade's careful insertions of hundreds of historical facts into *The Cloister and the Hearth*. The last such labour is perhaps Conrad's terrible preparations for *Nostromo*.

The painters are also conscientious researchers: Millais made studies for the harness and other trappings in 'Sir Isumbras at the Ford' from the Escurial and the Herald's College; and O'Driscoll in his memoir of Maclise says that for the 1858–9 Westminster fresco of Waterloo the painter copied the uniforms of the leading generals from coats, caps and arms which had been worn in the battle, while the War Office obligingly mocked up specimen uniforms for the lower ranks. But more than this, Victorian painters have a piety towards fact. Ruskin brilliantly misinterprets Turner in *Modern Painters* so as to make him the proponent of this exquisite care for detail. Detail in Turner is generally dissolved into an atmospheric mist, an irradiated haze like Shelley's intense inane, everything impalpable and quivering, all fire and air. Colour soaks into and dissolves form. In 1845 James Lennox bought Turner's 1832 painting of Fingal's Cave, and was dismayed at its foaming indistinctness: 'indistinctness,' Turner replied, 'is my *forte*.' But for Ruskin, Turner becomes a Victorian, as Shakespeare does for Bradley. He is said to specialise in minute preciseness: he alone can give the effect of depth and transparency to water, or can represent distance. 'Abundant beyond the power of the eye to embrace or follow,' Ruskin says of Turner's 'Mercury and Argus', 'vast and various beyond the power of the mind to comprehend, there is yet not one atom in its whole extent and mass which does not suggest more than it represents; nor does it suggest vaguely, but in such a manner as to prove that the conception of each individual inch of that distance is absolutely clear and complete in the master's mind, a separate picture fully worked out: . . . Not one line out of the millions there is without meaning. . . .' Likewise, Holman Hunt claimed he could see the satellites of Jupiter with his naked eye, and introduced a fly into the 'Oath of Rienzi over the Body of his Brother' to show off his microscopic realism.

Turner's paintings had been criticised for their insubstantiality –

Hazlitt referred to their 'tinted steam', and the snowstorm picture was called 'a mass of soapsuds and whitewash'. He is indeed daringly unpictorial: rather as Pliny said Apelles had painted the unpaintable, a thunderstorm, so Turner delights in ether, airy shapes and vortices of light, and sets his paint to depict a pageant of the elements, not a material world such as that which Constable so fondly lingers over. He is the most romantic painter, in that he most completely dissolves and transfigures the solid, opaque world of matter; and he turns eventually from oil with its thick impasto to the more transparent, melting, vaporous mode of water-colour. This Ruskin, emphasising verification and materialisation, cannot see. 'All transparent ghosts and un-outlined spectra,' he was to pronounce in a lecture of 1883, 'are the work of failing imagination.' Hence he makes Turner into a Victorian, obsessed by the researched accuracy and devotion to 'plain and leafy fact' of the Pre-Raphaelites. The nature he believes he finds in Turner is much more the nature he is posed amidst in Millais's portrait of him, begun at Glenfilas in 1853 – here the rock formations are studied with geological precision (as Butterfield studied the stone, brick and slate employed for his buildings; and Ruskin said of Brett's 'Stonebreaker', 'If he can make so much of chalk flint, what will he not make of mica slate, or gneiss?'), the rush of water boiling or spouting over the rocks conscientiously represented. In the same spirit, Millais made a botanical list of the plants on the river-bank near Surbiton which he included in his 'Ophelia', painted in 1851; and, as a tribute to the painting's naturalness, a Professor of Botany who was unable to take his students on a country ramble led them instead to the Guildhall to see the work, and lectured them from the flowers and plants in it, for these, he felt, were as instructive as nature.

Turner's atmospheric excitements have been earthed, and disciplined into the slow, sure, microscopic observation of the scientist. Ruskin himself made geological studies of quartz and other rock types, and his flower or bird studies have the curious chilly exactitude of the Pre-Raphaelites, everything anatomised and dissected, the precise individualisation of the parts detracting somehow from the sense of the living whole. His drawings of the 1840s relentlessly pursue details of the pattern of branches, but in abstraction from the trees as organisms; while he promised that his

plates in *The Stones of Venice* would have an 'almost servile veracity'. This scientific spirit reappears in George Eliot, who accompanied Lewes on his naturalist expeditions to the sea-side, and who approaches her characters as he did his biological specimens, as fascinatingly intricate, lower forms of life; and she holds them in her analytic gaze as if they were laid out under a lens for investigation. Manners become a subject for natural history. The leaves or blades of grass in Pre-Raphaelite paintings cry out to be counted, as much as the historical information in George Eliot's novels cries out to be believed true. Accuracy in numbering the streaks of the tulip becomes both the school and the proof of moral rectitude. Sir Hubert Herkomer wrote from Caernarvonshire, where he was painting 'Found', to some students of his Art School in 1884: 'Have any of you tried to paint grass honestly? I stuck to eight inches of grass for a day, and tried to realise that short grass. . . . It is so interesting to paint shoulders and chests and heads, my friends, but where is your moral courage when you come down to the feet? This manner of working from Nature is far more exhausting than working at home comfortably, after a given manner, from hasty sketches. All conscientious efforts are serious and earnest, and flimsiness of intent and desire to palm off as truths that which comes easiest to one cannot be counted as earnest effort. . . . The desire to take trouble seems to me at the bottom of many good deeds.' The grimly painstaking exercise of realism is a moral duty to the novelist as well: Mrs Gaskell points out that Ann Brontë, forced to watch Branwell's dissipation and deterioration, tormented herself until she became convinced of her 'duty to reproduce every detail', in *The Tenant of Wildfell Hall*. She pressed on with her task, refusing to spare herself, prepared to sacrifice her health and peace of mind in the uncompromising pursuit of the cruel details of the case: 'She hated her work, but would pursue it. When reasoned with on the subject, she regarded such reasonings as a temptation to self-indulgence. She must be honest; she must not varnish, soften, or conceal.'

Ruskin said that he learnt from David Roberts and, of course, from Turner, 'of absolute good, the use of fine point instead of the blunt one; attention and indefatigable correctness in detail.' And this detail often prevails over the whole. Pugin had laid it down in his *True Principles of Christian Architecture* that 'in pure archi-

tecture the smallest details should have a meaning or serve a purpose', and Ruskin's sense of the logic of architectural construction is sometimes not strong enough to restrain his fascination with subsidiary detail – the crockets on the Scaliger tombs, for instance; while his sketches sometimes show him to have had a capricious eye – in them points of detail of near-visionary intensity protrude, but disconnected from one another, with only a sketchy haze between them, a visual habit which perhaps explains some of the painfulness of Pre-Raphaelite pictures which allow no such areas of rest: every object bristles and dazzles, every blade of grass is a climax. Ruskin is most stimulated by highlights, excrescences, projections and minutiae: he admitted 'an idiosyncracy which extremely wise people do not share, my love of all kinds of filigree and embroidery, from hoar frost to high cloud.' The embroidered, diagrammatic look of Victorian detail is explained in some comments in *Praeterita* on Ruskin's own drawings. Drawing grass, like Herkomer, he notices 'the grace and adjustment to each other of growing leaves, a subject of more curious interest to me than the composition of any painter's masterpiece. The love of complexity and quantity before noticed as influencing my preference of flamboyant to purer architecture, was here satisfied.' This love of complexity and membrification predisposes Ruskin towards the flying buttress rather than the classical column. Drawing aspen, he is startled to discover it to be composed, as de Quincey had said of Shakespeare's plays, by finer laws than any known to men: 'all the trees of the wood ... should be beautiful – more than Gothic tracery, more than Greek vase-imagery, more than the daintiest embroiderers of the East could embroider, or the artfullest painters of the West could limn.' Or, drawing a bit of ivy at Norwood, he recognises the scientific obligation of the realist: 'I had virtually lost all my time since I was twelve years old, because no one had ever told me to draw what was really there! All my time, I mean, given to drawing as an art; of course I had the records of places, but had never seen the beauty of anything, not even of a stone – how much less of a leaf!'

There is a certain urgency to this pursuit of detail. Carlyle complained of the self-consciousness of view-hunting and 'paintings of scenery for its own sake' in the 1831 essay 'Characteristics', but he misses the purpose of this minute care – for nature is recorded by

the Victorians as if imperilled, as if art must preserve species we will soon see no more, and Ruskin charges architecture with the responsibility of reminding the city dweller, by means of its decorations, of the natural forms from which he is permanently estranged. The detail has a strange fixity and prominence – Rossetti's wood-spurge with its cup of three, Tennyson's crimson petal and white, the coloured jay's feather in Millais's 'Woodman's Daughter', the hallucinatory glare of the sunlight in Ford Madox Brown's 'Pretty Baa-Lambs', the death's-head beetle with which Holman Hunt's hireling shepherd is bemusing the credulous girl. Details emerge from their surroundings and hypnotise us. For all Ruskin's attack on the pathetic fallacy of the romantics, the Victorian eye is far from being a *camera lucida*: it takes possession of what it gazes on, holds it in mesmeric thrall. The romantic poets happily make landscapes express their moods, and romantic painters use light to paint emotion; but the Victorians cultivate an objectivity which becomes obsessive – they hold themselves back from the subjects they depict so tautly that we sense their thwarted involvement all the more strongly. There is a certain ferocity or desperation in their realism – if, as H. G. Wells said, their painting is different from photography in being truth lovingly told, it is also different in being truth intensely, and conscientiously, told. The blades of grass in Holman Hunt's picture of straying sheep along a hilly coastline are like flares, and their blazing distinctness alerts us to the rather hysterical moral warning the painter has forced upon this innocent scene – the sheep are the English people, lazily failing to defend their shores. Victorian realism, for all its scientific rigour, is possessive: it ingests its objects. Ruskin wrote to his father in 1853, 'I should like to draw all St Mark's, and all this Verona stone by stone, to eat it all up into my mind, touch by touch.' The romantics project themselves into nature; the Victorians draw nature into themselves, and Ruskin's desire to engorge Venice and Verona is fulfilled in the slow, steady way in which George Eliot absorbs Renaissance Florence into herself in *Romola*. The Victorians have more respect for factual certainty and accurate representation of nature than the romantics, because nature is more important to them – they cling to it as all they have to learn from and to sustain them, as Tennyson employs the process of describing things as a means of calming and steadying himself:

112

uncertain of everything else, he can still rest assured of what he can actually see. All larger explanations have failed; the Victorians must pursue Blake's programme quite literally, and discover a world in a grain of sand, a heaven in a wild flower – or a blade of grass.

For Ruskin, nature is an artist who exhibits a Pre-Raphaelite perseverance and conscientiousness; the Victorian painter's scrupulousness about detail is thus a tribute to the minute organisation of the natural world. 'When a rock of any kind has lain for some time exposed to the weather, Nature finishes it in her own way,' Ruskin notes in *Modern Painters*; 'first, she takes wonderful pains about its forms, sculpturing it into exquisite variety of dint and dimple, and rounding or hollowing it into contours, which for fineness no human hand can follow; then she colours it; and every one of her touches of colour, instead of being a powder mixed with oil, is a minute forest of living trees, glorious in strength and beauty, and concealing wonders of structure.' These wonderful pains are those of the Victorian artist, and *Modern Painters* is the central Victorian testament to nature. As such, it is the successor to *The Prelude*. Wordsworth alone of the romantics survived to become a Victorian, and the glad unexpected intimations of immortality, the revelatory spots of time, which nature had granted him in his youth, stiffened later into a dogmatic system, and nature became the model of law and duty. Wordsworth's nature was granitic, stern, severe, mountainous (in Haydon's portrait of him on the ascent of Helvellyn in 1840 he looks like a crag of the mountain) – not pulpy and sweet like Keats's, or ethereal and gaseous like Shelley's or Turner's, or misty, dim and flickering like Coleridge's; it leads on to the 'eternal rocks beneath' of the fourth volume of *Modern Painters*. Ruskin takes his epigraph, however, not from *The Prelude* but from *The Excursion*: he follows the later Wordsworth who is a priest anxiously serving the twin deities of Nature and Truth in daily sacrifices, not the young Wordsworth who steals the boat or hangs on the cliff or goes nutting, and who is more conscious of nature as a mystery than as an edifying writ, a supplementary scripture, to be authoritatively interpreted. For Ruskin, nature is like a Victorian painting: every detail is obedient to a design, and has a moral point – like the tresses of Milton's Eve, contrasted in their sweet but treacherous disorder with the manly cropped locks of

Adam, Ruskin sees the vine as a token of waywardness and its companion the pine as an emblem of steadfastness and resolution, refusing to bow with the winds; or he makes the mutual reliance of the several parts of a plant into a parable of helpfulness. Hence Ruskin's admiration for rocks, and his emphasis on the rocky, mountainous virtues of architecture: durable and firm, rocks are the stratum of law and organisation and permanence in nature. 'Thy righteousness is like the great mountains.'

The Prelude and *Modern Painters* are both strange hybrids. Wordsworth magnifies lyric self-consciousness to epic size; the poem becomes an epic by inverting epic tradition – it celebrates not action (the temptation of the French Revolution is resisted) but feeling, not history but nature, not achievement but quietistic repose, the cultivation of one's garden. Ruskin turns an encyclopaedia into an epic – scientific classification of natural forms becomes poetic, as does criticism, in the impassioned evocations of Turner's pictures. He produces a romantic version of the medieval bestiaries which marshal all living phenomena and demonstrate, often with Ruskinian improbability, how they illustrate religious law. The fugitive glimpses and dubious guesses of the romantics, their waking dreams and brief encounters with unknown modes of being, are assembled into Lewes's systematic classification of experience, as impossible a task as Ruskin's other attempt to bottle clouds. For Ruskin is attempting to give authoritative shape to something essentially indistinct and uncertain. The romantics, who had only shadowy intimations or fleeting visions, had developed a sort of lyric-narrative poem in which a revelation comes unexpectedly, often like Joyce's epiphanies startingly emerging from a banal incident, and then vanishes, leaving the poet hurriedly transcribing it, scrambling to define it (Wordsworth's hit-or-miss phrases, like 'something far more deeply interfused' or 'dim and unremembered sense'), hoping to pin a moral to its tail but more often than not failing – the jaunty irrelevance of 'God be my help and stay secure' or 'He prayeth best, who loveth best' both ruefully admit their inadequacy as explanations of the mysterious encounters of Wordsworth with the leech-gatherer or the wedding-guest with the ancient mariner. Keats's odes record not only the accidental origin of the vision but its fading away: the nightingale flies off, he is returned to himself. The poetry sadly and teasingly

114

confesses its own uncertainty: the person from Porlock interrupts, the phantom kingdom vanishes. Ruskin, however, aims at a massive accumulation, classification and exegesis of what the romantics leave as lyric moments; he builds in *Modern Painters* a museum in which to house all the phenomena of nature and the elements, and his own numberless sketches, along with the paintings of Turner: it is a structure into which any observation can be fitted, and by means of which anything in nature can be studied and justified, seen as a part of the creator's plan. Wordsworth drove traditional faith out of the epic and daringly put in its place bare, isolated moments of lyric perception; Ruskin took these lyric moments – the poetic equivalent, perhaps, to sketches, immediate and indefinite – and worked them up into a theological system. Wordsworth's poem deserts the authorities of religion, politics, heroism, the city, for nature; Ruskin takes nature and makes it the supreme authority.

But the attempt to codify nature could not succeed. *Modern Painters* struggles to give dogmatic shape and finality to the romantic religion of sensuous reverie; but romanticism derives from the fluid, the floating, the misty, the obscure, from opalescent colour and streamy association, everything which is antipathetic to the regularity of law, and the task is impossible. It is one of many gallant romantic attempts to get beyond the subjectivity of lyric – the poets tried to turn lyric into drama or epic, Ruskin to turn it into encyclopaedia and scripture; neither succeeded. Fixity and certainty might, however, be approached in microscopic detail; and Ruskin's details perhaps correspond to the visionary moments of the romantics. Ruskin retains a stronger sense of the minute detail than of the commanding plan: the whole is indifferent, but individual portions of it – the vine or pine, mountain crests or peaks, a detail of tone or light in Turner – we can be sure of. As an epic design, a justification of the ways of nature to man, *Modern Painters* fails to convince, but individual moments within its huge proliferation – lyric descriptions, pictures, excited records of sensations – do shine out. This rather moving failure is comparable with that of another treasure-house of detail, *The Ring and the Book*, in which we remain unconvinced by the Pope's intervention to pronounce from a position of authority on the contradictory individual testimonies; the confused details of the culpable

individuals seem closer to truth, for all their fragmentariness, than the Pope's final judgement.

Clouds defeat Ruskin – their fluidity weakens his system, and he struggles in the fifth volume to make something firm from them: 'On what anvils and wheels is the vapour pointed, twisted, hammered, whirled, as the potter's clay? By what hands is the incense of the sea built up into domes of marble?' The question is like that which Blake addresses to the tiger; but whereas Blake is content to leave it open, recognising the impossibility of an answer, Ruskin presses on in the hope of reaching a scientific and moral solution. He is better satisfied by the tough, enduring rocks of the fourth volume – slaty crystallines, for instance, possess a 'notable hardness . . . and a thorough boldness of general character, which make us regard them as the very types of perfect rocks'; they are 'one adamantine dominion and rigid authority of rock. We yield ourselves to the impression of their eternal, unconquerable stubbornness of strength.' There is a great difference between this granitic nature of Ruskin and that of Pater, which is streamy, limpid, relaxed. In *The Renaissance* Pater revels in the dissolution of solid rocky objects: 'each object is loosed into a group of impressions . . . this world, not of objects in the solidity with which language invests them, but of impressions, unstable, flickering, inconsistent'; 'the duration of the hard, sharp outline of things is a grief' to du Bellay among the Roman ruins; and Pater speaks of Gothic cathedrals as clumsily overweight, brawny and unrefined, rather like Henry James's loose baggy monsters – they have a 'rough ponderous mass' which is 'mere Gothic strength, or heaviness'.

The pursuit of detail is a pursuit of certainty, and this, it is felt, is too important to brook interference from the creative imagination. The Pre-Raphaelites, according to Millais, wished 'to present on canvas what they saw in Nature', so that for him 'the mysterious and unEnglish Rossetti' was not one of the brotherhood because he followed not nature but his fancy; and for John Guille Millais, the painter's son, the same is true of Burne-Jones. Mrs Gaskell disqualifies Charlotte Brontë for a similar reason – wishing at one stage to make a living as an artist, 'she wearied her eyes in drawing with Pre-Raphaelite minuteness, but not with Pre-Raphaelite accuracy, for she drew from fancy rather than from nature.' Rossetti

was thought to be impiously impatient, disgusted when Ford
Madox Brown set him to do still-lifes of pots and jugs, unwilling to
do the hard work of studying and transcribing natural appearances
which, for the Victorians, almost becomes a substitute for
imaginative creation. Imagination had indeed become a matter of
work, of taking pains and arduously grappling with technical
difficulties. The artist has a guilty conscience if he shirks these
obligations: 'The Woodman's Daughter' was a cause of great worry
to Millais because the tiny jay's feather among the foliage could not
be got right, and he was distressed for a month because the line of
a woman's back in 'The Vale of Rest' created a discord in the
composition.

Millais in fact reduces creativity to work. Ruskin, in a preface to
the folio *Examples of the Architecture of Venice*, published in 1851
to illustrate *The Stones of Venice*, wrote that 'the power of drawing,
with useful accuracy, objects which will remain quiet to be drawn,
is within everyone's reach who will pay the price of care, time, and
exertion.' Millais's difficulties were compounded because he had to
deal with objects which would not remain quiet to be drawn. Frith
had this trouble with the acrobats hired for 'Derby Day', but
Millais had his worst tussles with animals: the horse in 'Sir Isumbras
at the Ford' gave him much suffering – he had to work outdoors in
frost and snow on a ladder, and the horse refused to remain still;
again, in 1852 he wrote to Combe that his patience was being sorely
tried because 'I have been drawing a dog, which in unquietness is
only to be surpassed by a child.' All artistic difficulties become
technical: exactly reproducing objects, as Landseer prided himself
on his recreation in paint of the textures of animal fur; struggling
with the subjects and making them pose acquiescently. 'My man
Young,' Millais reports in his diary in 1851, 'was employed by Hunt
to hold down a wretched sheep, whose head was very unsatis-
factorily painted, after the most tantalising exhibition of obstinacy';
and the next day, 'Hunt employed small impudent boy to hold
down sheep. Boy not being strong enough, required my assistance
to make the animal lie down. Imitated Young's manner of doing so,
by raising it up off the ground and dropping it suddenly down.
Pulled an awful quantity of wool out in the operation.' In 1854
Rossetti painted a calf – possibly that for 'Found' – out at Madox
Brown's in Finchley, 'like Albert Dürer, hair by hair,' said Brown.

The Victorians were dedicated to detailed rendering of life, but the liveliness of their subjects was distracting and upsetting; and just as the exactness of Ruskin's sketches rather freezes the subjects into specimens, chills their life and spirit, so for the Victorian painters life, it often seems, is most picturesque, most placidly characteristic of itself, when dead. Thus many of their animal paintings are indeed still-lifes, painted from obligingly quiet, dead models, not from the frisky creatures which so vexed Millais and Hunt. Millais painted the sheep in 'Christ in the House of His Parents' from two sheep's heads bought from a butcher; and when he needed a mouse for 'Mariana', his father suggested scouring the countryside for one, but at that moment one scurried out from the wainscot and hid behind a portfolio. Millais gave the portfolio a kick, and found the mouse lying behind, dead, admirably picturesque, for it had taken up the best possible position for being drawn. The pure white goat Hunt procured in 1854 for 'The Scapegoat' died on the return journey from Oosdoom; and in 1858 the lion the zoo had lent to Landseer as a model for the sculptured bases of the Nelson Memorial in Trafalgar Square sickened and died while Landseer was out of town. Plaster casts were made from the carcass, on which Landseer continued stoically to work: 'anything as fearful as the gasses from the royal remains it is difficult to conceive even in spite of friend Hills nostrums for the renewal of healthy atmosphere. We have shut our eyes to the nasty inconvenience and opened them to the importance of the opportunity of handling the dangerous subject whilst in a state of safety. With the experience of the Animal photographs, Casts in Plasters and Studies you may believe that I shall neither disappoint you, my Country or the brave Nelson in my treatment of these symbols of our National defences.' In 1837 Landseer had written a curious letter to the Earl of Ellesmere about deer-stalking, in which the connection between the picturesque and the beast harmless and immobile in death also occurs: 'with all my respect for the animal's inoffensive character – my love of him *as a subject for the pencil* gets the better of such tenderness – a creature always picturesque and *never* ungraceful is too great a property to sacrifice to common feelings of humanity.' When Landseer and J. F. Lewis were students they often bought carcasses of foxes and game for dissection and study and stored them under their beds; they bought one of the

lions which died in the menagerie at the Exeter 'Change and preserved it, until neighbours forced them to part with the putrefied hulk. For his picture of Bavarian peasants relaxing 'After the Toil of the Day', Herkomer posed models on a covered platform in a shed in a cottage garden in Garmisch, and claimed the life of a gander for the picture, rigging it up in walking position with the aid of strings dangling from the roof, and painting from it until decomposition set in.

The pursuit of detail is incompatible with real liveliness: hence this relieved use of dead models or, with human subjects, lay figures. For 'The Proscribed Royalist' in 1853 Millais took the female subject's bright satin petticoat down to Hayes with him and set it up on a lay figure to paint the effect of sunlight on the material; the figure and face were taken from a professional model at a later stage. Thus the surface of the fabric and the light on it are exactly observed, but there is no life stirring inside. Significantly, the two models for 'The Black Brunswicker' never sat together: they were painted on separate occasions, leaning against lay figures. W. B. Scott in his memoirs shows Ford Madox Brown composing detail into a still-life. Visiting Brown's artisans' drawing-class in Camden Town he found the pupils, among them Christina Rossetti, making drawings from wood-shavings gathered in a joiner's yard; he at once guessed that Brown had employed these models for his 'Carpenter's Shop' for 'the shavings were lying on the carpenter's floor in the picture, one or two here and there like individual studies, not in masses and heaps as he would have found they did in any real joiner's shop.'

The luminosity, the almost hallucinatory vividness, with which every flower or leaf is picked out in a Pre-Raphaelite painting, is matched by George Eliot's determination to be exact about Florentine table equipage, tunics and shops; and in both cases the meticulousness inhibits the life of the work. The detail of the painters has a glossy deadness: the objects are frozen into specimens of which diagrams are arduously made, they are pinned down to a board for inspection, and there is such a clutter, with so many precisely individualised items each demanding exclusive attention, that the painting loses all spontaneous, mobile, contingent life, and stiffens into a tableau. The objects are put in glass cases, as in a museum; we feel this with the archaeological work of George Eliot –

she uncovers a Renaissance city and is certain about its topography, where the market was, where the barber had his shop, how much things cost, but it is a dead city, uninhabited – and with the array of objects set out, as in a museum, by Holman Hunt in 'The Shadow of Death'. When this picture was first exhibited in 1873, a pamphlet which accompanied it listed the bric-à-brac with which the stretching Christ is surrounded: 'the tressel on which the plank has been sawn is of a form peculiar to the East. . . . The saw is of a shape designed from early Egyptian representations. . . . The teeth are directed upwards, so that the cut is made by the pulling instead of the pushing stroke, as it is in the West. The red fillet, with the double tassel at the foot of the tressel is the aghal. . . . It is now worn by the Bedouin of Syria over a keffieh. The tools on the rack behind are from a collection of ancient carpenters' implements bought at Bethlehem. They include drills, an auger, mandrells, a plumb line, framesaw, and half-square, tools, most of which appear in Egyptian paintings of a date long anterior to the time of the Saviour. . . . The design upon the ivory surface of the box is almost an exact copy from the ornamentation of capitals of columns still existing at Persepolis. The rounded arch of the windows may, the painter thinks, be justified by more than one example of buildings of the Christian era, discovered at Jerusalem.' The painting has become a museum – a compendium of catalogued, labelled historic objects. The past has become a collection of exhibits. Another such museum is Maclise's 'A Winter Night's Tale', in which, scattered about the firelit cottage room in which the old crone is telling her story, are a Victorian baronial chair, a piece of sixteenth century armour, a German fifteenth century stein, some Dutch tiles, and a screen which eclectically mixes Romanesque, oriental and Gothic elements.

The Victorians seem to think that their hard work on detail earns them the right to desert truth in larger matters: because every object in the background has been carefully attended to, the foreground can be occupied by a grotesquely awkward and stagey figure, as in 'The Shadow of Death', or by a falsely sentimental scene. Thus Alma-Tadema, in 'The Favourite Poet', in the Lady Lever Gallery, combines archaeology and sentimentality, antiquity and domestic genre. He takes great pains with the background, the archaic frieze with its bronze medallions and inscriptions, or with a

Ford Madox Brown 'Stages of Cruelty'; the satire of Hogarth transformed by the Victorian novel

J. F. Lewis 'The Hhareem'

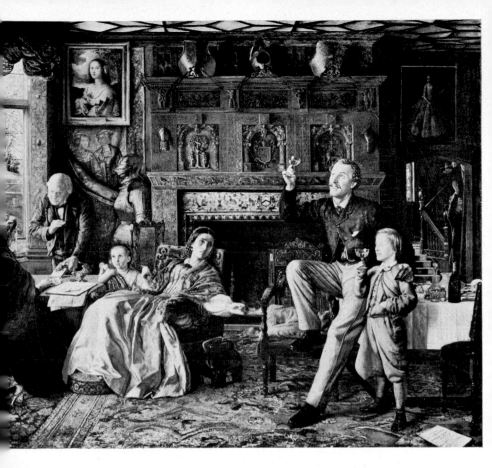

R. B. Martineau 'The Last Day in the Old Home'

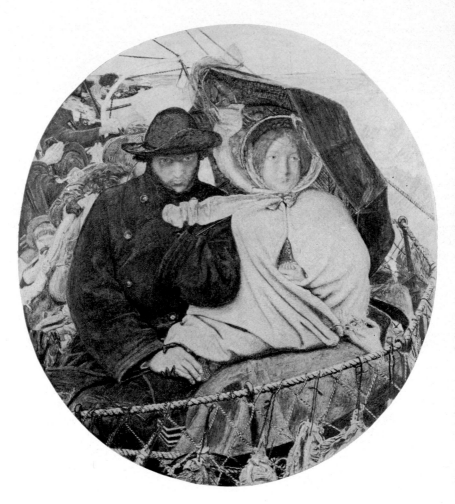

Ford Madox Brown 'The Last of England'

prop like the scroll; but the figures reading from the scroll are the languid, enraptured, dreamy heroines of a Victorian novel. Similarly, in Lytton's *Last Days of Pompeii*, the historical detail – 'Previous to our description of this house, it may be as well to convey to the reader a general notion of the houses of Pompeii'; or a footnote on a sacrificial rite refers us to 'a singular picture in the Museum of Naples' – is compromised by the Victorian love intrigue which occupies the foreground of the narrative.

The Pompeian excavations provided, in fact, a justification for Alma-Tadema's mode of classical genre, which seems absurdly unclassical in painting not heroic public action but sentimental anecdotes from the private life, for the classical ideal was a life lived in the public view, and Aristotle thought that only an idiot would wish to cower near the hearth in the very Victorian manner of Alma-Tadema's Grecian angels in the house. Pompeii modified the classical ideal, in uncovering the domestic detail of ancient life – it allowed the Victorians to overlook the difference between this remote past and their present. Paradoxically, archaeology made the past look more like the present: 'here we are admitted,' Lord Leighton rejoiced to find, 'into the most intimate privacy of a multitude of Pompeian houses – the kitchens, the pantries, the cellars of the contemporaries of the Plinies have here no secret for us.' The past, in becoming so completely known, has forfeited its autonomy, as the close scrutiny of the Pre-Raphaelites transfixes its objects and chillingly isolates them; antique houses have become snug Dickensian shelters, sentimental retreats. Leighton and Alma-Tadema abolish the past – they reduce it to a matter of scrupulous care about detail, literal exactitude, and lose all sense of its strangeness, its otherness; the spirit of their paintings is Victorian – Leighton's high-minded waxen personifications of the arts of peace and war in the Victoria and Albert Museum lunettes, a Grecian equivalent to the Albert Memorial; Alma-Tadema's sentimental anxieties – though the letter is antique. Their characters are Victorians dressed up for a charade. In the same way, Victorian architecture and design reduce the past to a series of systems of details which can be applied at will to any modern object.

This abolition of the past is anticipated in Lytton's Pompeian novel, in which archaeology and sentiment coincide to make us feel, in a phrase which sums up the effort of the Victorian historical

121

novel to become scientifically aware of the past and at the same time to turn it into a cosily known genre scene, 'at home with the past'. Archaeology joins science and sentiment, uncovering the detail of the past but suffusing it, as with the old letters discussed earlier, with regret for those dear dead days and dear dead faces; while the historical novel also assumes the process of historical change to be merely external – customs and appearances change, but sentiments do not. Lytton is both domestically and sentimentally intimate with the past. 'We love to feel within us,' he says, 'the bond which unites the most distant eras – men, nations, customs perish: THE AFFECTIONS ARE IMMORTAL! – they are the sympathies which unite the ceaseless generations. The past lives again, when we look upon our emotions – it lives in our own!' The perturbations which ruffle the relationship of Arbaces and Ione, jealousy, slander, gossip, are the same, Lytton argues, as those which operate today: 'we should paint life but ill if, even in times most prodigal of romance, . . . we did not describe the mechanism of those trivial and household springs of mischief which we see every day at work in our chambers and at our hearths. It is in these, the lesser intrigues of life, that we mostly find ourselves at home with the past.' The gods hid Pompeii from time, Lytton believes, 'to give it to the wonder of posterity; – the moral of the maxim, that under the sun there is nothing new.' He insists on similarities with the present – the Sicilian on the shore tells the fishermen a tale of shipwrecks and dolphins 'just as at this day, in the modern neighbourhood, you may hear upon the Mole of Naples'; giving a phrenological account of the vicious priest of Isis he notes 'towards the temples . . . in that organ styled acquisitiveness by the pupils of a science modern in name, but best practically known (as their sculpture teaches us) amongst the ancients, two huge and almost preternal protuberances'; bad taste runs riot in Pompeian topiary gardens as in Hackney or Paddington; the practices concerning the statue of Fortune cannot be dismissed as superstitious because in present-day country-house parties we 'often see a lady grow hypochondriacal on leaving a room last of thirteen.' Magistrates chattering in the forum are compared with lawyers at Westminster; Lepidus with a beardless flutterer in a London saloon; the ancient Italians, like the modern, would sell anything, Lytton says – not excepting a poor blind girl; a tight-

rope walker has descendants at Astley's or Vauxhall. Trivia remain constant: the Romans like the moderns send invitation cards specifying the time of the meal; and Lytton even compares tickets for gladiatorial combats in the amphitheatre with 'our modern Opera ones'.

This command of minutiae puts Lytton on relaxed, familiar, domestic terms with the past. He recognises in principle the public quality of antique life: 'As at Paris at this day, so at that time in the cities of Italy, men lived almost wholly out of doors: the public buildings ... might be considered their real homes: it was no wonder that they decorated so gorgeously these favourite places of resort – they felt for them a sort of domestic affection.' Yet the significance of Pompeii was that it revealed the domestic background of classical society: it found a place for the private life, and thus for the genre picture, in the ancient world. Interiors are more important to Lytton than communal places of assembly – the house of Glaucus is very small, like a Dickensian house which is a hutch or burrow for its inhabitant, and adorned and finished to the last degree, as a Dickensian house is stuffed full of ornament: 'it would be the model at this day for the house of a single man in Mayfair.' There is a glimpse of a classical kitchen, another treasury of domestic utensils: 'Small as this indispensable chamber seems to have been in all the houses of Pompeii, it was, nevertheless, usually fitted up with all that amazing variety of stoves and shapes, stew-pans and saucepans, cutters and moulds, without which a cook of spirit, no matter whether he be an ancient or a modern, declares it utterly impossible that he can give you anything to eat.' An unostentatious feast is presented as a domestic, not a public occasion: 'We are witnessing the domestic, and not the princely feast – the entertainment of a gentleman, not an emperor or a senator.' Diomed's villa, being very imposing, is described in detail, but Lytton is coy about the position of Ione's, wishing to preserve its sanctity as a home: 'Let the traveller search amongst the ruins of Pompeii for the house of Ione. Its remains are yet visible; but I will not betray them to the gaze of commonplace tourists.'

Glaucus visited by the blind flower girl in the Room of Leda; or Glaucus with Ione with her attendants at work around her, her harp at her side, in a simple robe, pale and blushing; or the pair in

the peristyle by the fountain, Glaucus having cast his lyre aside – these are genre pictures in antique settings, and might have been painted by Alma-Tadema, or by Poynter, whose simpering nymphs visit Aesculapius in a cool courtyard in which doves flutter and a fountain plays, or whose Psyche in the Temple of Love wistfully admires a butterfly on a sprig of flowers and lets her hair tumble over a naked shoulder. Lytton offers the intimate glimpses into domestic detail of the genre painter: Julia's dressing room, her cosmetics and unguents, jewels and combs; he takes the genre painter's delight in stuffs, costly substances, and the Pompeian chamber takes on the padded luxury of a Victorian interior, with its silver basin and ewer, carpet woven from looms of the East, ornamental lamp and papyrus roll, and curtains richly broidered with gold flowers. Or the Podsnappian flaunting of rich decoration at Diomed's banquet – couches veneered with tortoise-shell, quilts stuffed with feathers and ornamented with costly embroideries, the lofty candelabra and tripods of incense, while 'upon the abacus, or sideboard, large vases and various ornaments of silver were ranged, much with the same ostentation (but with more than the same taste) that we find displayed at a modern feast.'

The novelists, like Victorian decorators, apprehend the past through detail; but as the decorators felt free to transfer such detail to modern objects, so the novelists, in possessing the past so thoroughly, lose all sense of its separateness from them. There is a disparity like that in Lytton in George Eliot's archaeological reconstruction of Renaissance Florence, on which she was working in the very years in which the Italian government was sponsoring the systematic excavations at Pompeii and Herculanaeum: for all her conscientiousness about background detail, in the foreground differences between past and present are eliminated, for Romola's moral problems are the same as those which perplex Dorothea in the modern urban society of Middlemarch. But the novel does perhaps explain this curious combination of scholarship and sentiment, of study and invention. In the Rucellai gardens, the bust of Plato, George Eliot points out, has looked down on meetings of the Platonic Academy, on Pico, Ficino, Poliziano and Alberti – 'and on many more valiant workers whose names are not registered where every day we turn the leaf to read them, but

whose labours mark a part, though an unrecognised part, of our inheritance, like the ploughing and sowing of past generations.' This suggests that the historical novel is the logical backward projection of the social novel concerned with human fates in a modern world, for like genre painting it reveals, as recorded history cannot, the anonymous strivings of those who have made the present; Lytton is content to say that the human heart has not changed over the centuries, but, more than this, George Eliot wishes to emotionally identify us with our past. Imagined history becomes in a sense more authentic than the chronicles of those who actually lived – as in Tolstoy the secret of historical understanding lies with the anonymous soldier, not with the commanding general whose every action was scrupulously recorded – because it deals not with political decisions or military campaigns but with the private life, with the slow, blind, humble, nameless motions of human souls. Hence the imaginative excitement of Pompeii – the excavations revealed a frozen, mummified moment of everyday life, with anonymous figures caught in a crisis, accompanied by their dogs (or, in Lytton's novel, a tortoise), surrounded by their possessions and their graffiti. Pompeii exemplified both this moving anonymity of the past – 'I felt that Earth out of her deep heart spoke,' wrote Shelley in the city disinterred – and its similarity to the present. This historical sense is a secular equivalent to the believer's feeling which Savonarola describes to Romola: he 'feels the glow of a common life with the lost multitude for whom that offering was made, and beholds the history of the world as the history of a great redemption in which he is himself a fellow-worker, in his own place and among his own people!' – except that the history is not the working out of a divine plan, foreshadowed in prophecies and confirmed in miracles, but the painful, gradual struggle of humanity towards consciousness. The historical novel is a tribute to the march of mind, complementing this inexorable movement forwards by its emotional movement backwards. Another agrarian simile suggests that we are part of our history as we are part of the earth: Romola comes to 'the belief in a heroism struggling for sublime ends, towards which the daily action of her pity could only tend feebly, as the dews that freshen the weedy ground today tend to prepare an unseen harvest in the years to come.' The historical novel reverses this seasonal growth: we are

moved not by looking ahead to a remote fruition towards which our slightest deeds tend, but by looking backwards at the unknown, suffering fellow-workers of the past who have prepared our present condition for us. Romola and Savonarola aspire and dream forwards; we understand and sympathise backwards.

George Eliot takes great pains to accurately present the Florentine market: in the Mercato Vecchio mutton and veal were attested to be the flesh of the correct animals, she points out, because the skins were displayed with heads attached, according to signorial decree; and a similar conscientious spirit appears in a painting of 'A Cairo Bazaar: the dettal', which J. F. Lewis exhibited in 1876 with an explanatory note: 'In many of the nooks of Cairo auctions are held on stated days. They are conducted by dettals, or brokers, hired either by persons who have anything to sell in this manner, or by shopkeepers. The dettals carry the goods up and down, announcing the sums bidden for them with cries of Harraj, harraj, etc. . . .' But the atmosphere of *Romola* is best suggested by Lord Leighton's painting of 1855, 'Cimabue's celebrated Madonna is carried in Procession through the Streets of Florence . . .'; its huge size (87¾ × 205 inches), and the two years of work Leighton devoted to it, suggest George Eliot's labours with the novel, and they are equally conscientious about the detail of costume and religious custom. San Miniato in the background is accurately recorded, down to the oleanders and pinks on the wall, and the architecture of the shrine is studied from thirteenth century Gothic. As George Eliot has Poliziano, Piero di Cosimo and Machiavelli form up at the Nello's barber's shop, so Leighton introduces prominent historical characters into the anonymous past – there are portraits of Giotto, Gaddo, Gaddi, Nicola Pisano, and, looking on from a corner, Dante. Leighton's idealistic admiration for the central place of art in Florentine life is matched by George Eliot, who has Tito scorn the Christian barbarism of the Duomo but admire the classicism of Ghiberti's bronze baptistery doors, and whose Pietro Cennini explains the reason for processions: 'the great bond of our Republic is expressing itself in ancient symbols, without which the vulgar would be conscious of nothing beyond their own petty wants of back and stomach, and never rise to the sense of community in religion and law. There has been no

great people without processions.' The poised, fixed, characteristic attitudes of Leighton's figures, obligingly made to swivel towards the viewer, suggest George Eliot's calm, analytic exploration of the past: she too seeks out characteristic groups, as in her studious explanation in Book II Chapter V of why the various sections of Savonarola's audience had come to hear him; she too chooses representative processions: the feast of San Giovanni in 1492, the entry of the French into the city in November 1494, the procession of the Madonna of L'Impruneta, invisible in the reliquary, in October 1496. And the icy idealism of Leighton's picture, its Nazarene high-mindedness, has an equivalent in the novel in George Eliot's scholarship, often as insistent and cramping as that of Romola's father, the blind Bardi, and in her admiration in Florence of a certain intellectual picturesqueness – even the barbers are learned, eloquent and cultivated.

Both painting and novel draw attention to the amount of thoughtful labour which has gone into their conception and execution: they are pondered, careful works, weighted with toil, the reverse of insouciant, inspired, self-enjoying. Byron excused *Don Juan* by demanding, 'Is it not life, is it not *the thing*?'; George Eliot and Leighton would perhaps have contentedly sighed, 'Is it not work?' Nothing could be further from the sketchy rapidity of the romantics – Byron's lava-flow, or Turner's blotting of his folios because he had already begun a new oil-sketch before its predecessor was dry. The Victorians tend, indeed, to reduce imagination to work: creation becomes identified with labour, the exhausting trials of capturing the subject, literally holding it down in the case of Millais's animals. Trollope's autobiography is concerned not with the creative process but with writing as a kind of manual labour, with rigging up tables so as to keep to the required number of man-hours while travelling on trains or ships, with staying within the time-table. *The Times* critic in 1873 praised 'The Shadow of Death' because of the work (work being equated with seriousness) which had gone into it: 'We have here before us the fruit of five years intense toil by a man of rare earnestness, tenacity and originality. Besides the actual labour, no small part of the thought and knowledge of a very industrious life has passed into this canvas. The work challenges, if for this reason alone, the most respectful and thoughtful attention.' Ruskin applies the same criteria to

J. F. Lewis's 'Street Scene in Cairo' and another painting exhibited in 1856: 'How two such pictures have been executed, together with the drawing for the Water-Colour Society, all within the year, is to me wholly inconceivable; there seems a year's work in 336 alone.' And in 1857 Ruskin marvelled at the same artist's 'Hehareem Life – Constantinople', 'this drawing represents but a small portion of the year's labour of the master.' So distant are the Victorians from the inspirational flashes of the romantic sketch, so concerned with the studied and justified art of what George Eliot calls the scene, that Ruskin objects to Lewis's production of small water-colours, feeling that such 'conscientiousness of completion' ought not to be trusted to poor little pieces of white linen film.

Edward Lear in 1875 spoke of the 'exquisite and conscientious workmanship' of Lewis's paintings; Ruskin points to his conscientious conquering of the endless complexity of representing débris or fabrics, golden fringes and wall mosaics. Such technique is indeed a conquest – a victory over nature, comparable with the effort of science to control the elements, or with that of the historical novel to gain intellectual control of the past.

The artist becomes a workman. Mayhew in his anatomy of the underworld defines four categories of those who will work, enrichers, auxiliaries, benefactors and servitors, and he classes artists among the enrichers, 'engaged in the collection, extraction, or production of exchangeable commodities'; they fit into sub-group D, 'makers or artificers', which contains three sub-classes, mechanics, chemical manufacturers, and 'Workers connected with the Superlative Arts, that is to say, with those arts which have no products of their own, and are engaged in adding to the beauty or usefulness of the products of other arts, or in inventing or designing the work appertaining to them.' Division C of this sub-class contains painters, decorators and gilders; division l sorts together 'Artists, Sculptors, and Carvers of Wood, Coral, Jet &c.' – art is indistinguishable from craft; division n has architects, surveyors and civil engineers, division p authors, editors and reporters. The utilitarian standard of judgement prevents artists from being classified as benefactors: this role is reserved to educators and curators, spiritual and physical; hence, no doubt, the Victorian artist's essays into didacticism – it dignified art by making it more useful; the artist was envious of the nobler role of benefactor, who

confers 'some *permanent* benefit by promoting the physical, intellectual, or spiritual well-being of others'. Carlyle and the Rev. F. D. Maurice stand in a corner of Madox Brown's 'Work': 'In the very opposite scale from the man who can't work, are two men . . . who appear to have nothing to do. These are the brain-workers, who, seeming to be idle, work, and are the cause of well-ordained work and happiness in others.' The symbolist, aesthete and dandy make a decisive change, which is perhaps summed up in Wilde's languid attitude to Ruskin's energetic project for the building of the Ferry Hinksey road – art ceases to be work, becoming splendidly gratuitous, and the artist joins ranks with those who will not work, associated, particularly in France, with two of Mayhew's aversions, the vagrant and the thief; and Pre-Raphaelitism declines from the strenuousness and industriousness Ruskin praised in 1851 through the enervation of Burne-Jones to the morbid prostration of Beardsley.

Creation is reduced to work, to ensuring a pernickety exactness, and so is criticism: the critic inspects the picture with a microscope, as it were, testing its technical correctness as anxiously as if it were a piece of machinery in which faults might be dangerous. Ruskin in fact did recommend the magnifying glass as an aid to appreciation: in his Academy notes for 1856 he advises us to use one to admire the squirrel and birds in Inchbold's 'Mid-Spring', and in the same year he recommends the same attention to 'refinements in its handling which escape the naked eye altogether', such as the eyes of the camels, in Lewis's 'Frank Encampment'. Some people objected to Millais's 'Huguenot' because the man's arm could not have reached so far round the girl's, or because it is set on St Bartholomew's Day and there could not be nasturtiums in August; while Ruskin wrote of Maclise's 'The Wrestling in *As You Like It*' at the Academy in 1855: 'On the part of the hem of the Duke's robe which crosses his right leg are seven circular ornaments, and two halves, Mr Maclise being evidently unable to draw them as *turning* away *round* the side of the dress. Now observe, wherever there is a depression or fold in the dress, those circles ought to contract into narrow upright ovals. There *is* such a depression at the first next the half one on the left, and that circle ought to have become narrowed. Instead of which it actually widens itself!' On in 1859 he writes tuttingly of Roberts's 'Santa

Maria della Salute', 'My dear Mr Roberts, *is* this like a church built of white Carrara marble? . . . And then the gondoliers! still always where they couldn't possibly row!' Dickens as well in 1853 was obliged to defend one of the boldest inventions of his poetic fantasy, the spontaneous combustion of Krook in *Bleak House*, not by affirming the rights of the imagination, but by pointing to cases recorded in Verona in 1731, Rheims in 1725, and to an alcoholic liquor-shop proprietor in Columbus, Ohio, more recently. 'I do not think it necessary,' he writes archly, 'to add to these notable, and that general reference to the authorities which will be found at page 30, vol. ii., the recorded opinions and experiences of distinguished medical professors, French, English, and Scotch, in more modern days.'

This notion of work in art perhaps explains the curiously unselective approach of the Victorians, and above all the Pre-Raphaelites, to detail – this signifies a refusal to make things easier for themselves. Every object, every accessory, whether half-glimpsed or not, is felt to be of equal importance with the main subject, and is painted, as are Hunt's carpentry tools, with the same fetishistic attention. Work also makes architecture moving: in *Seven Lamps of Architecture* Ruskin says that a prime source of the agreeableness of ornament is our 'sense of human labour and care spent upon it'; therefore machine-made ornament is meretricious. Architecture can make a symbolic statement of the relation between work and leisure: Ruskin argues in *The Stones of Venice* that 'as, in all well-conducted lives, the hard work, the roughing, and gaining of strength comes first, the honour or decoration in certain intervals during their course, but most of all in the close, so, in general, the base of a wall, which is the beginning of its labour, will bear least decoration, its body more, especially in those epochs of rest called string course; but its crown and cornice most of all.' A building has become an organism with a moral life; and this law of Ruskin's is borne out in Butterfield's Balliol chapel, the texture of which expresses a moral drama as much as the finicky finish and individualisation of tiny objects characteristic of Pre-Raphaelite pictorial textures express moral ideas. The streaky bacon chapel is striped red and white, but near the ground the solid, earthy, abstemious red permits between its sturdy bands

only thin layers of white, like meagre sandwich-fillings, brief intervals of relaxation and pleasure, while further up the walls the white grows increasingly more assertive until it breaks into dominance, released from the tutelage of the red, in the chequered polychrome abandonment of gables and campanile. In its course up the wall the decoration has earned the right to flaunt itself at the top. The exuberance of detail on many Victorian buildings is perhaps an attempt to artificially re-create the condition of the Gothic cathedrals, which were accretions of the anonymous labour of centuries, their proliferation of detail the marks of the countless workers under whose hands the structures grew.

Another of Ruskin's laws for architecture in *The Stones of Venice* is that delicate ornamental detail ought to be near the eye: as he regretted that the detail of Lewis's 'Frank Encampment' was 'concentrated so as to become, to most people, all but invisible', so he rules that 'it is worse than foolish to carve what is to be seen forty feet off with the delicacy with which the eye demands within two yards; not merely because it is a great deal worse than lost: – the delicate work has actually worse effect in the distance than rough work. This is a fact well known to painters, namely, that there is a certain distance for which a picture is painted; and that the finish, which is delightful if that distance be small, is actually injurious if the distance be great.' Yet many of the paintings are visually painful because the distance, not only between them and us but also their interior space, is oppressively small – the boxed-in, shallow rooms of 'The Shadow of Death', 'The Awakening Conscience', or Hunt's 'Isabella and the Pot of Basil' or 'The Lady of Shalott' – so that the accumulation of objects, all finished with equal care, suggests the airless claustrophobia of a Victorian parlour stuffed with bric-à-brac. Just as the painters thought it immoral to smudge or blur or sketch – they prided themselves on their lack of facility; the Pre-Raphaelites nicknamed Reynolds 'Sir Sploshua' because he dashed over detail and outline, splashing on paint with an ease which they felt to be dilettantishly immoral, unworkman-like – so they seem to think it impious to select or organise the relation of things within a picture: this would be to impose on a nature whose every element is holy a hierarchy with man at the top. Wordsworth refuses to do this, making the trees and stones which surround his people more full of character, more moving,

than the people themselves, and the highest compliment he can pay character is to make it one, as he does Lucy, with rocks and stones and trees; the Victorians also refuse to do it, making items of furniture or blades of grass more individually alive than the people in their pictures. The details, like the sub-plots discussed in the first chapter, have staged a rebellion against the whole.

5. READING BUILDINGS

THE pictorial analogy is important in the literature of the nineteenth century – romantic art is visionary, but also visual; it possesses a quality of insight which reveals the inner spirit or symbolic life in natural appearances, as Wordsworth watches the leech-gatherer transform himself into a stone, a leviathan, and a bank of clouds. Ordinary things radiate mystery – the ecstatic glow of Samuel Palmer's harvest moons and fruit trees, the dazzling abstraction of Turner's light. A romantic painting, like a romantic poem, passing from reality into vision, is a casement

opening on the foam
Of perilous seas, in faery lands forlorn.

A Victorian picture is not, however, a casement opening on to the remote and magical, but a frame within which all is glazed into sympathy and picturesque harmlessness. The mysterious recessions of the romantics, which lead us in the exploratory manner of Lockwood edging from one room to the next towards the dark centre of Wuthering Heights, become the limited, crowded spaces of Victorian paintings, which are not casements but mirrors. These mirrors may flatter or accuse, meeting our gaze as does 'The Awakening Conscience': the picture contains an ornate mirror which makes it clear that the spectator is looking in at the cluttered, tasteless, sinful room through an open window from the garden, and it is towards us, towards this free innocent space of brightly sunlit green which is our vantage-point, that the trapped girl looks. The casement does not give on to a limitless realm of fancy but on to an uncomfortable, ugly parlour; the mirror reflects a bright free space of safe detachment, an innocence towards which the girl stares but to which she will never return. Within the frame of the picture are two further frames, the mirror and within that the open window; but this recession suggests not the dreamily limitless freedom of reverie, as distance does in a romantic painting, but entrapment. Its effect is ironic – the girl looks out hopefully towards the garden,

133

but it is behind her. Whereas the illusionism of van Eyck, literally holding a mirror up to nature in his Arnolfini marriage, or of Velasquez, disclosing in a mirror in 'Las Meninas' the king and queen as unmoved movers of the court the canvas displays, explains and orders relationships, Holman Hunt's device creates a treacherous complication, and has the disturbing effect of implicating the spectator in the situation. Its startling artifice suggests that movable panel in *Daniel Deronda* which flies open on the dead face and fleeing figure and terrifies Gwendolen. The optical tricks of van Eyck and Velasquez give the spectator hindsight: they enable him to see what is behind him, to see what the Arnolfinis and Velasquez with brush poised are looking at, outside the picture. But Holman Hunt's trick is not a peep-show which scientifically extends our vision, though there is a certain prurience in the notion of looking through the window at the abandoned pair; more than this, it has a narrative and moral purpose, and it compels the spectator into the role of witness. The picture addresses itself to him, as does its other-worldly counterpart, 'The Light of the World'.

As the preceding chapters have argued, there is an exchange between literature and painting in the Victorian period: painting learns to narrate, literature adopts the methods of the picturesque. But the architectural analogy is at least as important as the pictorial, and this chapter will discuss that peculiar literary architecture which appears in Ruskin's criticism, and in Hugo and Browning. Architecture becomes literary in the nineteenth century by becoming fantastic: as literature retires inside the mind and painting into vision and sentiment, so architecture frees itself from its classical virtues of firmness and rational foundation into the extravagance of neo-Gothic. I have quoted Flaubert's letter about the weightlessness of art, the finest works being those which contain the least matter, and pointed to *Tristan und Isolde* as a work which lifts itself above circumstance and actuality; and it is Wagner's influence which presides over one of the most astonishing examples of this trend in architecture, the castles Ludwig II built in the Bavarian mountains, Linderhof, Herrenchiemsee and Neueschwanstein. These castles pursue the impossible aim of making architecture weightless, of purging it of matter, transforming it into a vision hovering in the misty air. It is appropriate that

Ludwig never lived in them – like romantic cities, Turner's Venice, Dickens's London, they are places of dream, not habitable during the day. They are organised, as is *Tristan*, around night: their centre is not public rooms but the fantastically ornamented bed-chamber of the king, or, in Linderhof, the subterranean grotto re-creating the forbidden delights of the Venusberg. Like Proust's cork-lined room – and, perhaps, the elaborately padded and muffled railway-carriage of Queen Victoria – they insulate the dream from the cruel glare of the day. For all their absurdity, they have an extravagance, a discontent with rational limits, which is authentic-ally Wagnerian: *Tristan* prolongs a moment of ecstasy for four hours; they make a dream substantial. Flaubert had said that art must eliminate the material subject, and make style an absolute manner of seeing things, and Ludwig's buildings do this – they have no human purpose, no depth, no rational function; they are merely the pretext for a riot of style. Architecture ought to be rooted in the earth; they soar into weightlessness. They are the furthest possible extensions of Gothic, for the flying buttress and pointed arch had released stone from weight, heavy earthy solidity, and given it the freedom and lightness of spirit. The stones of the towers in Auden's poem on Oxford are utterly satisfied with their weight; but those of Neueschwanstein, like those of the St Pancras hotel or the iron and glass of the Crystal Palace, are dissatisfied with it, expressing that restless aspiration which seethes as well in Browning's poetry – the fretting against limits, the sadness that after all man's reach exceeds his grasp. It is interesting that Wagner's influence persists in a later builder of dreams, Antonin Gaudi, who tried in the façade of the Sagrada Familia church in Barcelona to create an architectural equivalent to the *Siegfried Idyll*.

The aspiration of architecture to weightless fantasy produces as well the Crystal Palace, whose transparent glittering structure, overbearingly massive yet brilliantly light, re-creates Gothic in glass. The arching vaulting lightness of Gothic is made even more unearthly by glass; it becomes airy architecture – as Ruskin's (albeit disparaging) comment in an appendix to *The Stones of Venice* suggests:

> The earth hath bubbles, as the water hath:
> And this is of them,

and the Queen wrote an appreciation of its fantastic character in her journal in February 1851: 'The sun shining through the Transept gave a fairy-like appearance. The building is so light and graceful, in spite of its immense size.' With its nave and baldacchino, it was a cathedral, though one built to the glory of commerce, and, with the trees projecting through its roof, the elms which provoked the Sibthorp dispute, it realised the fond romantic notion that cathedral naves were a reminiscence of the aisles, branching and multiplying and entwining into canopies, of the northern forest. Classical architecture is an affront to nature: its regularity and severity of design separate it from the disorderly growth about it; but romantic architecture merges with nature once again – and thus the Crystal Palace was not only a cathedral but a greenhouse; it contained not only the huge sturdy elm boles, whose cumbersome strength contrasted so markedly with the magic transparency of the supports, but numbers of other plants, with some tropical species by the fountain of glass in the transept.

The spectacular bird's-eye views of Victorian architectural drawings emphasise the vertical excitements, the soaring heights of Gothic; the aerial view with its dizzy exaltation seems more important than the dull good sense of the view from the ground. The frontispiece to Pugin's *Apology for the Revival of Christian Architecture* gathers together into an enclosure nearly two dozen Gothic revival churches, with their steep jagged roofs and forest of pinnacles, and the rays of the rising or setting sun send out spokes of light from behind the spire of the church in the centre; as if in a Martinian thunderclap, the New Jerusalem appears before us. But, lifting us above the view we would have of the buildings on the ground near them, the diagram passes over their actual discomfort and incoherence, turning them into a dream. Similar giddy aerial prospects are found in some of the designs submitted in 1860 to the competition for the new Law Courts in the Strand. Street's plan, for instance, has a vaulted hall enclosed by a high outer wall with towers at its corner and a huge record tower looming over it to the north-west, and, seen from above, with the lightly-sketched diminished city stretching away beyond it, and tiny people engulfed into its entrances, it resembles one of Martin's nightmarish cities. The stormy lighting of Burges's design makes it even more dramatic, with a massive tower threatening us from the

south-west corner on the Strand, its Gothic might dwarfing the fine classical proportions of Gibbs's St Mary-le-Strand next to it; in the centre is a castle, with a vaulted hall in which the judges were to assemble and from which corridors, supported by iron arches, ray out across the courtyards, connecting this secret enclave with the public courts on the edges. Like a Martin apocalypse, it is a fantastic vision of the sombre power of law.

The Crystal Palace uses modern engineering methods to build, for a commercial purpose, an enchanted castle which might have appeared in the paintings of Martin or Danby. Its oddity derives from the gap between modern and economical methods of construction and the extravagance of Gothic – a gap symbolised by those unlikely neighbours, King's Cross with its utilitarian roofing and Scott's St Pancras hotel with its confused jumble of towers, which glowers, like a metropolitan Otranto, above the toiling omnibuses in the Pentonville Road in John O'Connor's painting in the London Museum. The literature reveals a duality which is perhaps comparable, between iron fact and the extravagant freedom of sentiment and romance. Out of what seems reliable, trustworthy and rational, fantasy and strangeness flower – the gargoyles subvert the main plot and unseat its normal characters in Dickens; the painters work with an exhaustive literalism but produce not realism but something like hallucination, painfully and terrifyingly vivid; the hapless domestic objects exhibited in 1851 grow a weight of ornamentation on their backs which smothers their function and renders them useless. Victorian life and art abound in transformations of the real into the fantastic: an innocuous figure in Dickens becomes a monster; a knife at the Great Exhibition becomes an object to be placed in a reliquary, encrusted with decoration; a railway station becomes a Gothic cathedral; Paxton's iron and glass palace rears over the trees in Hyde Park. The extravagance of the buildings is matched in the other arts: the crowded fullness of the paintings, the conspicuous waste, the excessive length of the novels. The Victorians please by excess. Dickens particularly has a way of taking things too far, of amusing and frightening at once by pressing a joke to an extreme of grotesque unreality.

The romantics discerned a sympathy between characters and the landscape out of which they grow – Wordsworth's suffering people

are bent and bared like his thorn tree or hardened by endurance like his rocks; Shelley's bodiless, evaporating characters are fashioned out of air – they are clouds, vapour made visible. This sympathy takes a grotesque and humorous turn in Dickens – his characters are not harmonised with a natural landscape, but all queerly and disturbingly made out of the unnatural substances and scenes of their urban background. Once again, Dickens brings romanticism into the city. Wordsworth's characters are like trees, those gnarled blasted isolated trees Constable loved to sketch and paint; but those of Dickens are the product not of natural process but of a ghastly mockery of it: the knotty close-grained Silas Wegg has taken on the same consistency as the grim tough nuts he sells, becoming 'so wooden a man that he seemed to have taken his wooden leg naturally, and rather suggested to the fanciful observer, that he might be expected – if his development received no untimely check – to be completely set up with a pair of wooden legs in about six months.' The leech-gatherer or Lucy grow back into nature, becoming things imbued with sense; but the slow silent course of natural growth in Silas Wegg results in the unnatural: he becomes a thing in a quite different sense. And yet there is a weird naturalness to these Dickensian creatures – they are like mysterious animals, their eyes bright, as Keats put it, with a secret self-involved purpose, absorbing from their environment, taking its colour to camouflage themselves, creating a habitat for themselves, stubbornly managing to exist in unpromising conditions. And, like animals, they carry their houses on their backs. The Dickensian house is its occupant's shell; it grows from him and assumes his shape. The romantics had seen architecture as a part of the scenery; in Dickens it is the extension of a character, expressing a personality. Romantic architecture joins the life of nature; that of Dickens is animated by a life of its own.

This alertness to the life and character of buildings is anticipated in Ruskin's early work, *The Poetry of Architecture*. Constable had seen painting as a way of feeling; Ruskin applies the same emotional subjectivity to architecture, which he calls 'a science of feeling more than of rule'. Just as the insistence on reading pictures drew attention away from painterly qualities towards the sympathy and narrative curiosity they excited in the observer, so this approach to architecture dwells on the poetic suggestiveness or

moral atmosphere of buildings, rather than on their architectural
virtues. The tales told by the pictures spill over their frames; the
feelings which dwell in the buildings are summoned out indepen-
dently of the structures themselves. The competition between
painting, evoking the inner life, and the external forms of sculpture
has already been mentioned, and it is interesting to find Ruskin,
in *The Seven Lamps of Architecture*, in a discussion of colour in
architectural ornament, allying architecture with painting rather
than sculpture, because 'sculpture is the representation of an idea,
while architecture is itself a real thing. The idea may, as I think,
be left colourless, and coloured by the beholder's mind: but a
reality ought to have reality in all its attributes: its colour should
be as fixed as its form. I cannot, therefore, consider architecture as
in anywise perfect without colour.' Sculpture is a mental abstrac-
tion, but a building is a part of nature, organically formed and
growing: 'Now I call *that* Living Architecture,' Ruskin says of the
west front of Pisa Cathedral. 'There is sensation in every inch of it' –
as Hazlitt had said there was feeling in the flesh colouring of Titian.
Nature is the architect's mentor as much as it is the painter's:
he should not live in cities, but return to the hills and 'study there
what nature understands by a buttress, and what by a dome'.
Abandoning the classical notion of a building as a static diagram of
pure geometrical forms, Ruskin treats buildings as paintings, or as
landscapes.

Architecture possesses character, which, energetically taken to
extremes, produces grotesquerie; and in *The Poetry of Architecture*
Ruskin describes this grotesque individuality with a whimsicality
which suggests Dickens. The muddle of styles he finds in domestic
architecture creates a Dickensian absurdity: 'we have pinnacles
without height, windows without light, columns with nothing to
sustain, and buttresses with nothing to support. We have parish
paupers smoking their pipes and drinking their beer under Gothic
arches and sculptured niches; and quiet old English gentlemen
reclining on crocodile, and peeping out of the windows of Swiss
chalets.' Dickens was able to make exuberant imaginative use of
disorder like this – for him, bad taste is liberating. Waywardness
and disarray imprint character on a Dickens building: the Maypole
Inn in *Barnaby Rudge*, for instance, bristling with gable ends and
huge zigzag chimneys which wind the smoke into fantastic wreaths,

its floors sunken and uneven; if in Ruskin buildings become landscapes, in Dickens they become people, humours – we see the Maypole physically become the idea of somnolent peace, rural quiet away from the revolutionary terrors of the city, which it represents in the novel, for with its overhanging storeys, drowsy panes of glass, and front bulging over the path, it looks 'as if it were nodding in its sleep'. Its bricks are yellow and discoloured like an old man's skin, its timbers like decayed teeth, and its aged body is wrapped in a warm comforter of ivy. Irregularity and the pursuit of detail at the expense of the whole – 'the eye is drawn into the investigation of particular points, and miniature details' – receive a Dickensian justification from Ruskin: the English villa, he says, though barbarous as architecture is not false as taste, and its disorder pleases because it recalls the variety of natural architecture in the woods; and his description of forest scenery disclosing rich decorated gables recalls Bleak House, whose irregularities proclaim the quaintly eccentric happy privacy of its inhabitants – the fretwork and lack of system in the house, its maze of steps and doors and galleries, make it a closer-fitting case for them; it is less a house than a burrow. Dickens's humoristic architecture – Wemmick's fortified home, the boat at Yarmouth, the Nun's House in *Edwin Drood*, with the nuns walled up, Dickens fancies, in 'odd angles and jutting gables' – is a tribute to the perverse individuality of his people: as they refuse to be other than themselves, so they insist on living inside a structure which is completely characteristic of them, an emanation from them; and this cranky, stubborn, self-sufficiency is shared by the English villa as Ruskin describes it: 'it is a humourist, an odd, twisted, independent being, with a great deal of mixed, obstinate and occasionally absurd originality.' Ruskin's English chimneys have a Dickensian smugness, 'a down-right serviceableness of appearance, a substantial, unaffected, decent, and chimney-like deportment, in the contemplation of which we experience infinite pleasure and edification'.

He makes amusing use of Dickens in *The Stones of Venice*, in pointing to the sketch of the man who steals Dora's dog Jip in *David Copperfield* as the sharpest criticism of Renaissance balustrades – this man is described to the police as possessing legs like the balustrades of a bridge. Ingres had advised his pupils to make legs like columns; Ruskin's grotesquerie mocks at this

Olympian perfection. In the same study he anticipates Silas Wegg in attacking the mendacity of giving functionless bases to detached shafts: 'the bases of the Nelson column, the Monument, and the column of the Place Vendôme, are to the shafts exactly what highly ornamented wooden legs would be to human beings.'

Ruskin begins as a critic of painting, but moves almost at once towards architecture. *Modern Painters* fixes on Turner's pictures because they discern in nature the eternal moral plan beneath, and they are catalogued by Ruskin as a romantic equivalent to the summae of observed life carved on to the portals and arches and glowing in the windows of a Gothic cathedral. The cathedrals were sculptured encyclopaedias – Ruskin's vast hold-all of observations is a sketched and painted encyclopaedia. But his cathedral is built to a faith fragilely dependent upon glimpses, guesses, intimations, and the brave omnipotence of its structure is confounded by clouds, which cannot be defined, as the romantic poets were forced to helplessly suffer the deprivation of their visions – 'Fled is that music'; the knock on the door announcing the person from Porlock; Wordsworth's ageing. Ruskin's epic strives, like *The Prelude* or *Prometheus Unbound* or *Biographia Literaria,* to give both scientific accuracy and a mythological shape to the uncertain romantic religion; but, as Coleridge stumbles and draws back when it comes to the unveiling of the central mystery, the definition of Imagination, so Ruskin's moral anatomy of nature is baffled and betrayed; the confidence cannot be sustained, and, by the end of *Praeterita*, he is left as the poets were with fitful moments, the sad indistinct brilliance of the fireflies of Fonte Branda, like gleams of inspiration flickering through the darkening air. Turner records durations, glances, accidents of light – the visual equivalent of Wordsworth's spots of time; Ruskin wishes to construct from these a dogma: to build a cathedral out of paintings. And in dwelling on design, structure, organic arrangement, *Modern Painters* leads from painting towards the firmer, more substantial, more dogmatic security of architecture, in *The Stones of Venice*. The truths of architecture are solid, not momentary like those of painting. If *Modern Painters* is Ruskin's *Prelude*, an account of the growth of his mind and his wedding to nature, *The Stones of Venice* is his *Excursion,* severe, marmoreal, concerned less with youthful inspiration than with middle-aged duty. In the former he deals

with the rendering of natural appearances; in the latter with the laws of construction, the hard granitic substance underneath the natural beauty. The one is a folio of sketches elevated into encyclopaedia and Bible; the other is the product not of the sketcher but of the architect. Charlotte Brontë thought it 'nobly laid and chiselled. How grandly the quarry of vast marbles is disclosed! He writes like a consecrated Priest of the Abstract and Ideal.' The work has, she says, 'foundations of marble and granite'. As its first valedictory sentence, surveying the dangerous eminence of the three oceanic powers of history, Tyre, Venice and England, hints, it is a sombre epic account of the decline and fall of Venice, deriving from Milton by way of Gibbon, rather than from Wordsworth.

Ruskin moves from the ecstatic moments of painting to the stern durability of architecture, and in doing so he is swimming upstream, as it were, towards the source; for historically the development has been in reverse, from architecture to painting. Architecture, he argues at the end of *The Stones of Venice*, has declined into painting: 'the shadows of Rembrandt, and savageness of Salvator, attested the admiration which was no longer permitted to be rendered to the gloom or grotesqueness of the Gothic aisle. And thus the English school of landscape, culminating in Turner, is in reality nothing else than a healthy effort to fill the void which the destruction of Gothic architecture has left.' The permanent summaries of experience made by the cathedrals, their mirrors of nature, sculptured processions and hierarchies, their ordering of history, dwindle into the partial, limited scenes of the painters. The cathedral is a treasure-house of detail, museum, encyclopaedia and temple at once; in its massiveness it includes all of existence, and this bulging compendiousness becomes one of the persisting literary ambitions of the nineteenth century.

The passage in the second volume of *The Stones of Venice*, in which Ruskin contrasts an English rural cathedral with San Marco in Venice, reveals something of the literary significance of the cathedral, which in the first case is merged with nature and in the second with the city (and thus, as will appear in the discussion of Hugo and Browning, with the novel):

'And now I wish that the reader, before I bring him into St Mark's Place, would imagine himself for a little time in a quiet

English cathedral town, and walk with me to the west front of its cathedral. Let us go together up the more retired street, at the end of which we can see the pinnacles of one of the towers, and then through the low grey gateway, with its battlemented top and small latticed window in the centre, into the inner private-looking road or close, where nothing goes in but the carts of the tradesmen who supply the bishop and the chapter, and where there are little shaven grass-plots, fenced in by neat rails, before old-fashioned groups of somewhat diminutive and excessively trim houses, with little oriel and bay windows jutting out here and there, and deep wooden cornices and eaves painted cream colour and white, and small porches to their doors in the shape of cockle-shells, or little, crooked, thick, indescribable wooden gables warped a little on one side; and so forward till we come to larger houses, also old-fashioned, but of red brick, and with gardens behind them, and fruit walls, which show here and there, among the nectarines, the vestiges of an old cloister arch or shaft, and looking in front on the cathedral square itself, laid out in rigid divisions of smooth grass and gravel walk, yet not uncheerful, especially on the sunny side where the canons' children are walking with their nurserymaids. And so, taking care not to tread on the grass, we will go along the straight walk to the west front, and there stand for a time, looking up at its deep-pointed porches and the dark places between their pillars where there were statues once, and where the fragments, here and there, of a stately figure are still left, which has in it the likeness of a king, perhaps indeed a king on earth, perhaps a saintly king long ago in heaven; and so, higher and higher up to the great mouldering wall of rugged sculpture and confused arcades, shattered, and grey, and grisly with heads of dragons and mocking fiends, worn by the rain and swirling winds into yet unseemlier shape, and coloured on their stony scales by the deep russet-orange lichen, melancholy gold; and so, higher still, to the bleak towers, so far above that the eye loses itself among the bosses of their traceries, though they are rude and strong, and only sees like a drift of eddying black points, now closing, now scattering, and now settling suddenly into invisible places among the bosses and flowers, the crowd of restless birds that fill the whole square with that strange clangour of theirs, so harsh and yet so soothing, like the cries of birds on a solitary coast between the cliffs and sea.

'Think for a little while of that scene, and the meaning of all its small formalisms, mixed with its serene sublimity. Estimate its secluded, continuous, drowsy felicities, and its evidence of the sense and steady performance of such kind of duties as can be regulated by the cathedral clock; and weigh the influence of those dark towers on all who have passed through the lonely square at their feet for centuries, and on all who have seen them rising far away over the wooded plain, or catching on their square masses the last rays of the sunset, when the city at their feet was indicated only by the mist at the bend of the river. And then let us quickly recollect that we are in Venice, and land at the extremity of the Calle Lunga San Moisè, which may be considered as there answering to the secluded street that led us to our English cathedral gateway.

'We find ourselves in a paved alley, some seven feet wide where it is widest, full of people, and resonant with cries of itinerant salesmen, a shriek in their beginning, and dying away into a kind of brazen ringing, all the worse for its confinement between the high houses of the passage along which we have to make our way. Over-head an inextricable confusion of rugged shutters, and iron balconies and chimney flues pushed out on brackets to save room, and arched windows with projecting sills of Istrian stone, and gleams of green leaves here and there where a fig-tree branch escapes over a lower wall from some inner cortile, leading the eye up to the narrow stream of blue sky high over all. On each side, a row of shops, as densely set as may be, occupying, in fact, intervals between the square stone shafts, about eight feet high, which carry the first floors: intervals of which one is narrow and serves as a door; the other is, in the more respectable shops, wainscotted to the height of the counter and glazed above, but in those of the poorer tradesmen left open to the ground, and the wares laid on benches and tables in the open air, the light in all cases entering at the front only, and fading away in a few feet from the threshold into a gloom which the eye from without cannot penetrate, but which is generally broken by a ray or two from a feeble lamp at the back of the shop, suspended before a print of the Virgin. The less pious shopkeeper sometimes leaves his lamp unlighted, and is contented with a penny print; the more religious one has his print coloured and set in a little shrine with a gilded or figured fringe, with perhaps a faded flower or two on each side, and his lamp burning brilliantly.

Here at the fruiterer's, where the dark-green water-melons are heaped upon the counter like cannon balls, the Madonna has a tabernacle of fresh laurel leaves; but the pewterer next door has let his lamp out, and there is nothing to be seen in his shop but the dull gleam of the studded patterns on the copper pans, hanging from his roof in the darkness. Next comes a "Vendita Frittole e Liquori", where the Virgin, enthroned in a very humble manner beside a tallow candle on a back shelf, presides over certain ambrosial morsels of a nature too ambiguous to be defined or enumerated. But a few steps farther on, at the regular wine-shop of the calle, where we are offered "Vino Nostrani a Soldi 28·32", the Madonna is in great glory, enthroned above ten or a dozen large red casks of three-year-old vintage, and flanked by goodly ranks of bottles of Maraschino, and two crimson lamps; and for the evening, when the gondoliers will come to drink out, under her auspices, the money they have gained during the day, she will have a whole chandelier.

'A yard or two farther, we pass the hostelry of the Black Eagle, and, glancing as we pass through the square door of marble, deeply moulded, in the outer wall, we see the shadows of its pergola of vines resting on an ancient well, with a pointed shield carved on its side; and so presently emerge on the bridge and Campo San Moisè, whence to the entrance into St Mark's Place, called the Bocca di Piazza (mouth of the square), the Venetian character is nearly destroyed, first by the frightful façade of San Moisè, which we will pause at another time to examine, and then by the modernising of the shops as they near the piazza, and the mingling with the lower Venetian populace of lounging groups of English and Austrians. We will push fast through them into the shadow of the pillars at the end of the "Bocca di Piazza", and then we forget them all; for between those pillars there opens a great light, and, in the midst of it, as we advance slowly, the vast tower of St Mark seems to lift itself visibly forth from the level field of chequered stones; and, on each side, the countless arches prolong themselves into ranged symmetry, as if the rugged and irregular houses that pressed together above us in the dark alley had been struck back into sudden obedience and lovely order, and all their rude casements and broken walls had been transformed into arches charged with goodly sculpture, and fluted shafts of delicate stone.

'And well may they fall back, for beyond those troops of ordered

arches there rises a vision out of the earth, and all the great square seems to have opened from it in a kind of awe, that we may see it far away – a multitude of pillars and white domes, clustered into a long low pyramid of coloured light; a treasure-heap, it seems, partly of gold, and partly of opal and mother-of-pearl, hollowed beneath into five great vaulted porches, ceiled with fair mosaic, and beset with sculpture of alabaster, clear as amber and delicate as ivory – sculpture fantastic and involved, of palm leaves and lilies, and grapes and pomegranates, and birds clinging and fluttering among the branches, all twined together into an endless network of buds and plumes; and, in the midst of it, the solemn forms of angels, sceptred, and robed to the feet, and leaning to each other across the gates, their figures indistinct among the gleaming of the golden ground through the leaves beside them, interrupted and dim, like the morning light as it faded back among the branches of Eden, when first its gates were angel-guarded long ago. And round the walls of the porches there are set pillars of variegated stones, jasper and porphyry, and deep-green serpentine spotted with flakes of snow, and marbles, that half refuse and half yield to the sunshine, Cleopatra-like, "their bluest veins to kiss" – the shadow, as it steals back from them, revealing line after line of azure undulation, as a receding tide leaves the waved sand; their capitals rich with interwoven tracery, rooted knots of herbage, and drifting leaves of acanthus and vine, and mystical signs, all beginning and ending in the Cross; and above them, in the broad archivolts, a continuous chain of language and of life – angels, and the signs of heaven, and the labours of men, each in its appointed season upon the earth; and above these, another range of glittering pinnacles, mixed with white arches edged with scarlet flowers – a confusion of delight, amidst which the breasts of the Greek horses are seen blazing in their breadth of golden strength, and the St Mark's Lion, lifted on a blue field covered with stars, until at last, as if in ecstasy, the crests of the arches break into a marble foam, and toss themselves far into the blue sky in flashes and wreaths of sculptured spray, as if the breakers on the Lido shore had been frost-bound before they fell, and the sea-nymphs had inlaid them with coral and amethyst.

'Between that grim cathedral of England and this, what an interval! There is a type of it in the very birds that haunt them; for, instead of the restless crowd, hoarse-voiced and sable-winged,

drifting on the bleak upper air, the St Mark's porches are full of doves, that nestle among the marble foliage, and mingle the soft iridescence of their living plumes, changing at every motion, with the tints, hardly less lovely, that have stood unchanged for seven hundred years.

'And what effect has this splendour on those who pass beneath it? You may walk from sunrise to sunset, to and fro, before the gateway of St Mark's, and you will not see an eye lifted to it, nor a countenance brightened by it. Priest and layman, soldier and civilian, rich and poor, pass by it alike regardlessly. Up to the very recesses of the porches, the meanest tradesmen of the city push their counters; nay, the foundations of its pillars are themselves the seats – not "of them that sell doves" for sacrifice, but of the vendors of toys and caricatures. Round the whole square in front of the church there is almost a continuous line of cafés, where the idle Venetians of the middle classes lounge, and read empty journals; in its centre the Austrian bands play during the time of vespers, their martial music jarring with the organ notes – the march drowning the miserere, and the sullen crowd thickening round them – a crowd, which, if it had its will, would stiletto every soldier that pipes to it. And in the recesses of the porches, all day long, knots of men of the lowest classes, unemployed and listless, lie basking in the sun like lizards; and unregarded children – every heavy glance of their young eyes full of desperation and stony depravity, and their throats hoarse with cursing – gamble, and fight, and snarl, and sleep, hour after hour, clashing their bruised centesimi upon the marble ledges of the church porch. And the images of Christ and His angels look down upon it continually.'

Ruskin's two scenes, the drowsy piety of the cathedral close contrasted with the riotous profanity of San Marco, are, one might say, a Constable over against a Turner; they span the dissimilar worlds of the two greatest English romantic painters. Ruskin's English cathedral might have been Constable's Salisbury; his San Marco is certainly Turner's. The Constable half of the diptych is dark, wet and earthy; the Turner half is all fire and air, iridescent, explosive and visionary. The dark towers of the English cathedral have a moral steadiness: the clock regulates the duties of the town, the towers assert themselves as a landmark, 'catching on their square masses the last rays of the sunset.' They recall the spire of

Constable's Salisbury, which becomes a heroic force in his land-scapes, and particularly the large canvas of 1831, in the collection of Lord Ashton of Hyde, of the cathedral seen from the meadows – a cart toils through the mire, a tree gleaming white is bent by gusts of wind, the sky is as stormy as the earth is muddy, and the paint is laid on like mud flecked with snow; but, resisting the elements, the spire stands erect with heroic determination, and its triumph in the turbulent sky is signalled – like a victor being crowned in a history painting – by a rainbow. The landscape and the building express a drama, without human intervention; the comment of Constable's friend Archdeacon Fisher of Salisbury, that it represents 'The Church under a Cloud', imperilled by reformers, is ironically apt, for it does suggest will, struggle, energy.

Ruskin described the English scene in two very long sentences which meander ahead, perambulating, gathering up details, finding time for interruptions: the first winds from a retired street into the cathedral square, noting on the way every detail of window, cornice, porch and gable. It leads us forward; the second leads us up, from porch to mouldering wall of sculpture, arcades and gargoyles, higher up to the bleak towers so far above that the eye cannot pick out distinct details; and as it leads up it leads into nature, as Constable's spire is made to contend with the gusty clouds. Architecture becomes dramatic, engaged in an age-old struggle with the elements: at one level the grotesque heads are worn by rain and wind into 'yet unseemlier shape' and discoloured by lichen; above this, at the dizzy height of the towers, the traceries are like a cliff lodging the restless birds with their strange clangour 'like the cries of birds on a solitary coast between the cliffs and sea' – the building has become part of a desolate and storm-beaten landscape, in which it stands as an image of heroic fortitude, like the isolated trees of the painters and poets. This architectural drama of exposure and endurance appears as well in *Wuthering Heights,* in the contrast between the wild, fearful Heights and Thrushcross Grange cowering in cosy security in the valley. Ruskin's description of the Westmorland cottage in *The Poetry of Architecture* suggests Wuthering Heights: he says that its angles are strengthened with large masses and its windows narrow and deep set, and the house in the novel is strong and sturdy, its windows deep in the wall, its corners defended with jutting stones.

But more than this, Ruskin here again recalls Wordsworth: he finds in the building a brooding philosophic temper; the colour of the ground on which it stands, it is calm, quiet, severe 'as the mind of a philosopher, and, withal, a little sombre' – the gravity of Wordsworth. Architecture does carry a burden of narrative and moral sentiment in his poetry – 'The Ruined Cottage' is less Margaret's tragedy than the cottage's.

From Constable and Wordsworth, Ruskin passes to Turner and, perhaps, Dickens; from the grim, calm sublimity of the country to the uproar of city streets and the splendours, profanity and brazen confusion of Venice. The English cathedral suggests stern, unswayed moral force: tragically eroded by time, it has become part of nature, and moves us in the same way Wordsworth's stones and trees do; however, the Venetian cathedral has become not nature but a city, not set apart by a close and a square where we must not walk on the grass, but relentlessly burrowed into by a population of noisy, brawling, profane creatures, who crowd into the paved alley around it and invade the walls, their shops densely set in intervals between the shafts which carry the first floors, their wares spilling into the street, the shops (like Dickensian dwellings) gloomy holes in the earth. It is all a dark irregular catacomb, like Dickens's London; but into it a light suddenly breaks, with a Martinian or Turnerian éclat, and the crowded pillars fall back in amazement as 'the vast tower of St Mark seems to lift itself visibly forth from the level stones'; the arches collapse backwards and range themselves into seemliness, and beyond them 'there rises a vision out of the earth, and all the great square seems to have opened from it in a kind of awe.' The drama of architecture here is not Constable's noble endurance but the grandiose fantasy and teetering insubstantiality of Martin's architecture or Turner's – the spires of Venice in 'Juliet and Her Nurse', for instance, which Ruskin describes in *Modern Painters* as 'pyramids of pale fire from some vast altar'. For the romantics high mountains were a feeling; for Ruskin, so are buildings. And feeling transforms architecture into landscape: the sculpture twines in a jungle of buds and plumes, the capitals, as in Ruskin's drawings, are entwined and 'rooted knots of herbage'. The shadow receding from the pillars reveals 'line after line of azure undulation, as a receding tide leaves the waved sand'; while the iridescence and glowing decoration of the whole bursts at

the top – 'as if in ecstasy, the crests of the arches break into a marble foam, and toss themselves far into the blue sky in flashes and wreaths of sculptured spray, as if the breakers on the Lido shore had been frost-bound before they fell, and the sea-nymphs had inlaid them with coral and amethyst.' Marble foam, sculptured spray – metaphor fuses stone and sea; the materials of the building are wakened into life, yet bejewelled and frozen into art.

But as well as this Turnerian radiance, there is in the hectic and crowded animation of the scene a suggestion of Dickens. San Marco is surrounded by mean tradesmen, café idlers, military bands, cursing, fighting children, creatures listlessly sunning themselves like lizards in the porches, all indifferent to the splendours above them – 'and the images of Christ and His angels look down upon it continually.' The angel descending into the affray of the city – as Ruskin in *The Eagle's Nest* dreams of a Botticellian wreath of angels hovering over the crashing, rumbling, screaming confusion of Ludgate Circus – is an image dear to Dickens: the ray of light playing on Jo as he sweeps the church steps in *Bleak House*, or the entry of the blessed Arthur and Dorrit into the roaring streets at the end of *Little Dorrit*. Dickens's Gothic architecture includes both the grisly dragons and mocking fiends of Ruskin's English cathedral and the solemn angelic forms of San Marco – both Fagin and Oliver Twist, both Quilp and Little Nell.

There are indeed affinities between Turner and Dickens, for both confound the classical segregation of high from low, beauty from ugliness, by taking their creative start from the clutter and disarray of the city; they are alike in both being Hogarthian. Schlegel had said that romanticism, revelling in chaos and disharmony, got closer to the mysterious heart of things than classicism with its lucidity and proportion; and Turner and Dickens are poets of this chaos. Turner makes it sublime – tumbling boulders, thrashing waves, the vortex of the snowstorm as Hannibal crosses the Alps, a sea-monster glaring through the dawn mist, waterfall and deluge, the formless eruptions of light and colour in the pictures illustrating Goethe's theories – but its source, as Ruskin reveals in the passage in *Modern Painters* comparing his boyhood with that of Giorgione, is the grime and squalor and untidiness of his early surroundings, the Hogarthian or Dickensian world of Maiden Lane, Covent Garden. Hogarth's pictures are a

restless thronging hurly-burly of detail, lacking any sense of space: his imagination has nothing of the pastoral, as Hazlitt said; and Turner, for whom even the St Gothard was a *'litter* of stones', delights in the crowded chaos suggested to him by the city, in shingle, débris, heaps of fallen stones. Ruskin even finds clusters of greengrocery in his foregrounds; his forms are lumpish, like shape- less sacks tossed about in Covent Garden market: they are loose and baggy, like Victorian novels. Dickens too enjoys litter, the crowded untidiness of Mr Venus's shop in *Our Mutual Friend* or the genial chaos of Mr Brogley's in *Dombey and Son*, in which second- hand furniture is thrown together into strange incoherence, with chairs hooked to washing-stands poised on sideboards on the wrong side of dining-tables; and he even has an equivalent to the avalanches and rubble and tempests of Turner: this is the railway excavations in Staggs's Gardens in *Dombey*, which become an earthquake throwing up a topsy-turvydom of carts, confused treasures of iron and Babel towers, pitting the earth, erupting into hot springs, creating 'a hundred thousand shapes and substances of incompleteness, wildly mingled out of their places, upside down, burrowing in the earth, aspiring in the air, mouldering in the water, and unintelligible as any dream.' Turner too yearns, as Hazlitt said, 'to go back to the first chaos, or to that state of things when the waters were separate from the dry land, and light from darkness. . . . All without form and void.' But whereas Turner shows nature in an uproar, the chaos in Dickens is urban and man-made.

Ruskin's comparison of Turner, schooled in manners and morals at Chelsea and Wapping, picking up his language at Deptford, Billingsgate, Hungerford and Covent Garden, and consorting with the nymphs of barge and barrow, with Giorgione of Castelfranco in his world of beauty,[1] appears to be another Victorian lament, like the Prelude to *Middlemarch*, for the gap between the heroic and beautiful past and the vulgar present. In his notes on Turner's drawings Ruskin does make such a lament: 'while he lived, in imagination, in ancient Carthage, [he] lived, practically, in modern Margate', the town so loathed by Arnold. And as Maggie Tulliver in *The Mill on the Floss* wants to be rescued from the gypsies by Jack the Giant-Killer or Mr Greatheart or St George, but realises

[1] *Modern Painters*, vol. v, part ix, ch. ix 'The Two Boyhoods'.

'with a sinking heart that these heroes were never seen in the neighbourhood of St Ogg's – nothing very wonderful ever came there', so at the end of *Modern Painters*, in a dark passage of his private symbolism, Ruskin leaves Turner as the victim of the unheroic nature of modern life: art commemorates great spiritual facts, the triumph of Pallas in Athens, the Assumption of the Virgin in Venice, in England the Assumption of the Dragon, but there is 'no St George any more to be heard of; no more dragon-slaying possible; this child, born on St George's Day, can only make manifest the dragon, not slay him, sea-serpent as he is. . . .' The two boyhoods section is not, however, of this kind: it accepts the present, and transforms the coarse and unintellectual Turner into an epic hero and a prophet revealing the mysteries of the universe, the Angel of the Apocalypse.

The beauty of Venice is much less real than the ugliness of London. The lulling Tennysonian alliteration of Ruskin's description of Venice – 'still the soft moving of stainless waters, proudly pure' – and its melting blue distances make it a mirage, shimmering and weightless. Heaven is an arch, the sea a circle, the hills are poised, the Alps like a procession: the landscape has the finished lyrical perfection of the Claudes Ruskin derided; it is an ideal view floating, graceful and formal, above the actual, and he abruptly grounds it with the topographical exactness of what follows: 'Near the south-west corner of Covent Garden, a square brick pit or well is formed by a close-set block of houses. . . .' From a landscape of dream he passes to one we can walk into: 'Access to the bottom of it is obtained out of Maiden Lane, through a low archway and an iron gate; and if you stand long enough under the archway. . . .' The beauty of Venice is precious, enamelled, lapidary, like the golden dreams of the Pre-Raphaelites. Marble, gold, emerald, jasper, alabaster, 'every pinnacle and turret gleamed and glowed, overlaid with gold, or bossed with jasper' – it might be a city in a Pre-Raphaelite background, and its inhabitants, whose characters are as in Tennyson or Burne-Jones less important than their costumes, seem stitched into a Pre-Raphaelite tapestry or a stained-glass window, flat and decorative: 'pure as her pillars of alabaster, stood her mothers and maidens; from foot to brow, all noble, walked her knights.' They are merely mobile costumes: 'the low bronzed gleaming of sea-rusted armour shot angrily under their

blood-red mantle folds.' Venice is 'a wonderful piece of world. Rather, itself a world' – but like Tennyson's Arthurian realm, it is discontinuous with the real one, depending, as did classical art, on a rigorous exclusion. Venice has been purified, austerely forbidding the low, the quotidian, the ordinary – 'a world from which all ignoble care and petty thoughts were banished, with all the common and poor elements of life.' This exclusion has become an architectural ordinance: 'No weak walls could arise above them [its tremulous streets]; no low-roofed cottage, nor straw-built shed'; and it has become an exclusion of life: unlike the passage in *The Stones of Venice*, here the streets are not only free from foulness and tumult, they are free from life itself, feeling only the 'music of majestic change, or thrilling silence'. The streets are like Pugin's New Jerusalem or the langorously curling staircases and towers which often form backgrounds to Burne-Jones's paintings; they are part of a city of papier-mâché. In the London of Turner, on the other hand, dusty, dingy, sooty, muddy, everything is soiled by common labour, and its very untidiness and shabbiness excite a compassion which is found as well in the grotesquerie of Dickens, and which Giorgione's 'visions of Greek ideal' cannot permit: Turner's 'sensibility to human affection and distress,' Ruskin points out, 'was no less keen than even his sense for natural beauty – heart-sight deep as eyesight.' Like Dickens, he makes high art out of low materials. He is tolerant of vulgarity without himself becoming vulgar though 'on the outside, visibly infected by it, deeply enough; the curious result, in its combination of elements, being to most people wholly incomprehensible', as George Eliot found Dickens phrenologically very undistinguished, and high-mindedly wrote to Burne-Jones that nasty art would be produced by those with mean and nasty minds, great art only by those with noble souls. Ruskin finds in Turner something rather like the streaky bacon of Dickens's double plots, a twisting together of the vulgar with the noble, of Keats and Dante – the lip-licking delight in sense and cockney avidity of the one with the large philosophic intellect of the other; and his metaphor for this suggests something perhaps more inextricable than Dickens's 'regular alternation, as the layers of red and white', an entanglement of high and low, silk and tar: 'It was as if a cable had been woven of blood-crimson silk, and then tarred on the outside. People handled it, and the tar came

off on their hands; red gleams were seen through the black under-
neath, at the places where it had been strained. Was it ochre? – said
the world – or red lead?' Beauty shines through the mire.

Dickens's streaky bacon adapts to the novel Shakespeare's
interweaving of tragedy and comedy; both force angel and gargoyle
into tragi-comic proximity in a Gothic manner, for which Ruskin
has an architectural analogy. In *The Poetry of Architecture*,
discussing architectural composition and the means of increasing
the degree of an effect by contrast, he recommends placing a spot
of warm red in a chilly blue scene because the strong contrast will
render the blue chill more apparent, will intensify it; and he sees an
analogy to this in the solecisms for which Shakespeare was blamed
by neo-classic critics – his suffering the bawdy nurse and the
flippant Mercutio, the drunken porter, Lear's fool or the grave-
digger to wander into and interrupt the tragic action. But rather
than abruptly altering the mood, these things, Ruskin says,
'enhance it to an incalculable extent; they deepen its *degree*, though
they diminish its duration. And what is the result? That the
impression of the agony of the individuals brought before us is far
stronger than it could otherwise have been, and our sympathies are
more forcibly awakened.' Without the enlivening force of the
contrast, the tragedy would sentimentally taper off into a pity.
Again, in *Seven Lamps*, he insists that the drama of architecture
must be true to the dramatic contradictions of life, as Shakespeare
is; as he mingles genres, so architecture must think in shadow as
well as in highlights: 'the Power of architecture may be said to
depend upon the quality . . . of its shadows; . . . the reality of its
works . . . require of it that it should express a kind of human
sympathy, by a measure of darkness as great as there is in human
life: and that as the great poem and great fiction generally affect us
most by the majesty of their masses of shade, and cannot take hold
upon us if they affect a continuance of lyric sprightliness, but must
often be serious, and sometimes melancholy, else they do not
express the truth of this wild world of ours; so there must be, in
this magnificently human art of architecture, some equivalent
expression for that trouble and wrath of life, for its sorrow and its
mystery: and this it can only give by depth or diffusion of gloom,
by the frown upon its front, and the shadow of its recess. So that
Rembrandtism is a noble manner in architecture, though a false

one in painting; and I do not believe that any building was ever truly great, unless it had mighty masses, vigorous and deep, of shadow mingled with its surface.' A great building, in other words, must have a double plot.

In making architecture organic, Ruskin makes it tragic: the fate of the Venetian style is that of a Shakespearean hero, mined from within by moral weakness, led astray into decadence by the smooth beguilements of Renaissance classicism. Or perhaps, more than Shakespeare, Ruskin's architectural tragedy suggests George Eliot: as a character like Tito is betrayed by a series of self-persuasions which seem innocuous but which harden and corrupt him gradually, because they make him forfeit 'the noble attitude of simplicity' and enlist his 'self-interest on the side of falsity', so Venice declines from the vigour and piety of its Gothic youth by compromising with the false classicism of the Renaissance. Venice inadvertently reveals that it has lost its soul in its buildings, which are the outward evidence of its moral state as chance actions, tell-tale gestures, for instance his terror when he sees Piero's portrait of Baldassarre, are in Tito's case. The hardening of a cruel and selfish veneer of success and ambition in Tito is matched by the Venetian workman, who 'secured method and finish, and lost, in exchange for them, his soul.' George Eliot's unforgiving analysis of the consequences of a momentary wrong choice, the impairing of the will towards goodness which it entails – Tito, in rashly saying he believes his adoptive father to be dead makes it 'impossible that he should not henceforth desire it to be the truth that his father was dead; impossible that he should not be tempted to baseness rather than that the precise facts of his conduct should not remain forever concealed' – is translated by Ruskin into the history of art. The Renaissance demand for perfection demoralised the Venetians and they slipped, like Tito or Lydgate or Gwendolen Harleth, imperceptibly into corruption: 'imperatively requiring dexterity of touch, they gradually forgot to look for tenderness of feeling; imperatively requiring accuracy of knowledge, they gradually forgot to ask for originality of thought. The thought and feeling which they despised departed from them, and they were left to felicitate themselves on their small science and neat fingering.' Buildings are Ruskin's characters, and their constructional quirks are his equivalent to the entanglement of motive, wish and self-

delusion which concern the novelist; his account of the Palladian
church of San Giorgio Maggiore, for instance, is psychoanalysis in
architecture – in revealing the curious reasons for its form he has
defined its moral flaws. It is a confused attempt to serve two gods,
Christian church and Greek temple, and its fatal compromise leads
it into an embarrassing contortion: the high central nave of the
Christian plan must be faced, in the Greek manner, with pillars of
one proportion and height, which the builders achieve by the
expedient of first raising a Greek temple and then pushing another
temple on pedestals up through its roof. Ruskin seizes on this and
other such solecisms with the diagnostic glee and indignation of one
of Jane Austen's killing epigrams.

If the Renaissance has a treacherous luxury, Greek architecture,
for Ruskin, errs at the opposite extreme in its starved restraint;
he praises the mean between them, the growing, living, Shake-
spearean architecture of Gothic Venice. 'The Doric manner of
ornament admitted no temptation,' he says in writing of the Lamp
of Power; 'it was the fasting of an anchorite – the Venetian
ornament embraced, while it governed, all vegetable and animal
forms; it was the temperance of a man, the command of Adam over
creation.' It is Shakespearean in its comprehensive sympathy, and
in its vitality. Hawthorne's judgement of Gibbs's Radcliffe Camera
in Oxford in 1856 follows Ruskin's principles: 'I always see great
beauty and lightsomeness of effect in these classic and Grecian
edifices, though they seem cold and intellectual, and not to have
their mortar moistened with human life-blood, nor to have the
mystery of human life in them, as Gothic structures do'; Gothic
turns stone into flesh, as it were. It possesses a touchingly human
imperfection: reviling the dead perfection of the Renaissance,
Ruskin insists, as the romantics had drawn attention away from
the work of art as an artefact, consciously fashioned and in-
dependent, towards its origins in the emotions of the artist, that
the thoughts and feelings of the workman are more significant than
the product of his work. It is a law that 'his work must always be
imperfect, but his thoughts and affections may be true and deep.'
Ruskin's sympathetic sense of the necessary imperfection of
buildings corresponds to the refusal of the novelists to idealise their
characters: Charlotte Brontë says in *Shirley* that her pen draws
only imperfect specimens, avoiding both paragons and monsters;

George Eliot's Amos Barton is the essence of his mediocrity, and even his faults are middling; while in *Adam Bede*, like Ruskin scorning the panoply of Renaissance idealisation, she confesses herself happy to leave 'cloud-borne angels, . . . prophets, sibyls, and heroic warriors' for the domestic ordinariness of Dutch pictures.

Yet Gothic is also a force of nature: mountains, the Mont Cervin for instance, are treated as nature's architecture, and as well the noblest architecture is mountainous, monumentally stable and granitic, seeming not to care about the holes (arches) tunnelled into it, and not subsiding into them. These are laws about the ranking of detail which are 'exactly the same with respect to Rouen Cathedral or the Mont Blanc.' Goethe's account of his Italian journey anticipates Ruskin in its effort to yoke together romantic vision and scientific explanation – his theories of meteorology and the gravitational force of mountains attracting and holding clouds to them scientifically explain the romantic atmosphere of mountain gloom and thunderstorm, lowering northern weather and the Shelleyan struggle of electrical forces in the air; and he felt his knowledge of mountains and their minerals was of great advantage in his architectural studies. Ruskin presses the identification further, discovering in their rough wildness a 'look of mountain brotherhood between the cathedral and the Alp'. Buildings are transformed into landscapes: the difference between the pure Italian buttress-system and that of north is that between 'the sublimity of a calm heaven or a windless noon' and 'a mountain flank tormented by the north wind, and withering into grisly furrows of alternate chasm and crag' – between, one might say, a Claude and the stormy foaming rocky peaks of John Martin's illustration to 'The Bard'. At the end of the second volume of *The Stones of Venice*, his vision of the Alps rising behind the Ducal Palace, seen from the Lido, stirs him to wonder which is the nobler and more awesome work, the building or the hills. The image of the Alps crested with silver clouds, their rocks lifted higher than the clouds of heaven, is Wordsworthian; but it is applied, as it never is in Wordsworth, to art and to the works of man judged against those of nature. Ruskin brings Wordsworth into the city. Architecture becomes the city-dweller's substitute for nature.

Architecture is alive – 'a wall has no business to be dead,' Ruskin says, and he likens its foundation to an animal's paw – and its life

symbolises spirit. The Christian shaft actually builds the Christian idea of distinct services to the individual soul, where the shaft of the Egyptians embodies their notion of the servitude of the masses; the architect must learn from the form of 'God's arch, the arch of the rainbow and of the apparent heaven, and which the sun shapes for us as it sets and rises.' Construction symbolises the moral nature of a building. Ruskin's discussion of the arch line, for instance, insists on its inward strength, to use the phrase of Mrs Gaskell's Thornton: the arch line is the spinal marrow of the arch, the voussoirs the vertebrae protecting and clothing it; it is 'the moral character of the arch, the adverse forces are its temptations; and the voussoirs, and what else we may help it with, are its armour and its motives to good conduct', as if in one of Spenser's allegorical edifices. His House of Temperance has ordered proportions, a balance of masculine and feminine shapes and a constructional pattern based on the mystic numbers seven and nine, which are iconographically contrasted with the weak foundations of the House of Pride; similarly the square and speckled stone of Herbert's 'The Church-floore' represents Patience, while its sweet cement is Love and Charity. The moral life of Ruskin's buildings, however, is dramatic rather than diagrammatic. The engineering forces of resistance and calculation and balance are engaged, like Constable's spire, in a moral drama; a Ruskinian building has that Teutonic marrow, that inward strength independent of exterior nicety, which Thornton praises. The sturdiness of its members is a moral consistency, a refusal to deviate. It lives and struggles and prevails; it is personified, as the flatly iconic structures of the Renaissance allegorists are not.

Structure gives a building one half of its human life, will and intelligence; decoration gives it the other half, for it displays affection. Decoration is the irresponsible, sportive side of a building, its imagination indeed, and Ruskin refuses to place it under the rule of structure, leaving it free to wander and entangle itself and create its gargoyles, its forms 'beautiful and terrible mixed together', as in a Shakespearean play or a Dickens novel. This separation of structure and ornament opens up again the rift between whole and detail, for the ornamental fretwork is permitted to pursue its own course, and can tend to gain control, as the subsidiary figures do in Dickens. This is particularly liable to

happen because of the finickiness of northern grotesque detail: the
architects of the south respect broad surfaces and grand lines, but
those of the north delight, as Ruskin says, in small pinnacles, dots,
crockets, twitched faces, in 'the multiplication of small forms . . .
and a certain degree of consequent insensibility to perfect grace and
quiet truthfulness; so that a Northern architect could not feel the
beauty of the Elgin marbles. . . .' The play of detail rebels against
the whole: finials and crockets flaunting themselves on roof ridges,
admits Ruskin, have a liveliness which is 'adverse to the grandest
architectural effects, or at least to be kept in severe subordination
to the serener character of the prevalent lines' – as neo-classic
painters had clung to the chaste rigour of line as a defence against
the emotional effusions of colour. However, though such detail may
prevent a building from seeming majestic, it preserves it from
dullness. One of the de-humanising effects of factories is that they
reintroduce a uniform, mechanical version of the classical tyranny
of the line: men are 'wasted into the fineness of a web, or racked
into the exactness of a line.' Classicism has no place for the minute,
which fascinated Victorian novelists and painters; and grotesquerie
consists in minute quirks, in small twisted deviations – it creates a
treasure-house of detail which is, again, an indifferent whole.
Grandeur is always proportional, and Gothic structures, like
Victorian novels, prefer to expand into a loose baggy freedom.
Theirs is the unruly natural impetus Carlyle finds in revolutionary
ardour: 'there is nothing but what grows, and shoots forth into its
special expansion, – once give it leave to spring.' Proportion gives
way to proliferation. Gothic buildings and Victorian novels spread
like trees, or sprawl like cities. Ruskin regrets that pagan sculptors
were indifferent to the beauty of the stems of trees, 'but with
Christian knowledge came a peculiar regard for the forms of
vegetation, from the root upwards', and the history of this kind of
ornament is envisaged as the life-cycle of a tree: 'it began with the
rude and solid trunk, as at Genoa; then the branches shot out, and
became loaded with leaves; autumn came, the leaves were shed,
and the eye was directed to the extremities of the delicate
branches; – the Renaissance frosts came, and all perished.'

Against orders, Vitruvian laws, the standardised practice of
Palladio, Ruskin sets the liberty and contrariety of the grotesque.

As in the novel the grotesque derives from character, from an individuality which digs in its heels, a comic variant of that constancy Shakespeare's Romans admire, so in architecture it testifies to the Christian discovery of the value of every soul. For Aurora Leigh, poetry and philanthropy converge at this point: both recognise that the hungry beggar-boy

> Bears yet a breastful of a fellow-world
> To this world, undisparaged, undespoiled,
> And (while we scorn him for a flower or two,
> As being, Heaven help us, less poetical)
> Contains, himself, both flowers and firmaments
> And surging seas and aspectable stars,
> And all that we would push him out of sight
> In order to see nearer.

Christianity teaches, Ruskin says, that 'there is no intelligence so feeble but that its single ray may in some sort contribute to the general light', and hence Gothic architecture is alive in all its details: it is a spiritual democracy of detail, like a novel – 'every jot and tittle, every point and niche of it, affords room, fuel, and focus for individual fire.' The cathedrals are a testament to the freedom of thought of the workers, who can make their personal imprint upon the structures as the minor characters do upon Victorian novels, literally carving out an area for themselves; a Gothic cathedral is, like *The Ring and the Book*, an 'epic of free speech', to employ G. K. Chesterton's phrase. The Gothic architect and the novelist both revel in imperfection, irregularity, contradiction. Both realise that human faces are not symmetrical, that their oddities are expressive, and that 'to banish imperfection is to destroy expression, to check exertion, to paralyse vitality.' Rigid perfection is impossible in anything living – it is never complete, always in part growing, in part decaying; hence perhaps the sense of untiring hurrying movement in the novels of the period – they refuse to stay still long enough to crystallise into works of art; they always have some further branching and multiplying life to express. The Gothic architects 'out of fragments full of imperfection, and betraying that imperfection in every touch, indulgently raise up a stately and unaccusable whole'; and the novelists do the same, also working with artless materials, with the raw stuff of life, do without formal rules and without heroic or saintly perfection in their

subjects, but they indeed create stately and unaccusable – though perhaps indifferent – wholes.

Ruskin worries, in the discussion of the grotesque Renaissance in the volume on the fall of Venice, about how far the ludicrous and the fearful, which make up the grotesque, are compatible with noble art – a problem which exercised Dickens's critics as well: George Eliot was upset by his concentration on the humorous externals of idiom and manners at the expense of psychological character and conceptions of life; Henry James felt he was too entranced by grotesqueries to care about creating examples of rational humanity, or to be able 'to prosecute those generalisations in which alone consists the real greatness of a work of art.' The noble grotesque, Ruskin decides, has its source in three states of mind, apathy, mockery, and diseased, ungoverned imagination; and it is the satiric grotesque which is of most importance to literature, for not only does Ruskin allude here to Shakespeare – sorrow and infinite tenderness are intermixed with it, as Lear is accompanied by the loyal but petulant, whimpering fool, – he also suggests the Gothic affinities of Dickens's humour: this humour is demotic and spontaneous, but 'the classical and Renaissance manufactures of modern times having silenced the independent language of the operative, his humour and satire pass away in the word-wit which has of late become the especial study of the group of authors headed by Charles Dickens; all this power was formerly thrown into noble art, and became permanently expressed in the sculptures of the cathedral.' The Gothic cathedral is replaced not only by landscape painting, but by the Victorian novel: the gloomy sublimity of the one and the mocking jocularity of the other combine to make up a relic, a nineteenth century ruin, of the comprehensive art of the cathedrals. The novel also yearns back towards the inclusiveness of Shakespeare who was, as Hugo put it, the last of the Gothic cathedrals; and Ruskin, defending the grotesqueness of Tintoretto, adds, 'Of the grotesque in our own Shakespeare I need hardly speak, nor of its intolerableness to his French critics; nor of that of Æschylus and Homer, as opposed to the lower Greek writers; and so I believe it will be found, at all periods, in all minds of the first order.'

It is found, conspicuously, in Hugo, whose preface to *Cromwell* greets the anti-classical art of the nineteenth century, and whose

Notre Dame de Paris builds a monument to it. Swinburne said that this novel had a 'Grecian perfection of structure, with a Gothic intensity of pathos'; but its structure is as Gothic as its feeling. The Gothic cathedrals were sermons in stone, inventories of knowledge and systems of revealed truth graven into fixity and permanence; after the middle ages, however, this authoritative summary falters, and the monumentality of architecture gives way to the expository, hinting and defining mode of literature, which can take nothing for granted and must justify the ways of God to man as Milton does, rather than simply presenting them, showing them, as the cathedrals do. *The Ring and the Book,* as we shall see, is in a sense a cathedral built to doubt. Hugo's remarkable novel, though, creates in literature something like the amplitude of the cathedrals; or rather it transforms the cathedral into a city, into nature (as in the passage about its sunken foundations quoted in the third chapter), into fantasy, and into the grotesque individuality of a character, Quasimodo. The novel is a literary cathedral. In the nineteenth century, poems are like buildings: the romantics worked at things over long periods, allowing them to spread and expand, tinkering at them, and the novels rather haphazardly sprawled across several months, growing and taking improvised turns with each new instalment, in the same way as the cathedrals grew through a number of stylistic epochs; two architectural strata, Romanesque and Gothic, are overlaid in Notre Dame as two Wordsworths are in *The Prelude* or two Davids in *David Copperfield,* one young and gladly experiencing, the other older and reflecting, trying to make sense of the other's experiences. In the middle ages, buildings, on the other hand, are like poems: Claude Frollo adores 'the symbolical doorway of Notre Dame, that page of configuration written in stone by Bishop William of Paris, who has undoubtedly been damned for attaching so infernal a frontispiece to the sacred poem eternally chanted by the rest of the structure'; the savage Quasimodo loves the building for its beauty and harmony, as Caliban is thrilled into appreciation of the voices in the air, but the cultivated Frollo loves it for its mystic meaning, 'the symbolic language lurking under the sculpture on its front, like the first text under the second in a palimpsestus.' Medieval poems often seem to be the product of masons, built up as brick is added to brick, the whole cemented together by dogma; nineteenth century buildings

often seem to be the work of poets: Victorian Gothic is a literary and poetic abuse of architectural forms, which it draws on for their associations rather than for their appropriateness or utility, or indeed sometimes to disguise a shameful utility. A building becomes its aura, its poetic atmosphere, as in Ruskin's dissolution of the structure of San Marco into a foaming seascape.

In Ruskin's view, architecture declines into painting; in Hugo's, it declines into literature – the book of stone kills the book of paper, as the archdeacon says. 'During the first six thousand years of the world's existence . . . architecture was . . . the chief writing of the human race,' Hugo explains. 'Every human thought finds a page in this vast monumental book.' He agrees with Ruskin in seeing the Renaissance as a decadent interlude between the death of one art and the birth of its successor; Gothic architecture had been a democratic expression of the race, a deposit left by it, but Renaissance architecture is trivialised into mannerism and pseudo-antique pastiche. The great poems of the architectural period were themselves monuments: 'In India, Vyasa is as multifarious, strange and impenetrable as a pagoda. In Egypt, poetry, like the buildings, is majestic and composed in outline; in ancient Greece, it has beauty, serenity, calm; in Christian Europe, religious majesty, homely simplicity, the rich and luxuriant vegetation of an age of renewal. The Bible may be compared to the Pyramids, the Iliad to the Parthenon, Homer to Pheidias. Dante, in the thirteenth century, is the last Romanesque church; Shakespeare, in the sixteenth, the last Gothic cathedral.' Literature is an ant-hill, a Tower of Babel, a thousand-storeyed edifice: 'The eye may luxuriate in the arabesques, rose-windows, and lace-work on its outer walls. Every individual work, however fantastic and isolated it may appear, has its niche in that building. The result of the whole is harmony. From the cathedral of Shakespeare to the mosque of Byron, a thousand turrets cluster promiscuously about this metropolis of universal thought.' The Victorian museums in South Kensington and Oxford, themselves hives, ant-hills, massive accretions of matter, also testify to this nineteenth century sense of cultural history: the past has grown and accumulated, like a cathedral, like a city; it is a vast residue; the museum without walls turns out to be the treasure-house of detail.

The cathedral has the indulgent inclusiveness of Shakespeare and

the novel: it has their unity in diversity, the same sort of design underlying a thronging and apparently formless liveliness which the romantics perceived in nature – as Shakespeare or Homer and nature were said to be the same, so Hugo calls it 'a sort of human Creation; in short, mighty and prolific as the Divine Creation, of which it seems to have caught the double character – variety and eternity.' Like the novelist and like Shakespeare, it happily accepts the grotesque variety of life, not classically purifying it. Its logic is that of nature, not that of Vitruvius and Vignola, as for de Quincey Shakespeare's plays are like stars or flowers – its growth is vegetative ('a graft that shoots out, a sap that circulates'), and like the species of nature it is variegated without but simply uniform within: the cathedrals appear to differ, but they share an orderly design of two intersecting naves, chancel and chapels. 'The trunk of the tree is unchanging, the vegetation is capricious.' Quasimodo is an attempt to return to the medieval grotesque spirit which last appears in Shakespeare: the sad, charitable, deranged, smiling attitude to human folly of his clowns, which has already begun to change, in figures like Malvolio or Jaques, who envies the clown Touchstone, into the diagnostic, medical attitude to folly of Jonson, in whom the merciful humourist becomes the satirist coolly apportioning penalties. All are fools; all are ugly – hence the Flemish orgy of the grimacing competition. Quasimodo is a grimace, the leer of a gargoyle, 'a strange exception to the everlasting rule which prescribes that strength, like beauty, shall result from harmony.' He is a Gothic construction – though when he is in the pillory, Jehan Frollo calls to the crowd to watch the whipping, and advertises him as 'a fellow of Oriental architecture, with his back like a dome, and his legs like twisted columns!' This recalls not only the balustrade legs of the man in Dickens, but suggests the architectural wit of Carlyle's description of Teufelsdröckh's style in *Sartor Resartus*. The Teutonic disarray of the style is seen as a Gothic ruin, bristling with pinnacles, shambling into incoherence: his sentences stand 'in quite angular attitudes, buttressed-up by props (of parentheses and dashes), and ever with this or the other tagrag hanging from them; a few even sprawling out helplessly on all sides, quite broken-backed and dismembered.' Medieval German costume takes on a similar form: the men wear hats with peaks and Gothic-arch intersections. Classical architecture employs

165

perfect forms, the square and the circle, taking its geometric lucidity from a universe in which, it believes, all is pattern and proportion; this humoristic Gothic delights, on the other hand, in the contorted and the shapeless, in whatever is hilariously out of joint, restlessly uneven, for its universe is not in the classical state of equipoise but eager, bustling, leaping up to its God, unable to remain calm. The art of the North has a consuming energy, as Ruskin defines it in *The Stones of Venice*, in contrast with the torpor of the East, and the cumbersome frolics of Carlyle, Dickens and Hugo are an expression of this. Ruskin imagines that 'the Lombard of early times seems to have been exactly what a tiger would be, if you could give him love of a joke, vigorous imagination, strong sense of justice, fear of hell, knowledge of Northern mythology, a stone den, and a mallet and chisel. . . .'

Quasimodo is a gargoyle: he is Gothic animated, a detail terrifyingly emerging from the whole. When he rescues Esmerelda he appears on the gallery of royal statues above the portal, neck stretched, face deformed, like one of the stone monsters through whose gaping mouths the gutters drain themselves; later, during the siege, he appears on the topmost gallery among the sculptured demons and dragons which seem to be laughing in the firelight. Ruskin had pointed to the sleepless disquietude of Gothic – the mind is teased and fretted and perplexed by niche, pinnacle and knotty decoration; and this effect is recaptured by Butterfield in his stripes and zigzags, which are, as it were, grimaces in stone. Hugo more than describes Notre Dame as restless: he brings it to life, as Dickens does his buildings. It flickers alive in the firelight; it is wakened into life by Hugo's romantic lighting, by fire, lightning, moonlight. Quasimodo rescues Esmerelda in a swoop so quick that 'had it been night the whole might have been seen by the glare of a single flash of lightning' – as Kean's Lear was said to have been like reading the play by flashes of lightning. Frollo appears to the shuddering Esmerelda like the ghost of himself, 'an effect of the moonlight – a light by which one seems to see only the spectres of objects.' This is Gothic light: it has the gloomy suspended fearful spirituality of Dickens's fog. In a conscientiously scientific way Joseph Wright of Derby had made experiments in combining these romantic lights, which replace the serene rational light of classical landscape painting – the relation between the half-hidden

moon and the eerie furnace-fires in his pictures of Arkwright's mill and the blacksmith's shop, between moon and lantern in 'The Earth-Stopper', or between cloudy moon and the phosphorescent glow weirdly emanating from the suffocating dove, casting the room into shadow and transforming a scientific experiment into a drama, in the picture of the air-pump.

Chiaroscuro is romantic light. It animates not only the cathedral but the city: 'what was visible of Paris seemed wavering on all sides in a sort of shadow mingled with light, resembling some of Rembrandt's backgrounds.' Hugo calls Rembrandt 'the Shakespeare of painting'; he introduces grotesquerie into painting, yet transfigures the ugliness by the drama of his light. Frollo's hermetic eyrie is described by reference to a Rembrandt etching of a Faustian mystic in a cell full of the instruments of his demonic art, gazing at a luminous circle, a cabalistic sun of magic letters, which has appeared before him, 'at once horrible and beautiful'. As the romantic view of Shakespeare begins with his medieval Gothic qualities — his grotesque realism, his interweaving of tragedy and comedy — but translates these into the attributes of romantic Gothic, making him an apparition, a surging natural force, tenebrous and awesome, so Hugo passes from the Flemish realism and tragic light of Rembrandt to the nervous terrors of Goya, whose grotesquerie is the product of the sleep of reason, and whose shadows stir with monstrous life: what begins as realism has become a dream, so that the penitent in the cramped Gothic cell is 'one of those spectres, half light, half shade, such as are seen in dreams, and in the extraordinary work of Goya.' It is built from the romantic gloom: 'neither woman nor man, nor living being, nor definite form; it was a figure – a sort of vision, in which the real and the fanciful were intermingled like light and shadow.' Hugo's cathedral turns out to be, after all, a painting by Rembrandt and Goya, as Ruskin turns San Marco into a Turner, and as he argues that Rembrandtism though a false manner in painting is acceptable in architecture – architecture has given way to painting and to literature.

Hugo identifies the cathedral with the city, as Ruskin does with San Marco. He surveys fifteenth century Paris from the summit of the towers; both city and cathedral have grown, they are both products of natural process – a flood of houses overflowing the

ancient enclosures, other houses shooting upwards like plants confined laterally, seeking the air, accumulations of houses rising like water in a basin – and both are transformed into nature. The city quivers and vibrates when the bells are rung from all the steeples, becoming an orchestra, a 'symphony as a loud as a tempest'; and the cathedral too becomes an Aeolian harp, for, like Caliban's island, it is full of musical voices, the chants of its services, the trembling casements, the trumpeting organ, the humming steeples: its architecture makes stray vibrations orchestral. For all Hugo's tribute to grand public art of the cathedral, embodying the nation's history and immortalising its values, his sense of the building is subjective and romantic, so that for Quasimodo it turns out to be, like a snug Dickensian burrow, an exoskeleton – it is his egg, nest, house, country, world, and so perfect a fit is there between its angles and his that the two merge: he has 'taken its form as the snail takes that of its shell'; he adheres to it, 'like the tortoise to its shell. The cathedral, with its time-roughened surface, was his carapace.' He is the idiosyncratic detail which engulfs the rational whole; its Gothic becomes his, and, ceasing to be a public place enshrining authorised values, it becomes a strangely private one, hiding a monstrous yet somehow lyrical dream.

Notre Dame is an edifice of transition, which has grown over a long period; it is a formation such as beavers and bees also make, for 'the great symbol of Architecture, Babel,' Hugo says, 'is a hive.' The great Victorian poems are also like cathedrals. James Knowles in 1870 spoke of seeing Tennyson's *Idylls of the King* grow over several decades like Canterbury Cathedral – like Blake in his comparison with Westminster Abbey, he thought the Gothic building 'far more poetical than St Paul's' – as 'round some early shrine, too precious to be moved, were gathered . . . a nave and arches, then rich side-chapels . . . then a more noble chancel . . .'; and Henry James in 1912 spoke of *The Ring and the Book* as 'so vast and so essentially Gothic a structure, spreading and soaring and branching at such a rate, covering such ground, putting forth such pinnacles and towers and brave excrescences, planting its transepts and chapels and porticos, its clustered hugeness or inordinate muchness. . . .' Browning's poem is a cathedral, and a city. Gothic irritates and stimulates the eye with detail, and Victorian ornament

also delights in knobs, in florid or jagged outcrops of decoration, in notches, flounces, bobbles, fringes, plush frames, gilt clasps; and here there is perhaps an analogy to the cluttered, inchoate, teeming character of Browning's verse. His verse is, like a city, crowded. Or like a Victorian painting, the lines are crammed with things – circlets, slivers, files' tooth and hammer's tap, ring-thing, rondure brave: the first lines bristle with detail – and choked with substantives, a 'manageable mass', a lump of raw matter not yet moulded into form. The alliterative tendency of the verse somehow intensifies the muddle, as the things alliteratively bump into one another, like Dickens characters colliding in a London street:

> Quote the code
> Of Romulus and Rome! Justinian speak!
> Nor modern Baldo, Bartolo be dumb!
> The Roman voice was potent, plentiful . . .

or clamorously draw attention to themselves through noisy internal rhyme:

> Thus wrangled, brangled, jangled they a month.

We *hear* in the verse the roaring narrow streets of medieval Italy. Browning's emendations in 1872 and 1889 often concentrate not on clarifying but on making the fray denser with new inversions and coinages, giving a perverse animation to minutiae so as to produce in language something of that failure of selection noticed in the paintings. Things jostle and nudge themselves into prominence, the words are like impatient people elbowing their way through a crowd:

> Buzzing and blaze, noontide and market-time

or

> Spark-like 'mid unearthed slope-side figtree-roots.

Browning's metaphors are like the ornament of 1851, having a perverse unnatural exactness, an extravagant ingenuity: they are machine-made versions of Donne's conceits; hence the appropriateness of the gold-alloy idea which gives the poem its title.

The queer grotesque heterogeneity of the market-place in San Lorenzo is an image for the poem and for the swarming multitudinousness of the Victorian novel, a Dickensian plenitude of odds and ends, like one of Mayhew's swags:

> 'Mongst odds and ends of ravage, picture-frames
> White through the worn gilt, mirror-sconces chipped,

> Bronze angel-heads once knobs attached to chests, . . .
> Samples of stone, jet, breccia, porphyry
> Polished and rough, sundry amazing busts
> In baked earth, (broken, Providence be praised!)
> A wreck of tapestry. . . .

The angels recall the decapitated cherubim on the funereal bureau of Mrs Clennam in *Little Dorrit*. The things are all crumpled, broken, chipped, worn, tattered, even the Virgin in the street-corner niche remembered by Pompilia:

> The babe, that sat upon her knees, broke off, –
> Thin white glazed clay, you pitied her the more.

Browning, like the novelists with their baggy monsters and the painters with their claustrophobic spaces, seems to be straining against the frame, anxious to cram in as much as possible. The form becomes a receptacle, a hold-all like Mrs Betsey Prig's amazing apron, and the criterion is not discipline or relevance but tight packing in of detail; this shapelessness joins art and nature, for the poem comes to seem a miscellany of objects like the world itself, or like the raw matter of experience. Classical form imposes itself on the material; Browning's form is merely something to pour the material into – the half-print half-manuscript yellow book containing the documents about the murder case is 'a book in shape', yet actually a mass of life,

> but, really, pure crude fact
> Secreted from man's life when hearts beat hard.

To the romantics, a poem was like a flower; Browning's shares the life not of nature but of man-made artefacts: the book he tosses in the air and the poem made out of it, as a cake is made out of dough, are one with the teeming life of the market, the flapping brown-etched prints, the clinking copper cans, the outspread straw-work, the rows of brass lamps. And, like Dickens's novels, it is one with the city: Browning describes the process of reading as one with that of threading the maze of Florence. In the piazza the book leads him stumbling through market-wares, and

> Still read I on, from written title-page
> To written index, on, through street and street,
> At the Strozzi, at the Pillar, at the Bridge;
> Till, by the time I stood at home again . . .
> I had mastered the contents.

This is a poem about its own growth: it includes its own sources and describes its development from them. The book is a ruin from which Browning, kicking through the crumblement by the road-side, reconstructs an edifice, as Hugo imaginatively (and Viollet-le-Duc actually – the historical novel is a branch of romantic archaeology) 'repairs' Notre Dame. Browning begins with facts, proceeds to character and thence to judgement; it is as if James's New York prefaces had become part of the novel. The first part grows ruminatively, returning to the book and to the gold-alloy metaphor, modifying, shedding, entwining and recapitulating: 'Here it is, this I toss and take again,' or 'beseech you, hold that figure fast!' Book I deals with 'fact untampered with', the prelude to the creative process which James confines to his prefaces; amplifying and inventing, asking 'Is fiction which makes fact alive, fact too?', Browning suggests James refusing to hear the end of the anecdote which he was to make into *The Spoils of Poynton*, working at the transmutation of life into art. Later, the poem grows by multiplication of aspects, in the monologues. the brooding of Book I, puzzling over the artistic possibilities of the case, leads to the employment of opposing points of view, 'voices called in evidence'. This is the novel which the poem contains, and its technique indicates the novel's developing tendency to abandon action for consciousness, for now facts matter less than their refraction by the minds of the reflectors. But from the ambivalence of experience the poem passes to the judgement made by the Pope, whose authoritarian finality – 'I have mastered the whole matter: I nothing doubt' – James could not countenance, for it retreats from the fascinating dubiety of the novel to the dogmatic certainty of epic. A cathedral which seems to be built to relativism – and Ruskin claimed that classical and medieval art was great because it built to its gods, but modern art was insignificant because it built to no God – turns out after all to enthrone the Pope.

This self-modifying growth is an image of aspiration, of busy striving for heaven, yearning and reaching upwards like the fretful verticality of the Gothic cathedrals:

> Man, – as befits the made, the inferior thing, –
> Purposed, since made, to grow, not make in turn,
> Yet forced to try and make, else fail to grow, –

> Formed to rise, reach at, if not grasp and gain
> The good beyond him, – which attempt is growth, –
> Repeats God's process in man's due degree. . . .

The short stuttering continually qualified phrases are a series of
leaps, or of jumping boards, one vaulting to the next, straining
ahead. But as well as straining forward, the poem finds time to
saunter, to explore detours; it is a poem not so much of action as of
idling, loquaciously expansive, picking a wayward path through
the complicated maze of the case, rather than classically taut and
cleanly shaped. It finds time and room, like a novel, for detail –
as Ruskin praised Gothic for being able to accommodate a
multitude of workers, each imprinting his own personality on the
edifice. Hugo points out the endless variability of the Gothic plan,
and Browning perhaps gains a similar freedom for himself in the
image of the Bernini fountain in the market-place of the Barberini,
which sends a jet of water

> High over the Caritellas, out o' the way
> O' the motley merchandising multitude.

The Triton is an image of force, of grotesquely lively power,
snorting water from his wreathed horn, steel sleet breaking to
diamond dust, chaotically beautiful in the crush of the piazza; the
verse catches the mannerism of the design – the wide-mouthed
dolphins balancing the huge shell on their tails, the rearing
straining posture of the sea-god, the huffing and puffing as he emits
the jet – and Browning sports with language with some of the
animal exuberance with which the Triton sports in the water.
Browning splashes and romps in language, churning it up, hurling
it into collapsing shapes and cascades. The Triton possesses above
all the energy Ruskin found in northern art, and Browning makes
him Gothic rather than baroque – he is in his way a gargoyle, and
he gives warning of the poem's freedom to indulge in playful detail
of this kind.

He also suggests that, as for Keats the long poem was a place to
wander in (as one can wander through Dutch landscape paintings,
or Claudes), so for Browning one of its delights was the possibility
it offered for a more urban sort of loitering – the wanderings of the
flâneur here by the Barberini, or the gossips

> Midway the mouth o' the street, on Corso side,
> 'Twixt palace Fiano and palace Ruspoli,

172

or the palace-step in San Lorenzo meant for the lounging knaves of
the Medici. The poem's 'muchness' suggests the cathedral and the
city at the same time, and, lazily and erratically moving ahead,
capriciously turning aside, sniffing the trail of gossip down back
streets, it assumes the form of the city. As a city poem it is a poem
of crowds: the spectators cramming the organ-loft, climbing
columns, fighting for spikes of the chapel-rail for a perch from
which to view the bodies. Everything becomes noisily social: at
Arezzo Pietro trumpets his wrongs

> At church and market-place, pillar and post,
> Square's corner, street's end, now the palace-step
> And now the wine-house bench,

where Violante is voluble

> In whatever pair of ears would perk
> From goody, gossip, cater-cousin and sib,
> Curious to peep at the inside of things,

and the nominal trade of the prostitute who is spotted by Violante
and followed home is washing clothes at the cistern by the Piazza
di Monte Citorio, where she whispers to idlers who pause to admire
her shining ankles beside the fountain; the bench the fugitives sat
on at the hostel becomes an object of wonder, and in Arezzo Guido
must 'traverse the length of sarcasm in the street'; not only does
the Abbate read Pompilia's letter, he also gives it to 'all Rome to
ruminate upon'. Browning's own interest in the case harmonises
with that of the gossips: he too pries and peeps, questioning, eaves-
dropping, listening to whatever version of the facts he can hear,
delighting in exaggerations and biases as the crowd at the church
hopes for much from Curate Carlo, an expert in improving the
event. The intricacy, the blind corners and dark passages of human
motive through which the poem gropes, are imaged in the labyrinth
of the city which the characters negotiate: Pietro sallying into the
Piazza di Spagna

> across Babbuino the six steps,
> Toward the Boat-fountain where our idlers lounge,

or Violante mingling with the crowd on the way to confession,
marching in at the right-hand door in the west front of St Peter's
and boldly up the left nave, then later, passing by San Lorenzo, she

> Dives down a little lane to the left, is lost
> In a labyrinth of dwellings best unnamed,

> Selects a blind one, black at base . . . ;

or Paolo's leading Guido to the woman-dealer in perukes in the
Piazza Colonna; the letters thrown to Caponsacchi in the street
from behind the lattice; Pompilia hustled to the church to be
married, through

> the Lion's-mouth
> And the bit of Corso;

gossip smelling its way to the decent home 'cornered in snug
Condotti'; the Comparinis' change of abode from the Via Vittoria,
where the neighbours are too inquisitive, to a villa on the outskirts
in the Pauline Way, to which a friend from Civitavecchia might get
access surreptitiously; Guiseppe's tense pacing through the city.
He makes his way to the window:

> So, I went: crossed street and street: 'The next street's turn,
> I stand beneath the terrace, see, above,
> The black of the ambush-window . . .',

as the murderers make their way to the suburban villa:

> The dreadful five felt finger-wise their way
> Across the town by blind cuts and back turns.

Archangelis refers to 'this huge, this hurly-burly case': it has a
way, a Gothic way perhaps, of growing unexpectedly, spreading
and complicating itself, becoming everyone's business – hence the
introduction of the two advocates and the town speculation
surrounding them. The double plot is reshaped to cope with this
expansion: the red and white of the streaky bacon are not so much
overlaid as arranged in concentric circles, as it were – the three
central monologues, buried deep in the poem's centre like the
pieces from Cathy's diary in *Wuthering Heights*, are tragic and
intimate, but surrounding them, the three gossips to one side, the
pair of advocates to the other, are more detached and jocular
accounts of the same events. These events inspire either tragic
intensity or comic inconsequence, and Browning revels in this
disunity: the poem seems to spread outwards, like circles in water,
and the further away from the events the more comedy a
commentator can afford; it spreads like a tree, it sprawls like a
town. The Pope employs the simile of a tree, saying that 'little
seeds of art' grow great into leafage and branchage, and this is how
the poem grows; he also insists that 'truth, nowhere, lies every-
where', and not absolutely in any portion: it is 'evolvable from the

whole' – a whole which is no more than a treasury of puzzling, inconclusive detail. Transforming poetry into the novel, the cathedral into the city, epic authority into the novelist's finger-wise feeling of his way into motive and conscience, *The Ring and the Book* provides a moral justification for that artistic flaw James found in *Middlemarch*: we have only details; from them we must try to build a rather shaky whole.

6. 'THE PAST FOR POETS;
THE PRESENT FOR PIGS'

DESPITE Browning's transformation of poem into novel, there comes to be an enmity in Victorian literature between the novel and poetry, the one burrowing into the detail of the present, the other retreating into a dream of the past, the one accepting the rowdy chaos of life, the other seeking to order or refine it, to make it grand or to make it beautiful. The two forms stand anxious guard over their boundaries. The poets resent the novelists: Matthew Arnold's 1853 preface to his poems warns against appeasement of the novel, against compromise with the local and temporary in novelistic verse. He wishes to defend the poetic tradition against such dangerous hybrids as Clough's *Bothie*, or *Maud*, or *The Angel in the House*, a group of domestic epics 'dealing with the details of modern life which pass daily under our eyes', and fated to be transitory. The painters share this fear and hatred: Delacroix called realistic art dirty and disgusting; Burne-Jones recoiled in dismay from the unpoetically brutal ends of Anna Karenina and Tess of the D'Urbervilles – he felt that such perverse cruelty on the part of the novelists could only be explained as a desperate attempt to shock hard hearts into sympathy, and he was sure he had no need of this treatment. The novelists are equally suspicious of poetry: when Scott's Lucy in *The Bride of Lammermoor* makes a poetic pledge of fidelity, Ravenswood chides her, 'This is poetry . . . and in poetry there is always fallacy, and sometimes fiction.' She agrees to promise again 'in honest prose'. Catherine Morland, who is expelled from Gothic fiction and made to accept the unsurprising sobriety of life in the midland counties, has many descendants in the Victorian novel, characters whose poetic hopes are contradicted by actuality, who are made to submit, painfully and not gladly as Catherine does, to what George Eliot called 'the pressure of that hard unaccommodating Actual', the domain of which is prose. Maggie Tulliver longs for release from the tedium of her surround-

ings by some heroic rescuer, but must learn that the figures of myth and epic do not inhabit the neighbourhood of St Ogg's; Dorothea Brooke must acquiesce in the frustrating, hampering conditions of Middlemarch life. The novel makes of its prose a grim standard of stern reality and middling satisfaction to which the characters must bow.

A fretful, uncertain irony plays over these disappointed figures – they are tragic in their apprehension of their fates, yet comic in being victims of their own delusions, who are only reminded at the end of something they should always have known. The dreamers and questers in romantic poetry are released into ineffable fulfilments, like Prometheus or Endymion or Mazeppa or the happily accommodating Don Juan, who all awake to find their dreams truth; but those who desire poetic lives in novels are inevitably brought to grief. Mrs Arrowpoint in *Daniel Deronda* has written a fictionally reconstructed life of Tasso, and Gwendolen flatters her by agreeing that 'imagination is often truer than fact'. The novel is of course to teach her the inescapability of fact. Trollope's treacherous Lizzie in *The Eustace Diamonds* is addicted to Byron (as Gwendolen's 'uncontrolled reading' leaves her unprepared for the shock of reality), and feels 'for the moment that after all, poetry was life and life was poetry', or 'poetry was what her soul craved; – poetry, together with houses, champagne, jewels, and admiration.' Isabel Archer wishes to affront a poetic destiny, like Millie Theale hovering on her precipice above the coloured beauties of the world; but, like Millie, she is made to descend – the visions of both are cruelly disappointed, and they find themselves entrapped in fact, in prose, in the novel. Isabel admits that the world is, after all, very small.

Prose is the mode of necessity, poetry of freedom; realism limits, vision liberates. Jane Eyre is a rare and early case of a romantic heroine who is allowed to succeed, but only at the price of a flagrant sacrifice of fact to vision, of the unalterable circumstances of the novel to the soaring fulfilments of poetry: magic releases her, Rochester's wife is removed, she receives a fairy inheritance, she hears Rochester's nocturnal cry at the other end of the country and goes to him. She is saved for happiness and poetry; Fanny Price and Anne Elliot are also saved from Jane's fate of becoming a governess with the same happy unreality. But this George Eliot's

prose conscience will not permit: after the loss of the family fortune Gwendolen is to become a governess, though she swears she'd rather emigrate, and although satiric reference is made to wish-fulfilling romances in which plain governesses (presumably like Jane Eyre) make brilliant matches, the marriage which saves her from that miserable fate is, she is aware, itself fatal. Catherine's choice of a heroic, poetic future with the Lisztian Klesmer is a comment on this, for it stings her mother into a recognition, a parody of George Eliot's own, of the gap between literature and life: what is all right for Leonora in her book on Tasso is not all right for her daughter. Gwendolen craves the epic: she tells Rex she would like to go to the North Pole, or ride steeple-chases, or go to be a queen in the East, like Lady Hester Stanhope; she regrets that 'we women can't go in search of adventures – to find out the North-West passage or the source of the Nile, or to hunt tigers in the East.' But she too is entrapped and enfeebled by social convention, and can achieve nothing.

Poetry represents dreamy release, the novel chafing contingency. Romantic poetry becomes suspect because it flatters our sense of our own limitless capacities; the novel returns us to the necessary social world in which we are encircled by others, whose existences limit and circumscribe our own. Arnold, however, is suspicious not only of romantic poetry but also of the novel, and puts in their place, in the 1853 preface and the 1861 lecture on translating Homer, the poetry of the grand style, classic and severe, frowning down on the tormented complexity and over-richness of modern verse and on novelistic poetry involved in the minutiae of behaviour and the ephemera of fashion. The classic poem deals, in a spirit of seriousness and moral grandeur, not with behaviour, but with action; the grand style is monumental and external, depicting the permanence and truth of things, a calm objectivity which the modern artist has deserted to move inside the mind. Arnold's account of the decline from classic grandeur to romantic intro-version accepts the developments outlined in the first chapter of this work. He is in accord with other theorists of romanticism, Schiller, who called the ancient poet naïve and impersonal, possessed utterly by the objects of the world, like Homer, and the modern sentimental, constantly intruding into his work as Byron does; or Schlegel, for whom Greek art rejoiced in a harmony of the

faculties, in a serene balance, whereas modern art has become Christian and romantic, impelled by impossible desires, agitated by internal discords, and thus blending the elements separated by the ancients, verse and prose, seriousness and mirth, spirit and sense. But while the other critics, like Hugo in the *Cromwell* preface, welcome the liberation from genre and rules and extol Shakespeare's rebellion against them, Arnold yearns for the rigidity and restriction which have been overthrown. He distrusts Shakespeare: when beginning *The Tempest* in 1853 he wrote to Clough, 'How ill he often writes!' He insists that Shakespeare's example is as bad as that of the florid romantics, with his unclassical torrent of images and confusion of tragic and comic; regretting the breakdown of the classical segregation of styles, Arnold points to Oedipus and Macbeth as figures who are essentialised in the classical way, freed from the local and casual, and in doing so quite misses the great difference between Sophoclean and Shakespearean tragedy – it may be true, as D. H. Lawrence said, that there are no W.C.s in the houses of classical tragedy, but Shakespeare's genius lay precisely in riddling the sombre and passionate atmosphere of tragedy with the comic and low, Macbeth's nightgown, the puckish mischief-making of the witches, the porter's drunkenness.

The grand style commemorates action, public deeds. But modern literature has turned from the public to the private, from the classical ideal of a life spent in the public view, in which only the idiot prefers the quiet of private life, to self-absorption, sheltering inside oneself and inside the home; from celebration of action to exploration of consciousness. Action may be grand. A deed in an epic may have a finished perfection and prowess which immortalises it. But consciousness can never be grand – it is, as Sterne was the first to realise, too waywardly associative, too undisciplined and bathetic; it specialises in scurrilous unclassical leaps from tragedy to comedy, as when, at Bobby's death, Susannah thinks only of her chances of acquiring Mrs Shandy's green dress, or when, at his mother's death, David Copperfield relishes the awe with which his school-fellows regard his bereavement; it is, like Byron, everything by starts and nothing long. Despite Arnold's emphasis on the sustaining power of poetry which deals with action rather than the nervous, rebarbative, soliloquising mind, the successes of modern literature have been with consciousness, its failures with

action. The novel has been able to represent the last refinements of thought and feeling, but not the public deeds of those who live by doing rather than by delicately responding to the deeds of others. Dickens's grotesques have, in their moments of relaxation, a malevolent suggestiveness which is much more terrifying than their actual villainous schemes, and the economic dealings of his Mr Merdle in *Little Dorrit* are as obscure as those of Mr Vanderbank in *The Awkward Age*, who is Deputy Chairman of the mysterious 'General Audit', or Mr Brookenham, whose equally vague employment is 'Rivers and Lakes', and is worth 'twelve hundred – and lots of allowances and boats and things. To do the work.' James, who leads the novel from the private into the secret life, succeeds with his reserved, prurient, subtle observers, but cannot demonstrate in Christopher Newman or Adam Verver the ruthless ability to act necessary to the accumulation of their vast fortunes, just as Forster succeeds with the speculative Schlegels but not with the empire-building Wilcoxes. Virginia Woolf can present the half-dozen lyric consciousnesses of *The Waves*, but must leave out the man of action, Percival, in whom they are so obsessively interested, as in *Jacob's Room* the inquiring minds encircle a centre, Jacob, who is simply not there – who exists not in what he does or is but in what others think about him. And Clough, reviewing the 1853 volume, discerned in Arnold himself a strain of 'over-educated weakness of purpose', an inadequacy for the kind of cathartic action his preface recommends. Despite his longing for the solidity of epic and for respite from the spiritual discomforts of an age lacking in moral grandeur, Arnold in his confessional poems and in 'Empedocles on Etna' deals with patchy doubting moods in a way which establishes him as an ancestor of Prufrock and the other over-cultivated, reticent, Jamesian persons of Eliot's early poetry.

Arnold finds classical justification for the grand style; he also guards its exclusiveness by attaching it to the classics, the few touchstones and the patrician 'small band of the very best poets, the true classics'. Medieval and Renaissance rhetoricians had non-committally divided styles into high, medium and low, allowing the appropriateness of each to its own subject matter; but for Arnold the grand style has become an exemplary standard, a moral ideal as well as a literary kind: it is a counterpart to the culture or 'totality' or 'study of perfection' of *Culture and Anarchy* or the

heightening of ethics, the 'morality touched by emotion' which is the poetry of religion in *Literature and Dogma*. George Eliot has a similar dream of a stern grandeur. In 1867 she reprimanded Frederic Harrison for his mockery of Arnold's 'cant about culture', saying, 'I don't know how far my impressions have been warped by reading German, but I have regarded the word "culture" as a verbal equivalent for the highest results of past and present influences'; and she hopes to join the 'choir invisible' of humanist saints who, like Daniel Deronda, live as sublime types of self-sacrifice, urging men to vaster issues.

> So to live is heaven:
> To make undying music in the world,
> Breathing as beauteous order that controls
> With growing sway the growing life of man.

The uplift, the grand style emanating from a noble nature, the secular equivalent for religious inspiration, are very Arnoldian, as is the reverence for tradition in *The Spanish Gypsy*:

> We had not walked
> But for Tradition; we walk evermore
> To higher paths, by brightening Reason's lamp.

The grand style with its earnestness, its way of consoling man by interpreting the world to him, its 'thoughts sublime that pierce the night like stars', actually serves the march of mind. Arnold has a counterpart to her choir invisible in the guardian angels of humanism who, with his father, hover over a shabby humanity in 'Rugby Chapel':

> And through thee I believe
> In the noble and great who are gone . . .
> . . . souls temper'd with fire,
> Fervent, heroic and good.

George Eliot conscientiously composed poetry in later life because she regarded it as the ideal vehicle for uplift, for elevating her humanism into something more inspiriting and reconciling. Prose, and the novel, depress; poetry rouses and heightens. Poetry for her could do without natural magic so long as it had moral profundity. She took to poetry as a kind of religious labour; Arnold eventually denied himself expression in verse, because he believed poetry must depend on a secure religious faith, and this he had lost. Yet he was sure the future of poetry would be immense, and in this

certainty he had been anticipated by Carlyle, who wrote of the 'high destinies which yet await literature', and insisted that 'the proper task of literature lies in the domain of BELIEF.'

Ravenswood had been distrustful of poetry for the traditional reason that it was more concerned with elegant feigning than with plain truth; for the Victorians, however, it has a chance to redeem itself by divesting itself of fancy and ornament and assuming the austere moral responsibilities of prose. Poetry turns out to be prose heightened, as religion is ethics heightened: Carlyle prophesies that 'poetry will more and more come to be understood as nothing but higher knowledge, and the only genuine Romance for grown persons, Reality', as George Eliot was to turn the novel into a branch of natural science, its subject the emergence of individuals and their societies into higher states of consciousness. Art has become too important to be allowed to be purely imaginative: this is perhaps the significance of Pre-Raphaelite rectitude about detail – the painstaking accuracy is a tribute to the significance of art, a way of making its revelation more certain, of scientifically verifying it. Romantic dreams are to be chastened, as they are for Charlotte Brontë's Shirley: 'She returned from an enchanted region to the real world: for Nunneley Wood in June, she saw her narrow chamber; for the songs of birds in alleys, she heard the rain on her casement; for the sigh of the south wind, came the sob of the mournful east.' The new function of art is not to soothingly deceive us about reality but to reconcile us to it. In the same novel Louis Moore says, 'I approve nothing Utopian. Look Life in its iron face: stare Reality out of its brassy countenance', and Charlotte Brontë follows his advice, aware that the novel is too important to be merely fictional – it is to be stripped of romance, its characters are to be 'more or less imperfect, my pen refusing to draw anything in the model line'; they are not, as she says in *The Professor,* to be rocketed to the heights of rapture or to be plunged into bottomless despairs, but will behave like persons of regular life and rational mind; they are to be ringed by no 'golden halo of fiction'. The novel embodies a normative truth which avoids dramatic extremes, settling for a safe tepidity: it ceases to be fictional, as poetry ceases to be poetic. Poetry replaces religion; the novel moves into the same domain of cognitive, explanatory, consoling truth as science and philosophy.

These new responsibilities of literature are debated in *Aurora Leigh*. Like Comte, Romney argues that poetry is defunct, the age of mystery and incantatory splendour having given way to the new era of science and pragmatic realism:

> You poets are benighted in this age;
> The hour's too late . . .
> Set a swan
> To swim the Trenton, rather than true love
> To float its fabulous plumage safely down
> The cataracts of this loud transition-time.

Poetry is decorative extravagance; only prose is adequate to the challenges of the time, and this anxiety about the survival of the medium joins with another concern – of her hack work Aurora says

> In England no one lives by verse that lives;
> And, apprehending, I resolved by prose
> To make a space to sphere my living verse

so that economic reasons enforce the identification of poetry with freedom and prose with drear necessity, of the one with pleasure and self-expression, the other with labour, the one with grapes, the other with bread. Poetry promises relief from the bleak conditions of every day, yet in doing so condemns itself to futility. Prose is for the present, poetry retreats to the past. The split is revealed in Tennyson's *Princess*, which slackly and dully tries to cope with the contemporary problem of women's education, and can acquire poetic life only in detours, in regressions, trips to a distant lyric past, in the interpolated songs. Poetry withdraws from what Romney calls 'the agonising present' either into the past, or into the narrow chamber of the individual sensibility: Romney opposes his public life to the private life of Aurora, who, he feels, ought to be nestled in the domestic sanctities, intent on her crochet-work, while his world

> Uncomprehended by you, must remain
> Uninfluenced by you – Women as you are,
> Mere women, personal and passionate . . .

The romantic poets were merely personal and passionate, not knowing enough, as Arnold said, and now this has come to seem an inadequate and effeminate response to the problematic world: poetry has dwindled into emotive effusion, what Romney calls personal reactions (which were to become Forster's 'personal

relations': he used the novel as the Victorians had used the poem, as a defence against painful and confusing change) and sets over against more pressing universal problems. The world has forgotten

> To rhyme the cry with which she still beats back
> Those savage, hungry dogs that hunt her down.

Poetry has become a luxury, because

> The time is done for facile settings up
> Of minnow gods, nymphs here, and tritons there;
> The polytheists have gone out in God.

Here Romney's argument falls in with the ironies of Thomas Love Peacock: crabwise the romantic poet moves backwards, into mythic muddle and the picturesque ruins of discredited faiths, away from clarity and scientific reason, burying his head in the obscure and irrational. The Victorians have not the leisure for poetry:

> who has time
> An hour's time . . . think! . . . to sit upon a bank
> And hear the cymbal tinkle in white hands?

and indeed the most original Victorian poetic forms are hard-pressed, hurried, restlessly businesslike: Browning's jogging railway rhythms, or the telegraphic prose, relaying startlingly abbreviated messages, which Dickens devises for things like the fog in *Bleak House*.

Poetry may, however, make itself more useful by renouncing imagination and espousing reality instead. 'The old gods are dethroned,' Elizabeth Barrett wrote in a letter of 1845, turning down Browning's suggestion of Prometheus as a subject; and in 'The Dead Pan' she rejoices in rumours of the god's death and the decline of the cold classicism sponsored by him. The poets disclaim Pan; poetry grows into the maturity of truth:

> Earth outgrows the mythic fancies
> Sung beside her in her youth:
> And those debonaire romances
> Sound but dull beside the truth.

Romney welcomes the invasion of the poet's hidden places:

> You break the mythic turf where danced the nymphs,
> With crooked ploughs of actual life, – let in
> The axes to the legendary woods,
> To pay the head-tax,

and this transformation of a romantic landscape into a real one is

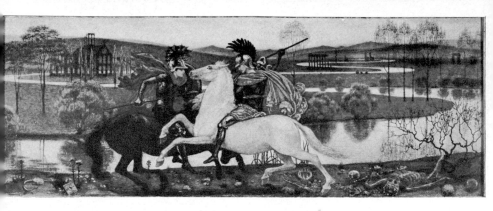

Walter Crane 'Ormuzd and Ahrimanes'

Sir Edwin Landseer 'Morning'

Two pictorial analogies to Arnold's 'Sohrab and Rustum'

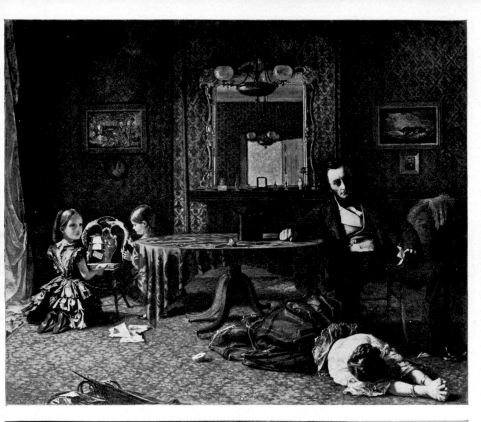

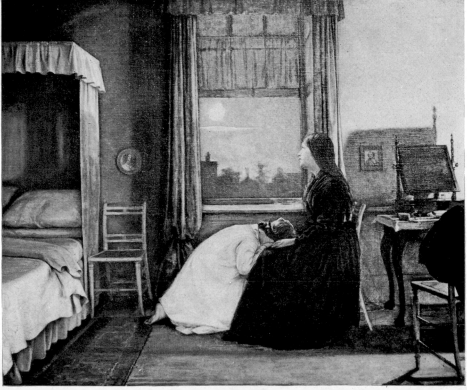

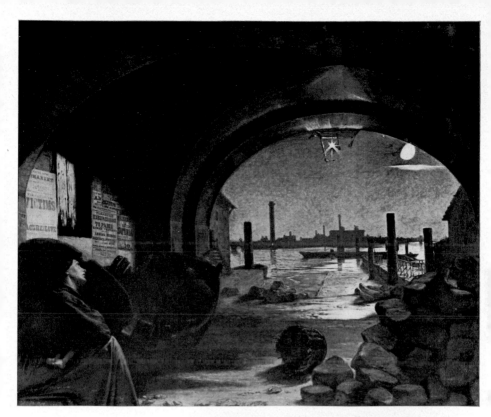

Augustus Leopold Egg 'Past and Present' number 1-number 3

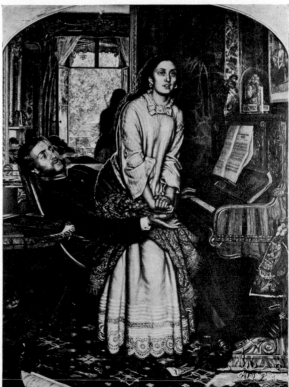

W. Holman Hunt 'The Awakening Conscience'

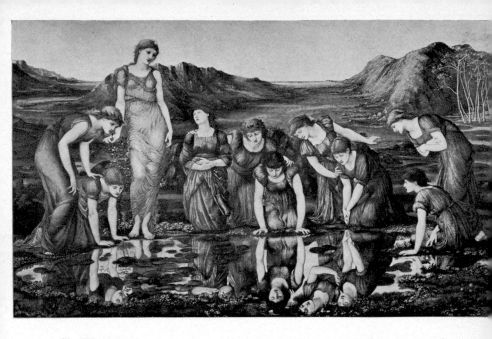

Sir Edward Coley Burne-Jones 'The Mirror of Venus'; the lyrical nymphs of
Botticelli stranded in a desolate Victorian waste

matched in *Shirley*, in which mind marches on from Martin's Wordsworthian reverie in the woods and his vision of a nymph, and the romantic day dreams ('the talk of a dreamer – of a rapt, romantic lunatic') Louis confides to his journal, to Robert's plan for the development of the copse: 'The copse shall be firewood ere five years elapse: the beautiful wild ravine shall be a smooth descent; the green natural terrace shall be a paved street: there shall be cottages in the dark ravine, and cottages on the lonely slopes: the rough pebbled track shall be an even, firm, broad, black, sooty road, bedded with the cinders from my mill.' The dream landscape of Claude and Salvator Rosa is metamorphosed into a populated, improving, productive Victorian reality.

Arnold's grand style lifts itself above the temporal and temporary; the poems of modern life which offended him attempted to come to terms with the new reality, as did the paintings of modern life, which also belong to these years: Millais's 'Woodman's Daughter' in 1851, Madox Brown's series of 'Work', 'The Last of England' and 'An English Autumn Afternoon' begun in 1852, Frith's 'Life at the Sea-Side' of 1854 and 'Derby Day' of 1856. The genre painters look in their repudiation of what Thackeray in *The Newcomes* calls ' 'igh art' and 'the Hantique' to the example of the novel – Frith read through Dickens for subjects. And he happily accepted the imprisonment in his time which so irked Arnold: he admits that though one of his paintings, an archery-scene, is of trifling interest artistically, 'the dresses will be a record of the female habiliments of the time', and he determined on the subject of a Private View at the Royal Academy in 1881 because of 'the desire of recording for posterity the aesthetic craze as regards dress.' Clough challenges Arnold's disdain for the merely local and realistic in writing about his 1853 volume in the *North American Review*; he notes the Victorian distaste for poems after classical models and for romantic exoticism: 'we have grown prudent and prosaic', and demand that poetry should make intelligible everyday life, invest with significance or even dignity the dingy work we must do. Announcing *Household Words* in 1850, Dickens promised that it would cherish the light of Fancy, and reveal that in all familiar, even repellent, things, there is Romance enough. The industrial landscape so painful to Arnold – 'London, with its unutterable external hideousness' or 'Margate, that brick-and-

mortar image of English Protestantism' – is transformed by Dickens: towering smokey chimneys, which are towers of Babel in *Shirley*, become 'swart giants, Slaves of the Lamp of Knowledge', like Eastern Genii; art is to make us aware of the hard truth of reality, but may also make it entrancingly strange. Each form aspires to the condition of the other, poetry envying the sober truthfulness of prose, prose – at least in Dickens's case – desiring for its depressing reality some of the imaginative amplitude of poetry. Poetry for Arnold consoles for the unsatisfactoriness of reality by superciliously ignoring it; for Clough it can only console by reconciling us to it. The novel, he goes on, is preferred to the poem because it does not disguise those dreary matters of fact 'which, if we forget on Sunday, we must remember on Monday' – as Charlotte Brontë had pledged *Shirley* to be 'as unromantic as Monday morning, when all who have work wake with the consciousness that they must rise and betake themselves thereto.' The novel offers a common and comfortable house to live in; only poetry bothers with Ionic porticoes.

Clough raises the question of the ephemeralness of realistic art. We are not marble statues: Arnold's statuesque fixity and reverence for classical models are futile, for at least the plain tales of the novelist are certain of one reading, 'thrown away indeed tomorrow, but ... devoured today.' The novel is indeed related to the newspaper – Arnold in a letter to Clough in 1849 had listed among moral horrors of the present age 'newspapers, cities', and he identifies the press with the brutal headline 'Wragg is in custody'. Yet Balzac might have made a novel out of this very headline. Novelists have made imaginative use both of the labyrinthine structure of the city and of the sensationalism of the press, Browning expanding a murder case, Dickens developing the journalistic sketch, Joyce in *Ulysses* finding in a newspaper office a puffing of Aeolian force. Baudelaire connects cities and newspapers, their chronicles, as proof of the heroism of modern life in his critique of the 1849 Salon: 'The pageant of fashionable life and the thousands of floating existences – criminals and kept women – which drift about in the underworld of a great city; the Gazette des Tribunaux and the Moniteur all prove to us that we have only to open our eyes to recognise our heroism.' Likewise, Daniel Deronda recognises that the chief poetic energy lies 'in the force of imagina-

tion that pierces or exalts the solid fact, instead of floating among cloud-pictures. To glory in a prophetic vision of knowledge covering the earth, is an easier exercise of believing imagination than to see its beginning in newspaper placards.'

The 'poetic and marvellous subjects' Baudelaire finds in the city lack, of course, the marmoreal finality and elevation Arnold longed for: events in a city are distracting, abrupt, ephemeral, colliding, assaulting us in the impressionistic frenzy Dickens so brilliantly evokes, and to Arnold this tumult of impressions was merely another instance of the sick hurry of modern life. Clough, however, warns that the Muses were deserting Pindus, Parnassus and Castaly to inhabit the desolate city; and his reference to 'the solitary bridges of the midnight city, where Guilt is, and wild Temptation' recall one instance of this shift of the Muses: Doré's illustrations, and particularly that to Hood's 'Bridge of Sighs'.

The grand style in Milton (who, Arnold says, naturalised it in English) is a reflex of his strength, his indomitable will; in Arnold though it seems a reflex of weakness – flight from grimy actuality to a soothingly remote classicism. Clough hints at Arnold's squeamishness: comparing his donnish refinement with the manner of the Glasgow mechanic, Alexander Smith, he wonders if that educated sensibility is 'too delicate ... for common service?' Arnold's classicism is indeed reinforced by his gentility – both press him from the actual to the ideal; and this genteel revulsion is shared by other Victorians. John Forster complains of the sternness of the didacticism of *Bleak House*, craving some harmless sportive relaxation; some of the vicious grotesques are 'much too real to be pleasant; and the necessity becomes urgent for the reliefs and contrasts of a finer humanity.' Wordsworth thought Crabbe's poems 'mere matters of fact, with which the Muses have just about as much to do as they have with a collection of medical reports, or of law cases', and Arnold complained to Clough in 1848 that his poetry was deficient in beauty, though Clough in 'O land of Empire, art and love' had insisted that poetry must recognise the vile and filthy as much as classical loveliness, and had taken on the novelist's responsibility of being honest about the unpleasant:

> The dirt and refuse of thy street
> My philosophic foot shall greet.

The classical columns rise from the gutter.

The painters too are uneasy about reality: after the exhibition of 'Applicants for Admission to a Casual Ward' in 1874 Sala urged Sir Luke Fildes to abandon such painful realism for cultivation of the beautiful, while in 1876 *The Times* castigated Fildes's 'Widower' because the 'intense painfulness of its dirty boots and squalling infants made it unsuitable for the living-room and uncomfortable to live with.' Fildes's work reveals a strange split between his menacingly real English social subjects and the idyllic prettiness of his Venetian flower-girls, between honest prose and yearning poetry. Fildes was horrified when in 1908 a German photogravurist suggested that his Venetian subject 'The Devotee' should be retitled 'Lancashire Lassie', because factory girls also wore shawls over their heads: the picture's sentiment depended on its not possessing that topical relevance the German wished to give it.

The Victorians edge close to reality, yet withdraw in fright. Distance lends a harmonising enchantment to the view – the past is beautiful, Carlyle thought, because safe, whereas the present and future are fraught with danger – and Arnold mentioned to Clough in 1853 a scheme for dividing his poems 'according to character and subject, into Antiquity – Middle Age – and Temps Moderne.' This was in a letter written from Fox How in August; in November, in a lecture on Pre-Raphaelitism in Edinburgh, Ruskin employed a similar scheme: 'the world has had essentially a Trinity of ages – the Classical Age, the Middle Age, the Modern Age.' This is a museum sense of the past and its art, for the contents of a Victorian museum are thought of as historical specimens, disposed so as to provide information and to map the orderly progress of human evolution. 'Classicalism began,' Ruskin goes on, 'wherever civilisation began, with Pagan Faith. Medievalism began, and continued, wherever civilisation began and continued to *confess* Christ. And, lastly, Modernism began and continues, wherever civilisation began and continues to *deny* Christ.' This division imposes a similar incarceration in a particular time on literary forms: they become exhibits in the museum as well, products of one or other of the phases of the spirit, separate from one another in their glass cases – epic and tragedy classical, idyll and romance medieval, and the novel, with its shabby realism and denial of heroism, sadly modern. Men too are historical specimens: heroes are as defunct as mastodons, the present race has fallen off lamentably from the

standards of the past – Ruskin selects a representative individual
from each epoch for comparison: 'Leonidas had the most rigid sense
of duty, and died with the most perfect faith in the gods of his
country, fulfilling the accepted prophecy of his death. St Louis had
the most rigid sense of duty, and the most perfect faith in Christ.
Nelson had the most rigid sense of duty, and – You must supply
my pause with your charity.' Arnold's grand style is a sort of time
machine, a device for transporting himself from the iron time of
unbelief into the lost certainty and authority of classical heroism.
But it can work only as a pastiche, a deception; the poet is
inescapably of his time, aware that only certain things are possible.
Thus, as Ruskin lays it down that 'all ancient art was *religious,* and
all modern art is *profane*', so G. H. Lewes wrote to William Bell
Scott about his huge religious-didactic poem *The Year of the World,*
that such a work in the nineteenth century 'can only be a more or
less ingenious failure. The nation has no creed; the poet cannot
therefore find a response.' History was, as much as geology and
biology, a science which taught the Victorians to doubt and
despair, for it made them conscious of their place in the museum;
it made them feel that their time had determined them and was
imprisoning them.

Yet Mrs Browning urges in *Aurora Leigh* that poetry should
enthusiastically agree to be of its time; she disagrees with critics
who think the epic exhausted and long for a distant grandeur, like
Payne Knight suggesting that Homer's heroes were twelve feet tall.
(Thackeray had made an amusingly similar point in *The Newcomes*:
Gandish the classicising history-painter boasts of the high art of
his picture of Boadicea, and Smee whispers, 'High art! I should
think it *is* high art! fourteen feet high, at least!') To Mrs Browning
the idea that remoteness means magnification and closeness
diminution is an optical illusion:

> Every age,
> Through being beheld too close, is ill-discerned
> By those who have not lived past it.

Classical subjects only acquire the grandeur they possess for Arnold
because he is far away from them, because their antiquity and
irrelevance to modern life make them appear austere, untroubled,
nobly simple; a similar illusion encouraged people to think the
varnish essential to a painting because in this way time smokes it,

warmly mellowing it. Samuel Palmer calls Claude the greatest of landscape painters because of 'that Golden *Age* into which poetic minds are thrown back, on first sight of one of his genuine *Uncleaned* pictures.' In the same place, a letter of 1875 to F. G. Stephens, Palmer argues that works of genius are always synchronised with the past rather than the vulgar present, which is suitable, he says, for dogs and cats, for these cannot see beyond the immediate satisfactions of appetite. Mrs Browning, however distrusts

> The poet who discerns
> No character or glory in his times,
> And trundles back his soul five hundred years,
> Past moat and drawbridge, into a castle-court.

Grandeur is as much an escape as Tennyson's picturesque mythology. Arnold aspires to a Homeric virility, but his actual achievement in 'Sohrab and Rustum' and 'Tristram and Iseult' has a languor which suggests Burne-Jones's description of a painting as 'a beautiful romantic dream of something that never was, never will be – in a light better than any light that ever shone.' Burne-Jones qualifies his statement so as emphatically to rule out any possibility of the dream's being realised; futility has become an essential part of romanticism, and his own wan figures droop with it. Wordsworth spoke of 'a light that never was on sea or land' – he is confident that poetry and painting can transfigure the real by force of vision, as Constable's horse leaps from the muddy sluice-gate into the magnificence of an equestrian statue, or Turner's train steams across the bridge into a cataclysm, or as Palmer's sheaves glow with an unearthly radiance. But Burne-Jones's light better than any that has ever shone is plaintive rather than confident, forlornly dim rather than visionary, not an inspiration but a comfort and a refuge. Romantic art transforms the real; Victorian art can only evade it. The poet has fallen on an iron time, a time of prose, and the Arnold who wrote to Clough in 1852 cursing the '*blankness* and *barrenness*, and *unpoetrylessness*' of the age invites comparison with the Burne-Jones who lamented that the time was out of joint, and in 1854 went to Godstow to the burial-place of Fair Rosamond to dream of 'the pageantry of the golden age', only to be recalled to the nineteenth century by 'the wreathing of steam upon the trees where the railway ran.'

Burne-Jones spoke of his century as 'the years I cannot convince myself of living in', and he designed armour 'on purpose to lift it out of association with any historical period.' He tried to build his dreamed-of past: among properties for paintings in his studio, 'substitutes for unattainable realities' as his wife called them, were a dummy dulcimer made of deal by a carpenter, and a wooden pole with a branch on a hinge which did service as a tree. Mrs Browning scoffs at such fastidiousness:

> To flinch from modern varnish, coat or flounce,
> Cry out for togas and the picturesque,
> Is fatal, – foolish too. King Arthur's self
> Was commonplace to Lady Guinever;
> And Camelot to minstrels seemed as flat,
> As Regent Street to poets.

In her enthusiasm for 'this live, throbbing age', 'the full-veined, heaving, double-breasted Age', she recalls Baudelaire who, in reviewing the Salon of 1845, insisted on the epic quality of modern life: 'how great and poetic we are in our cravats and our patent-leather boots.'

In prose Arnold can wittily and incisively commit himself to the problems of his prosaic age, but in poetry he must yearn for a world of poetry, in which beauty and serenity will hold reality at bay. This split between the controversial liveliness of the prose and the aloof grandeur of the verse, corresponding to that between the novel marching ahead with the Comtean mind, reconciling the classes, explaining society to men, and poetry, scurrying crabwise backwards into archaism, is part of the strange disease of modern life which also forced on Victorians a division between public and private, business and pleasure. As Mill separates the public rhetoric of prose from the private lyric confessions of poetry, so Dickens's Wemmick anxiously keeps his office sentiments and his domestic Walworth sentiments in different compartments. The split becomes psychological: in 'The Private Life' James explores two complementary cases of self-division – Browning, who had no social presence, guarding all his genius for his work, over against Lord Leighton, who was all glittering exterior but hollow within: his genius went into his life, leaving none over for his works. James was startled by a similar disparity in Arnold when he met him in Rome in 1873 – he was unable to relate the dapper gushing figure

with the monocle screwed into one eye to the poet who confided his discomforts and sorrows in private. Charlotte Brontë was also offended by Arnold's 'seeming foppery'. But Arnold explains in the verses on Senancour: the poet is driven in contrary directions, to the world without, and to solitude. That he should be one person in public, another in private, one in prose, the other in verse, is part of his Victorian uneasiness – a poet in a prosaic age, drawn to the detail of human suffering, yet flinching from it into a world of imagined beauty.

Tennyson recoiled into the medieval, Arnold into the antique; but neo-classicism could only be maintained in haughty defiance of all in the national life and literature which was new, changing and exciting. Dickens sneers at it – he wrote to the Baroness Burdett-Couts from Rome in 1845 that the faces of the professional artists' models on the Spanish steps were familiar, having bored him for years in the postures of Venerable Patriarch or Assassin, and he thought it 'a good illustration of student life as it is that young men should go on copying these people elaborately time after time, and find nothing fresh or suggestive in the actual world about them.' Ridiculing Dumas's versification of *Orestes,* he said that he trembled at the sight of classical drapery on the human form. In *North and South* Mrs Gaskell sets the classical culture into sharp opposition with the hearty, energetic actuality of contemporary life. Mrs Thornton disapproves of her son's reading the classics in a speech which might almost be a counter to Arnold's 1853 preface, as a defence of the poetry of modern life: 'I have no doubt that classics are very desirable for people who have leisure. But . . . the time and place in which he lives seem to me to require all his energy and attention. Classics may do very well for men who loiter away their lives in the country or in colleges; but Milton [the industrial town] men ought to have their thoughts and powers absorbed in the work of today.' Later, her son makes a more damaging point. Oxford colleges are being contrasted with Dark-shire factories, and he asserts, 'we are of a different race from the Greeks, to whom beauty was everything, and to whom . . . a life of leisure and serene enjoyment . . . entered in through their outward senses. . . . I belong to Teutonic blood . . . we do not look upon life as a time of enjoyment, but as a time for action and exertion. Our glory and our beauty arise out of inward struggle. . . .

If we do not reverence the past as you do in Oxford, it is because we want something which can apply to the present more directly.' Against the Grecian, Thornton sets the Gothic, and as Ruskin had condemned the dead static harmonies and dull perfection of the one in comparison with the growing, vital energy of the other, so Thornton attributes to the Grecian an enervated sensual passivity and to the Gothic muscularity and crude but honest strength. The old kind of beauty has a lucidity and clarity and noble grandeur; the new kind may be raucous, ungainly, strident, but, buzzing with activity like Dickens's novels or *The Ring and the Book*, it has the strength if not of fine proportions, then of inward fullness and life.

Strenuousness is one of the Gothic qualities in Victorian painting: the deliberate awkwardness of Holman Hunt's stretching Christ, the hammers swung by Bell Scott's Newcastle workmen, the painstaking literalism of Millais's 'Christ in the House of His Parents', the aching strain of the postures of its figures. The truthfulness of this picture was 'mean, repulsive, and revolting' to Dickens; *The Times* thought its minuteness, its determination to spare no detail of dirt or labour, was disgusting. It is indeed ponderous and painful, because it refuses to be easy and accomplished; its ugliness flaunts its integrity. Strenuousness and a sense of exertion, daring to draw attention to itself in a certain clumsiness, predominate in Madox Brown, who abandons the classical standard of beauty for workmanlike deliberation and honest strength. The subject of 'The Last of England', for instance, is not so much composed as crammed inside the frame. This frame is oval, but Brown refuses to make his figures submit with graceful curves to the tondo; there is no pleasing circularity to the composition – the picture bluntly resists its frame, or strains against it. The jumble, the urgency to squeeze narrative and moralising detail into the limited space, the green vegetables hanging from the rails for scurvy, the various groups of indisciplined emigrants, create enigmas, a puzzling complication of the relations between the central figures, Thomas Woolner and his wife – what are they sitting on? how is the enormous umbrella being held? whose hand is that folded in the mother's in the opening of her cape? where is the body belonging to it? how are this pair related to their scrambling neighbours pressed into a strip of the picture behind them? in particular, who is that in the life-boat? The faces of the

protagonists, her regretful gaze, his suppressed rage and grief, create a still centre for the picture, but this, however, is contradicted by the riot of subsidiary detail around the edges: the detail both crowds in upon the two sad faces, and beats against its frame. The picture continues outside its frame; only by compression and contortion has it been pushed inside. The serene spaciousness of classical composition, with the figures and the landscape which encloses them calmly parallel to the picture frame, is brutally disregarded.

Defiant ugliness was pursued by one side of the Pre-Raphaelite brotherhood; the other side, the party of Rossetti and Burne-Jones, clung to the idea of beauty, but to a beauty necessarily enfeebled and etherealised, a beauty which was attractive precisely because it did not exist. These painters admit their own inadequacy by making a religion of weakness, in a spirituality which droops and dozes. Burne-Jones thought it essential to bar expression from painting, and quoted Winckelmann's theory that the age of expression in Greek art is already the age of decadence. But the abstraction of the Greeks is a lucid joy, a poise and clarity which are safe from the disturbance of momentary or accidental emotions, whereas that of Burne-Jones, or of Leighton, does not express a superiority to feeling so much as a waxen incapacity for it. Burne-Jones's symbolism must be purified of contact with life: he writes that the queens in his Avalon picture 'are queens of an undying mystery, and their names are Lamentation and Mourning and Woe. A little more expression and they would be neither queens nor mysteries nor symbols, but just – not to mention baser names in their presence – Augusta, Esmeralda, and Dolores, considerably overcome by a recent domestic bereavement.' As poetry for Arnold is incompatible with a world in which women can be called Wragg, so for Burne-Jones it recoils even more fastidiously from names like Augusta. Ugliness is the principle of individuality and of character; beauty, as priggishly virginal as Tennyson's Sir Galahad, must safeguard itself by ridding itself of character, energy and liveliness.

But the novel thrives upon ugliness. Thackeray in *Esmond* mocks history and drama for obsequiously recording the deeds of kings who, beneath their ceremonial costume, are as wrinkled and mean and pock-marked as the rest of us: the novel refuses to kneel; its truths are familiar rather than heroic. Thackeray employs

realism to unmask. War, for instance, dwindles from an epic subject into a shabby and confused reality: 'I am not going to give any romantic narrative of the Seven Years' War,' says Barry Lyndon; in *Vanity Fair* Waterloo is reduced to a few alarming noises in the night off-stage which spur Jos Sedley to a hasty decampment; Esmond berates Addison for dishonestly elevating war into the high style in his poem on the Blenheim campaign: 'the murder of the campaign is done to military music, like a battle at the opera. . . . You hew out of your polished verses a stately image of smiling victory, I tell you 'tis an uncouth, distorted, savage idol. . . . You great poets should show it as it is – ugly and horrible, not beautiful and serene.' The deceit of rank is also exposed: the Pretender has bad teeth and a squint, and those who believe him a god find him to be 'no more than a man, and not a good one.'

Poetry chooses the remote: 'Hogs live in the present; Poets in the Past,' decreed Samuel Palmer in 1862; 'or with the grace of alliteration – The Past for Poets; The Present for Pigs.' Prosaic art, however, makes a virtue of proximity. George Eliot attacked Young in 1857 for a 'deficient human sympathy', an 'impiety towards the present and visible'. He flies to the vague and unknown, and Arnold when confronted by the steaming squalid streets of Bethnal Green, the pale weaver in Spitalfields or the tramp in Belgrave Square invokes images of sanctity as a way out – in 'East London' the idealism of the preacher transfigures his surroundings; in 'West London' he argues (and this is what Fildes implies about the queue for the casual ward) that the beggar's spirit towers above her state, because she is proud in her indigence. George Eliot points to Cowper as the poet of nearness and closeness, of domestic fondness: he has 'that genuine love which cherishes things in proportion to their nearness, and feels its reverence grow in proportion to the intimacy of its knowledge.' Madox Brown urged the claims of nearness in 1855, when Ruskin asked him why he chose such a very ugly subject for 'An English Autumn Afternoon', and he replied, 'Because it lay out of my back window.' His description of the picture takes pride in its exact fidelity: he promises that it is 'a literal transcript of the scenery round London, as looked at from Hampstead. The smoke of London is seen rising half way above the fantastic shaped, small distant cumuli, which

accompany particularly fine weather. . . . The time is 3 p.m. . . . late in October.' The painter, like Deronda, finds a 'sense of poetry in common things'. In 1873 Ruskin was involved, albeit on the other side, in another dispute on the same issue: emerging from an exhibition in Burlington House, he met G. F. Watts, and fumed that the Old Masters were all wrong because they didn't paint exactly what they saw. Watts objected that there were truths more real than surface facts, which Ruskin denied; and, pointing to a scavenger's heap of mud by a grimy lamp-post, 'Paint that as it is!' he cried. 'That is the truth.' Shit, as Zola said to Mallarmé, has the same value as diamonds; ugliness is truer than beauty. In a letter to Watts next day, Ruskin derided classicism: 'You yourself were paralysed for years by your love of the Greek style – you never made an entirely honest, complete unaffected study of anything.' Yet, so contradictory and hot-tempered are Ruskin's principles, that in 1884 he returns to the opposite camp, and attacks Herkomer's picture of emigrants landing in America, 'Pressing to the West', because the artist is 'content to paint whatever he is in the habit of seeing. . . . Mr Herkomer, whose true function was to show us the dancing of Tyrolese peasants to the pipe and zither, spends his best strength in painting a heap of promiscuous emigrants in the agonies of starvation.'

Aurora Leigh comes to the opposite conclusion – Paris makes her realise the glory of nature and the infinite, lovable variety of ugliness, which art must cherish. Hazlitt had said that his attempts at painting had taught him to see 'good in everything, and to know that there is nothing vulgar in nature seen with the eye of science or of true art.' Realism is democratic, as Alton Locke points out; it also possesses a scientific impartiality, and Aurora demands

> How is this,
> That men of science, osteologists
> And surgeons, beat some poets, in respect
> For nature, – count nought common or unclean,
> Spend raptures upon perfect specimens
> Of indurated veins, distorted joints,
> Or beautiful new cases of curved spine;
> While we, we are shocked at nature's falling-off,
> We dare to shrink back from her warts and blains. . . .

In accepting ugliness, the artist joins hands with the philanthropist:

Aurora claims that she and Romney are doing the same work by different means,

> Because we both stand face to face with men,
> Contemplating the people in the rough, – . . .

Yearning for beauty and grandeur, Arnold not only repudiated the finest poetry and fiction of his time, but also his own best poetry. For he is most moving when most imperfect, when writing not with grand generality but with pained subjectivity. The grand style has an armour-plated objectivity, but Arnold's lyrics of failure and regret, 'The Buried Life', 'A Summer Night' or the Marguerite poems, are pitifully vulnerable. The stumblings of their verse enact the groping and uneasiness of the honest doubter, their slack limping diction suggests the exhaustion of the damned vacillating state which so worried Tennyson. The 'Stanzas to the Author of Obermann' relate this dazed feeling and the uncertainty of the verse, so unlike the confident music of the romantics, to the impossibility of attaining a classical Miltonic calm and completeness of vision in the distracted nineteenth century; the very inadequacy of the verse beautifully confesses the confusion experienced:

> Like children bathing on the shore,
> Buried a wave beneath,
> The second wave succeeds, before
> We have had time to breathe.
>
> Too fast we live, too much are tried,
> Too harass'd to attain
> Wordsworth's sweet calm, or Goethe's wide
> And luminous view to gain.

This is an apology for both the patchiness of his mood and for the wrenched, anxious verse.

Arnold's Miltonic ambition is at odds with his own poetic temperament. In 'Resignation' the epic poet is seen as a Carlylean strong man, fierce of will and with superabundant energy, freed from the cares and torments of ordinary life:

> In the day's life, whose iron bound
> Hems us all in, he is not bound.

The Poet looks down from some high station on the life of a populous town – contrast Browning down in the market-place. Yet

the modern poet is a weak man, for whom action is a 'dizzying eddy', who confides his weakness as Clough or Hopkins or Eliot's timid over-cultivated young men do, or who lives through the substitute of art, concealing himself behind masks, like Yeats. Arnold, in this contradictory poem, exposes part of the failure of his Miltonic aspiration to be strong – weak in himself, he envies and enjoys at imaginative second-hand the strength of others, the feckless, irresponsible gipsies, who are comparable to Yeats's dancers and fighter-pilots and horsemen. The poem admits that action and involvement are after all not compatible with poetry; grandeur comes not from Homeric or Miltonic energy and will, but from retirement, and its 'sad lucidity' and 'rapt security'. The poet is disabled for life and detached from it – Arnold anticipates James's sad comment on his own celibacy, that to have married would have implied he thought better of life than he did:

> Blame thou not therefore him who dares
> Judge vain beforehand human cares.
> Whose natural instinct can discern
> What through experience others learn.

The poet opts out of experience – he leaves it to others, as Axel left living to his servants, and chooses insight instead. He is 'to men's business not too near'. As in Freud's characterisation of the artist, imagination compensates for what the artist's impotent, over-sensitive disposition denies him in life:

> Who need not love and power, to know
> Love transient, power an unreal show.

The novel, as has been argued, increasingly opposes the values of insight to those of mere experience, of sad lucidity to energy and action, of personal relationships to telegrams and anger; and here Arnold, despite himself, is connected with the novel. Arnold's resigned poet is like the Jamesian artist, relying on reflection and inventive curiosity, the adventure of mental detection, holding himself at an ironic distance from experience itself in order to appraise it. George Eliot makes the Victorian picturesque intellectual and even scientific, whereas James makes it mental and aesthetic. Felix in *The Europeans* takes a Jamesian view of Boston: his sister finds it repellent, but for him it is picturesque, and he resolves to make a sketch of it. 'He possessed what is called the pictorial sense, and this first glimpse of democratic manners stirred

the same sort of attention that he would have given to the movements of a lively young person with a bright complexion.' Felix's attitude to people is aesthetic as well: his uncle is 'a most delicate, generous, high-toned old gentleman, with a very handsome head of the ascetic type, which he promised himself the profit of sketching.' Emotion too becomes a matter of aesthetic or even mathematical appraisal: Dr Sloper in *Washington Square* makes himself a geometrician of relationships, taking the measure of his submissive surfaces, his daughter and her young man, and Acton in *The Europeans* conceives a mental passion for the Baroness, who appears to him as an algebraic problem. This aesthetic sense comes to be employed by James as a criticism of political action. Hyacinth Robinson in *The Princess Casamassima* is made to realise that the richness of culture derives from those very inequalities against which radicalism rages; Olive in *The Bostonians* is like Dorothea Brooke in aspiring to martyrdom, but where George Eliot takes Dorothea's disappointment as proof of the unheroic nature of modern life, James makes the opposite moral point, that her desire was mistaken anyway, that the answer is the quiet if desperate contentment of the private consciousness, as Catherine Sloper realises, in taking up her sewing. Basil Ransome is the connoisseur critical of the activist: 'Don't you care for human progress?' Olive challenges him, and he replies, 'I don't know – I never saw any. Are you going to show me some?' His interest is picturesque: 'Is it something very picturesque? I should like to see that.' Olive retorts, 'It isn't Boston – it's humanity,' to which his answer is the quietist one: 'the human race has got to bear its troubles.'

The resigned poet becomes the reflective, ironic novelist. It is interesting that James should have described Burne-Jones's painting, after attending his exhibition in 1877, in terms which suggest his own novels: 'it is the Art of Culture, of reflection, of intellectual luxury, of aesthetic refinement,' he writes, 'of people who look at the world and at life not directly, as it were, and in all its accidental reality, but in the reflection and ornamental portrait of it furnished by art.' The averted gaze of the painter corresponds to the detachment of the novelist; both, like Pater's Florian Dedal, steep their observed worlds in reflection, saturate them with art. Burne-Jones's figures are angels because, doleful and emaciated, they are spirits released from matter; the characters of the later

James are angels because they are supernaturally intelligent – they see and know with an unearthly subtlety.

The resigned poet lacks even the romantic conviction of having found intimations of immortality in nature; he simply hears it echo – having lent it his voice – his own sadness, like Swinburne's forsaken garden (a subject painted by Millais), or Tennyson's bleak blank Gower Street, or Browning's polluted desert round the dark tower. Arnold admits that

> the mute turf we tread, . . .
> The strange-scrawl'd rocks, the lonely sky,
> If I might lend their life a voice,
> Seem to bear rather than rejoice.

The pathetic fallacy, as Ruskin called it, was the product of desperation: nature no longer speaks to the poet, as it did at Tintern Abbey or Chamonix; its only life is as a disconsolate reflection of his – and even then he must inject his emotions into it. In 'The Youth of Nature' Arnold shows the one life within us and abroad giving way to the pathos of the pathetic fallacy – it is Wordsworth who lends new life to the lakes and mountains; and in 'The Parting' the Shelleyan rapture of being swept along by the imperative natural force of the autumn winds

> I come, O ye mountains!
> Ye torrents, I come!

falters into Victorian abjectness – as David Copperfield after his bereavement is soothed first by nature in Switzerland and then by Agnes, so here nature calms and commiserates, cradles the poet and rocks him to sleep:

> Fold closely, O Nature!
> Thine arms round thy child.

For Arnold the grand style is the product of a noble nature – the intricacy of matter expresses the poet's mental richness, but style is the reflex of character. Arnold presumably cut out Empedocles from the 1853 volume because, though plentiful in mind, he was deficient in character. Lacking stolidity, force, resolution, he was – like Arnold – too querulously intellectual. Milton is the great exemplar of style as character, making egotism sublime by verbal force and assurance, and the Victorian ideal of the poet was vatic, Miltonic, grand. Dr Arnold believed that poetical inspiration lifted man above his 'cold and selfish, and worldly' state of normal being.

Carlyle thought that 'the true literary man is the light of the world; the world's Priest; – guiding it, like a Sacred Pillar of Fire, in its dark pilgrimage through the waste of Time.' And Trollope in his autobiography ruefully admitted that poetry deserved higher honours than prose: 'That nobility of expression, and all but divine grace of words, which she is bound to attain before she can make her footing good, is not compatible with prose.' But the age lacked such great natures, as Arnold points out in a letter of 1853 to Clough about novel heroes: 'It gives you an insight into the *heaven-born* character of Waverley and Indiana and such like when you read the undeniably powerful but most un-heaven-born productions of the present people – Thackeray – the woman Stowe etc.' The Thackeray novel in question is *Esmond*, whose hero is a vacillator, oscillating between opposed loves and loyalties in the way Arnold feared; but there is one attempt at a noble nature elevated, like the ideal of the poet, above the worldly, in a Victorian novel – *Daniel Deronda*.

Yet Deronda's embodiment of the ideal not only implies an artistic failure – he is artistically bad because morally good, whereas Gwendolen is artistically good because morally doubtful – but also, so resistant is the novel form to this sort of absolute, sets up a curious inadvertent counter-reaction within the work. Gwendolen expresses irritation on our behalf, for she initially resents Deronda for the precise reason which makes the Jewish chapters so oppressive: the trouble with both is their supercilious high-mindedness, their proud distance from the prosaic aims of Gwendolen and, we feel, the rest of us – 'The darting sense that he was measuring her and looking down on her as an inferior, that he was of different quality from the human dross around her, that he felt himself in a region outside and above her, and was examining her as a specimen of a lower order, roused a tingling resentment.' The visionary figure smiles down upon the accommodating, middling, fallen world of the novel – yet with killing effect: the mortification Deronda's noble nature inflicts on Gwendolen in returning her pawned necklace is passed approvingly by George Eliot, and again Gwendolen, the imperfect character who lives in a novel and not in the sublime destinies of epic, protests on our behalf: 'he was entangling her in helpless humiliation: it was another way of smiling at her ironically, and taking the air of a

supercilious mentor. . . . No one had ever before dared to treat her with irony and contempt.' Deronda's goodness not only ruins him as a character – as well as possessing a Grandisonian priggishness, he is less complex and interesting than his moral inferiors, Gwendolen and Grandcourt – but sets up a civil war within the novel, between Gwendolen's imperfect prose and his unworldly poetry. They are, however, similar as individuals: he is, like Klesmer, the antithesis of anything the novel of manners could contain, and thus a measure of its inadequacy, its inability to deal with ideas and spirit; yet so is Gwendolen, who refuses to dwindle into marriage, to share the fictional fate of a Jane Austen or Charlotte Brontë heroine, and 'felt ready to manage her own destiny' – which means to manage the novel. Girls are stupid, she thinks, never doing what they like; and she is a measure, like Deronda, of the limitations of her fictional forbears. For both hero and heroine the novel becomes a spiritual adventure. In her case this is private, but in his, though private it becomes at the same time historic, for in discovering his parentage he discovers his cause and is freed into the larger possibility she, as a woman, is denied – a possibility he must, however, leave England, and the novel, to fulfil. Deronda is released from the novel; Gwendolen is held within it, for she fails, and, trapped in social forms, achieves nothing – her destiny in the end turns out to be merely the unsatisfactory prosaic one of a novel heroine. Yet this failure makes her artistically a success, whereas Deronda, to succeed, must not only be made fictionally uninteresting but must eventually be emancipated altogether from the novel and its mediocre reality of compromise and dissatisfaction.

George Eliot fabricates a character as an alternative to the prose of the age; in the 1853 volume Arnold fabricates a poetic style for the same purpose: epic and pastoral become ways of evading modern life. This is an indirection known to the painters as well. In October 1852, the Queen visited Manchester, and confided to her diary a grim account of its devastation: 'As far as the eye can reach, one sees nothing but chimneys, flaming furnaces, many deserted but not pulled down, with wretched cottages around them . . . a thick & black atmosphere. . . .' As a souvenir of the visit, she commissioned a water-colour from William Wyld, who introduced a subtle pastoral amelioration of the ugliness: in the picture's smoky

distance are the dark satanic mills, but enveloped in a mist of romantic indistinctness, while the foreground is occupied by a pastoral alternative to the city – Claudian goats graze, rustics picnic on the sward, an unpolluted stream curves serenely away. The industrial city becomes a picture, and so ceases to be threatening. Similarly, in Arnold, the Miltonic simile of the Tyrian trader at the end of 'The Scholar Gipsy' does no work of characterisation, as it would in Milton; it is a decorative digression which pleases by its very distance from the pain of the subject: the poem can be softened into a picture. The same languid pictorialism enervates 'The Strayed Reveller': much as, for all the call of Ulysses to action, Tennyson's 'Lotos Eaters' melts into an elegiac musical reverie, so here there is no violent ecstasy, only sleepiness – the numb swoon of the youth, the voluptuous winding of Pan's flute. As 'Sohrab and Rustam' softens tragic action into elegiac sentiment, so 'Tristram and Iseult' softens passion into mild, distressed lament; and in both this muting is achieved by making pictures, by creating a landscape suffused into sentiment:

> All round the forest sweeps off, black in shade
> But it is moonlight in the open glade:
> And in the bottom of the glade shine clear
> The forest chapel and the fountain near.

As, when Keats attempts epic, the grand externality subsides into soporific pictorialism, so in Arnold's epic fragment the celebration of action weakens into lyric landscape-description, with Sohrab wandering, like Keats's Apollo, expectantly in the cold wet dim dawn fog, or the Oxus which, seen in grey morning at the beginning and as night comes down at the end, takes over from the nominal heroes to become the central character, meditative, solemn and withdrawn. Digressions, which in Milton characterise or amplify, creating space for the powerful sweep of his imagination, in Arnold become lyric evasions of epic: the tents, for instance, like bee-hives

> in the low flat strand
> Of Oxus, where the summer floods o'erflow
> When the sun melts the snow in high Pamere.

Landscape is quiet; by such detours Arnold can take refuge in it from the strain of epic action. The Miltonic similes are unlike their originals – for instance, the early comparison of the Tartar horse-

men to cranes. Milton's geography is musical, exotic and adventurous, Arnold's more exact and duller, more conscientiously informative about Caucasian topography and primitive mores – the large men from the Bokhara and Khiva ferment the milk of mares, while the lighter men of the south drink only camel-milk; or the nature of the skull-caps. Arnold's exoticism is a little too cautious and researched; he recalls Holman Hunt buying his white goat and taking it to the Dead Sea so as to exactly capture the landscape of the Moab mountains. This conscientiousness is very different from the freer, more inspired and delighted exoticism of the romantics, Byron's letters during his Mediterranean trip, or those of Delacroix from Morocco. For Delacroix, Morocco was a flaming repudiation of classicism: 'the pink-limbed heroes of David and company would cut a very sorry figure here, next to the children of the sun.' Arnold's is the sedate orient which was being placed, in the 1850s, in glass cases in the South Kensington museums.

For all its attempt to keep out the age and its disquiets, Arnold's epic reveals itself as uncomfortably of its time, not colossally beyond it. In this it is like Victorian neo-classical paintings. For all their study of folds for garments from the Parthenon frieze, Leighton, Watts and Alma-Tadema cannot manage the quiet grandeur and calm elevation of the classical. Melancholy weakens the heroic in 'Sohrab' and the urgency of doubt and self-questioning transforms 'Empedocles' from classical drama into a Victorian dramatic monologue, taken over by its self-engrossed protagonist. Likewise, classicism mummifies Leighton's figures into a Nazarene immobility, as happens in Arnold's *Merope*; or else those of Alma-Tadema in their marbled living-rooms or apodyteria relax from classical nobility into genre cosiness, as happens with Arnold's wet pearl-fisher returning to his patient wife in their hut on the sands. Genre invades epic again when Rustum's puzzlement on sighting Sohrab is likened to a rich woman's looking through her curtains at the drudge making her fire and wondering how such a creature lives. Here the Victorian novel and the disturbing problems Arnold's preface wishes to exclude intrude into the epic, for this confrontation of rich and poor suggests Mrs Gaskell's *Mary Barton*, which has a chapter epigraph asking

> How little can the rich man know
> Of what the poor man feels,

and which is full of tense scenes like Arnold's at the window –
a labourer scavenging for food for his dying son watches a rich
woman emerge from a shop laden with delicacies for a party, which
is Arnold's picture in reverse.

The poem's tone is unmistakably Victorian. Ruksh is more a
domestic animal – like one of Landseer's obedient and tearful dogs:
he follows his master 'like a faithful hound, at heel' – than an epic
or romantic war-horse. The horse was a romantic symbol of energy:
Mazeppa's wild horse with 'feet that never iron shod', painted by
Delacroix, Stubbs's rearing horse frightened by a lion, the herd of
stallions in *The Rainbow*. But Ruksh, reared from a colt by Rustam,
is a Victorian pet rather than a creature of romantic force. He
tearfully sympathises with the tragedy and has to be comforted,
like Landseer's 'Old Shepherd's Chief Mourner', or another
empathic dog, Emily Brontë's savage Keeper, who, writes Mrs
Gaskell, 'walked first among the mourners to her funeral; he slept
moaning for nights at the door of her empty room, and never, so to
speak, rejoiced, dog fashion, after her death.' The tears flowing
from the dark, compassionate eyes of Ruksh and, big and warm,
caking the sand, mark, as does the placid flowing of the Oxus out
to sea, the modulation of epic into elegy, of action into sentiment.
The mingling of heroic and sentimental does resemble Landseer's
animal dramas, and in the year of the poem, 1853, he contributed
one such painting, 'Morning', to the Academy exhibition. Attached
to a sketch for this are some lines which sum up the spirit of
Arnold's poem: 'Locked in the close embrace of death, they lay,
those mighty heroes of the mountain side – contending champions
for the kingly sway, in strength and spirit matched, they fought –
and died.' Arnold's eagles simile suggests Landseer's 'Eagle's Nest'
in the Victoria and Albert, which has an eagle in a mountainous
landscape calling to its returning mate; and Landseer is again
evoked when the shriek of Ruksh is likened to the roar of a
wounded desert lion on the sand. Injecting human character into
animals, or offering genre glimpses of, for instance, a pottery
workshop in Pekin (when the sign of Sohrab's arm is described) or
children romping in the summer fields (when the blood wells from
his side) Arnold becomes inadvertently Victorian.

Epic is softened into lyric at the end, as the action is obscured by
the twilight and then left behind as the river flows on. The heat

of the battle gives way to frosty starlight, the crowded plain to a
hushed waste, and the river loses itself in the sea, as the action has
forgotten itself in the landscape. The poem is like a picture with a
foreground of violent action and a spreading background of quiet
landscape which absorbs, as it were, the disruption – a contem-
porary example is the allegorical combat between two knights
called Ormuzd and Ahrimanes, painted in 1868–70 by Walter
Crane. Here too action is softened into a melancholy landscape,
which is also a museum of architectural history, strewn with
picturesque ruins: a river winds away beyond the knights, whose
horses, rearing as they clash spears, are placid and uninvolved;
at each of its many serpentine curves stands a temple to some lost
faith: an Egyptian gateway, a Celtic dolmen, a classical temple, a
Gothic cathedral. Doubt and sadness mistily obscure the action,
and Crane's comment that the whole effect is 'of a subdued
twilight, as of the dawn' exactly suggests the end of Arnold's
poem. The knights are meant to be good and evil, struggling
through the ages; but there is no ferocity to their battle, and in the
wide horizontal composition they are merged into the gentle
quietistic flow of the river which loops away into the distance
behind them.

Arnold's suspension between epic pastiche and novelistic reality
is shared by Tennyson. 'The Epic' introduces his poem of Arthur's
death as a tale, like the ghostly one in *The Turn of the Screw*, told
round a Christmas fire; Tennyson regrets, as Maclise had done, the
passing of the old honour from Christmas and the dwindling of its
rituals into a few games, the dotard parson regrets the decay of
faith – and the poem sympathises with these dying falls, softly
collapsing from epic activism into a moody lament for the passing
of the old order. Everard Hall, who has burnt all of his epic but the
eleventh book, has a robustly Aurora-like argument against the
obsolete form:

> Why take the style of those heroic times?
> For nature brings not back the Mastodon,
> Nor we those times; and why should any man
> Remodel models? These twelve books of mine
> Were faint Homeric echoes, nothing-worth. . . .

It is a clever trick to have only the eleventh book salvaged by
Francis Allen; for this provides an excuse for the poem's modula-

tion from epic into elegiac fragment – as Arnold's example reveals, a Victorian could not command the assurance for the active part of an epic, and turns instead to regret about the time's being out of joint; here, providentially, all of the epic but its elegiac conclusion is destroyed.

In an epilogue, dreaming of Arthur's return
> like a modern gentleman
>> Of stateliest port,

Tennyson attempts to bind together epic past and the novelistic present of the country-house party, but the novelistic actuality is even less real than the dream: the grunting parson and the smouldering fire have less substance than the swarthy-webbed swan and the black-stoled and black-hooded queens. In *The Princess* again novelistic detail – Sir Walter's charity, the tenants in his park, the leaders of the Institute patiently instructing the multitude, demotic shrieks and laughter – remains separate from the Gothic past of the chronicle and the abbey ruin. This embarrassment about connecting past and present betrays itself in a debate about the tone of the poem: Lilia wants something grave and solemn, the men burlesque; the princess is to be

> six feet high,
> Grand, epic, homicidal. . . .
> Heroic seems our Princess as required –
> But something made to suit the time and place.

The poem is unsettled by worries about what sort of reality it is presenting. Its chivalric past is noble; and yet absurd. It is a dream; but it contains satire. It withdraws crablike from contemporary disquiets, from the democratic revels in the park; however it is invaded by controversy, the question of women's rights. Finally it abandons all attempt at reconciliation and determines to be a helplessly contradictory medley of past and present, Sir Ralph burning the peasants, Sir Walter acknowledging their cheers,

> A Gothic ruin and a Grecian house,
> A talk of college and of ladies' rights,
> A feudal knight in silken masquerade,
> And yonder, shrieks and strange experiments.

It has the indecisive eclecticism of Victorian ornament or architecture, hoping to synthesise details and features from quite different styles, or applying ecclesiastical forms to domestic objects;

the past has become a museum or an encyclopaedia of systems of detail which can be happily conscripted to modern uses, and the products of this technique hang rather dubiously, like domestic articles which have been turned into ecclesiastical vessels, or Gothicised railway stations, between past and present, belonging to neither. Tennyson ruefully confesses the uncertainty: a feud arises between mockers and realists,

> And I, betwixt them both, to please them both,
> And yet to give the story as it rose,
> I moved as in a strange diagonal,
> And maybe neither pleased myself or them.

The poem hovers between novelistic bustle and energy – the tumbling babies, the holiday games, the cheering tenants – and a somnolent lyricism. As if to symbolise this, the prince is subject to waking dreams, and his seizures give the poem an excuse for its lapses from action into lyric drowsiness:

> On a sudden in the midst of men and day,
> And while I walk'd and talk'd as heretofore,
> I seem'd to move among a world of ghosts,
> And feel myself the shadow of a dream.

Epic slides from action into listless reverie, a Tennysonian sleeping sickness perfectly captured in some chivalric paintings of the period – in Burne-Jones's Briar-Rose series, in which the knights have laid their weapons by to sink into a trance in which they are held by the entwining thickets of roses; in Rossetti's picture of St George killing the dragon, which has an effete knight kneeling before an even more torpid dragon, while the Princess of Trebizond is bowed over fast asleep next to them; in the poetic effeminacy of Watts's 'Sir Galahad', for whom the model was Ellen Terry – head bent, hands clasped, leaning against his drooping horse, he seems to emit a sigh of hopeless resignation which is very far from heroic. Tennyson's poem shares the peculiarity of its hero: it too is apt to nod off into a lyric coma, to melt from epic into idyll. It does so in scenes like that of the games in the gardens, with the ladies smoothing petted peacocks or oaring shallops to a low song; or their appearance in the chapel as a flock of Burne-Jones angels in the chapel:

> Six hundred maidens clad in purest white,
> Before two streams of light from wall to wall . . . ;

or Ida's floating through the sighing air to tend the wounded; or the huddling snowy-shouldered women, like herded ewes or flowers waving in a storm, when the letters arrive. This gentle caressing lyricism is disturbed from time to time by strident imitation of Milton, as in 'Sohrab':

> Not peace she look'd, the Head: but rising up . . .
> 'What fear ye, brawlers? am not I your Head?
> On me, me, me, the storm fast breaks: *I* dare
> All these male thunderbolts . . .'

As in Arnold's poem, there is a tournament, but action and violence are muffled:

> Yet it seem'd a dream, I dream'd
> Of fighting,

and the hero succumbs to the peace of unconsciousness.

In these cases, epic declines into lyric; and in 'Empedocles', Arnold's finest poem for all its offence against his critical theory, classical grandeur collapses into contemporary dubiety. As literature had retreated from action to consciousness, so Empedocles has withdrawn into himself, his ability to act weakened by his quizzical, self-tormenting intellect; he is akin to Hamlet – but not to the romantic Hamlet, the poetic dreamer; rather a Victorian Hamlet, a doubter, a figure like G. H. Lewes who, as Trollope said, 'has encouraged himself to doubt till the faculty of trusting has almost left him.' The depressed, preoccupied sternness of the poem has none of the confidence of grandeur; it belongs, in the Victorian division between the modes, rather to the sombre seriousness of prose than to the blandishments of poetry. Empedocles would be at home in a Victorian novel – he suggests the struggles of Mrs Gaskell's Rev. Hale or Mrs Humphrey Ward's Robert Elsmere when their faiths falter; he is intellectually representative, suffering the same doubts as Arnold himself in Rugby Chapel or George Eliot with F. W. H. Myers in Trinity College gardens, doubts which even, briefly, visited the Queen, who asked the Dean of Windsor if he was ever uncertain, as she was, whether it might all be true. The isolation of Empedocles derives from the fearful intellectual self-reliance of people who had to make trial of their beliefs and devise alternatives for themselves; he turns his poem into a dramatic monologue because only the private conscience can be trusted. Mill suggests the agonised reasoning which lay behind the

dramatic monologue in his remark that 'as in an age of transition the source of all improvement is the exercise of private judgement, no wonder that mankind should attach themselves to that, as to the ultimate refuge, the last and only resource of humanity.' Empedocles, holed up in this last refuge, cramped in the posture of Rodin's Thinker, has an absorbing seriousness which is as new as the Victorian conscientiousness about hard work on art and the exhausting study of detail: artists had not felt intelligence to be such a pressure and responsibility before. 'We feel, day and night, the burden of ourselves,' as Empedocles puts it.

The Victorian sense of a duty to rethink things and a commitment to the labour of realism and truth-telling lead to the expectation that art should embody ideas or contribute to knowledge and understanding. George Eliot in her essay on Riehl attacks Dickens, as Arnold does Chaucer, for a merely humorous delight in eccentricity, for evading his responsibility to be serious and consolatory; Millais similarly sees the great object of painting as to assist in the march of mind, to turn 'the minds of men to good reflections ... heightening the profession as one of unworldly usefulness to mankind.' Margaret in *North and South* is shocked by some young wits who 'talked about art in a merely sensuous way, dwelling on outside effects, instead of allowing themselves to learn what it has to teach.'

Art, free and light and waywardly inspirational for the romantics, has become burdened by the Victorians. If romanticism is the youth of the nineteenth century, Victorianism is its middle age; romance is appropriate to the one, realism to the other – youth is poetic but maturity turns to prose. Charlotte Brontë, who survived from the romantic spring into the Victorian winter, her first novel poetic fantasy but its successors sober prose, shows herself conscious of the difference of climate, in the century's life-cycle and in her own: 'I have now outlived youth,' she writes in a letter of 1848 to Miss Wooler; 'and, though I dare not say that I have outlived all its illusions – that the romance is quite gone from life – the veil fallen from the truth, and that I see both in naked reality – yet, certainly, many things are not what they were ten years ago. ...' Two years later, in a letter to a Cambridge admirer of *Jane Eyre*, she asks whether the reader's enjoyment 'has its source in the poetry of your own youth' rather than in the work itself, and

whether this phase of life may not soon be cast off: 'perhaps, ten years hence, you may smile to remember your present recollections, and view under another light both "Currer Bell" and his writings?' Yet she allows a seasonal appropriateness to such feelings, though separating the periods of life: 'Youth has its romance, and maturity its wisdom, as morning and spring have their freshness, noon and summer their power, night and winter their repose.'

Arnold's mind ran much on this difference of generations. The 'Stanzas from the Grand Chartreuse' find the innocence of the romantics – Byron's self-display, Shelley's lovely lyrical wail – a sort of literary wild oats, something adolescent to be grown out of; and the 'Memorial Verses' see Wordsworth as a spirit of spring fallen on a wintry clime, a force of pristine romantic inspiration living into the changed Victorian world of depressed, obsessive reflectiveness. Wordsworth is a poet of the youth of the race, and as a letter of 1852 puts it, 'the difference between a mature and youthful age of the world compels the poetry of the former to use great plainness of speech as compared with that of the latter.' The romantics wrote poetry of enjoyment and were free to be musical or pictorial; the Victorians write poetry of worry and intellectual search and must be wintrily plain – must turn poetry into prose.

The two generations appear in 'Empedocles' – the boy Callicles is the romantic poet; Empedocles, who has matured into the 'settled trouble' of Victorian seriousness and laid the use of music by – renounced the easy consolations of romantic lyricism – is the Victorian poet. The unthinking Callicles plays upon a harp, the Aeolian harp being the favourite image for romantic spontaneity. 'Touching thy harp as the whim came on thee' is Pausanias's description, and elsewhere he makes a criticism like Arnold's own that the romantics didn't know enough: 'a boy whose tongue outruns his knowledge.' Callicles takes thoughtless lyrical delight in the lanes, valleys and mountains celebrated by his songs; but in Pausanias's view – the Victorian one – nature has no revelatory power, but can only be used medicinally, as Tennyson used it, or as Ruskin in the lucid intervals of *Praeterita* concentrates on, say, the fireflies as a momentary relief from his mind's mad preying on itself. Pausanias prescribes this Victorian cure for Empedocles:

try thy noblest strain, my Callicles,
With the sweet night to help thy harmony.

211

In Act II Empedocles announces the failure of romantic confidence in happiness and inspiration – the small pleasures from which romantic poems grew, sports of country people, music in the woods, sunset over the sea, seed-time and harvest, can only give joy to those who are contented already. The Victorians had more worrying problems to preoccupy them, and Empedocles will not allow nature to call him out of himself, to overwhelm him with its multitudinousness; Arnold's insistence that the poet cling to authoritative ideas and to a severe noble style which keeps at bay the charms and distractions of sense is a form of this defensive self-reliance. Empedocles is one

> Whose habit of thought is fix'd, who will not change,
> But in a world he loves not, must subsist
> In ceaseless opposition, be the guard
> Of his own breast, fetter'd to what he guards,
> That the world win no mastery over him.

In contrast with this stern self-possession, Callicles has the youthful insobriety Arnold found offensive in the romantics – as Keats sprinkled his tongue with cayenne pepper to savour claret more finely, so Callicles sings with his head full of wine. When Empedocles takes up his harp again, however, it is to solemnly accompany his meditation; the weightiness is Victorian. In earlier days, according to Pausanius, he had the romantic poet's Orphic power to transform nature or become one with it, but he has matured, as the nineteenth century did – as Wordsworth, the only romantic to live beyond youth, did – from mystery into renunciation, gloom and self-division, and, like Arnold and Tennyson, he projects his own fearful moods and nervous uneasiness on to the large broils of the age:

> There is some root of suffering in himself,
> Some secret and unfollow'd vein of woe,
> Which makes the times look black and sad to him.

Callicles loses himself in the landscape he sings of, becoming a disembodied voice from below, but the burden of thought denies this romantic release to Empedocles. It is no longer true that an impulse from a vernal wood can tell one more of man than all the sages; he is the rational Victorian who believes mind governs earth and heaven and who must work out a way for himself:

Man has a mind with which to plan his safety.
Know that, and help thyself.

The transition from romantic to Victorian is apparent also in the setting. Callicles sings first of the nature of Wordsworth and Keats – streams, pastures, woody well-watered dells, mossed roots of trees, ivy and hyacinths. But his description issues in a changed landscape:

> glade,
> And stream, and sward, and chestnut trees,
> End here: Etna beyond, in the broad glare
> Of the hot noon, without a shade,
> Slope beyond slope, up to the heat, lies bare.

This is the Victorian waste land: the darkling plain, Dickens's brickfields and rookeries, Ruskin's Croxted Lane in 1880. Empedocles is alone in a charred, melancholy waste. Colour and beauty (as Ruskin's prophetic weather-forecast claimed) have been bled from nature.

There is a corresponding differentiation in the verse. In Act I the philosophical questioning of Empedocles is framed by two mythological fables of Callicles. These, enacted in grassy glens or warm Adriatic bays, are back with the innocent ignorance of Leigh Hunt's romantic classicism: for Hunt, with his happy excesses of animal spirits – 'I have southern blood in my veins' – Greek mythology prettily joins the forms of nature to man's erotic desires, and his nymphs make green dresses for themselves in leafy wildernesses. (Victorian nymphs, however, have that 'strain of special sadness' George Eliot discerned in Burne-Jones – those of his 'Mirror of Venus', for instance, lacking sensuousness, modelled from Botticelli, but with none of the wayward delights of fluid Florentine line, stare into a discoloured pool in a vacant lunar landscape.) Callicles's verse flows easily through long stanzas, where Empedocles argues in brief, bitter bursts, in stanzas with a pungency like Hardy's poetry. Again the gap between generations appears – from Leigh Hunt's lip-licking enjoyment of the world's beauty to Hardy's questioning of the universe's cruelty. Callicles sings of a happy metamorphosis – Cadmus and Harmonia become two bright snakes, removed from their Theban calamities to a delicious Illyrian landscape, just as, in his first song, the heroes rest in the placid fields of Elysium. The romantic relaxes into nature;

213

but Empedocles the Victorian is thrown back on the resources of his own intelligence and powers of endurance. In Act II Callicles sings the fable of Typho, beautifully and unreflectingly; Empedocles answers by divining the hard moral truth in it, its warning that great qualities are trodden down.

Shaken out of the serene romantic repose in nature, Empedocles faces the Victorian task of reconciling contradictory creeds, working out the truth for himself, by delving into his own bosom; and his analysis is that of the Victorian novel – man's error is to fancy the world as extension of his will; he has no right to happiness, and must submit to the limits of life. It is the Victorian novel which presses these limitations, as Arnold says the age has

> bound
> Our souls in its benumbing round.

Epic encourages our sense of our own power, romantic poetry exhilarates us, but we are chastened by the novel, which compels us to admit the reality of other people and their different claims on life. The novel comes to set itself against romanticism because it insists on the intransigence of circumstances, not the freedom of vision, and regard for others rather than the rush to express and fulfil ourselves. Romantics who find their way into novels are submitted, from Catherine Morland onwards, to punishing dis-illusionment, and George Eliot seems to be diagnosing the moral folly of romanticism in arguing that 'We are all of us born in moral stupidity, taking the world as an udder to feed our supreme selves' – again, as in Arnold, romanticism appears infantile, a greedy feeding on life from which we must be weaned. Dorothea's hopes are discouraged: she must recognise that Casaubon 'had an equivalent centre of self, whence the lights and shadows must always fall with a certain difference.' Empedocles endorses this central truth of the novel – what he calls 'the obstinate mind', which refuses to bow to necessity, is its recurring subject, from the satires of Jane Austen to the tragedies of George Eliot. He insists that

> Our cry for bliss, our plea,
> Others have felt it too.
> Our wants have all been felt, our errors made before.

This is demonstrated by the novel, by its form as much as by any explicit moral it contains – in George Eliot's novels, for instance, it is the expansion of relationships, the growth of a society of other

people with other desires, and our submissive attention as readers to their problems, which teach us that our demands are relative, that we ought to mark the world's ways, not have it learn ours. Empedocles glances at the forms of selfishness which receive more extended treatment in the novel, bad manners, refusal to change one's habits, the invention of false powers in ourselves, greed for pleasure whatever the cost; and his warning

> Other existences there are, which clash with ours

is the basic moral truth of the novel. Even the nature which the romantics had found so compliant has now acquired a will, a centre of self, of its own:

> Like as the lightning fires
> Love to have scope and play
> The stream, like us, desires
> An unimpeded sway.
>
> Like us, the Libyan wind delights to roam at large.

Empedocles's final abrupt act of suicide is a conclusion which, however, no Victorian novelist would have permitted. Even George Eliot, for all her gloom, felt that her obligation was to console, not to tell dangerous and damaging truths, and her conclusions always have a meliorism which softens the problems into picturesque safety; she allows her characters release (Dorothea and Will) or flight into an ideal (Deronda) or union in death (Maggie and Tom), where Empedocles sneers at man's self-deluding invention of a benevolent superintending power. He finally arrives at something like the quiet despair of the conclusion to *The Renaissance*: life leaves us scope for the enjoyment of immediate and simple pleasures, so that we are after all loath to die; so Pater saw life as a painfully brief span into which we must cram the most intense, though evanescent, sensations.

Literary forms seem to struggle for pre-eminence in an almost Darwinian way, and only the fittest survive. The novel proved itself the central form in the nineteenth century: it is, in the end, the inheritor of romanticism and it supersedes the attempts of the poets to re-create Shakespearean drama; it spills over its boundaries to imprint its methods and subjects on painting, drawing this art away from its classical dependence on epic, history and mythology; it jealously squabbles with poetry and when they divide the literary

realm between them it is the novel which takes for itself the life of the present, while poetry is made to retreat defensively into the past – the one grapples with fact, the other retires into dream. And yet the novel acquired this central position before it had altogether outgrown the primitive rudeness of its eighteenth century origins, for as a form it had been patched together out of hybrid materials, journalism, private letters, periodical essays, satire, which often had more in them of life than of art; and it remained sprawling, sluggish, unkempt, rough and improvisatory. Eminently unclassical, it had all the same ousted the more venerable classical forms, and James's comments on the Victorians, with which this book began, express a certain puzzlement about this – the novel is the form of limitless possibility, the only form adequate to the challenges of nineteenth century life, and yet it has no theory, no self-proclaimed classical status; it has achieved wonders, and yet its practitioners seem to lack the consuming devotion of the artistic conscience. The novelist seems not to think of himself as an artist. The authority usurped by the novel must, then, be legitimised by artistic seriousness: the novel, which in this chapter appears as the rival of poetry, must in its turn become poetic. Victorian art and literature are, like life, crowded, contradictory, growing and spreading in an energetic anarchy, a riot of detail uncontrolled by the whole; a new generation, however, felt the need to purify art of life, to separate them, as Robert Louis Stevenson did in his reply to James's 'The Art of Fiction': 'Life is monstrous, illogical, abrupt, and poignant; a work of art, in comparison, is neat, finite, self-contained, rational, flowing and emasculate.' Works of art cease to be organic, and begin to be iconic.

INDEX

INDEX

INDEX

221

INDEX